CHANGING the TIMES

Irish Women Journalists

1969 — 1981

Edited by ELGY GILLESPIE

THE LILLIPUT PRESS • DUBLIN

First published 2003 by
THE LILLIPUT PRESS LTD
62-63 Sitric Road, Arbour Hill, Dublin 7, Ireland

A CIP record is available from the British Library.

ISBN 1 84351 018 9

ACKNOWLEDGMENTS
*This book could not have been completed without help
from Irene Stevenson and Esther Murnane of the Irish Times Library,
David Slater of the Irish Times Picture Desk, Ann Toseland of Cambridge University Library,
and Davey Hennigan whose "The Big Fight" about Ali's visit sparked the idea.
And thanks to Lilliput's junior staff, Frieda Donohue and Eva Kenny,
for diligent proof-reading.*

Set in 10 on 15 point Caslon
Designed and typeset by Anú Design, Tara
Printed in Dublin by βetaprint

Changing the
Times.

Ed.

Books are on loan

for 21 days.

Overdue books

charged at €1.00

per week.

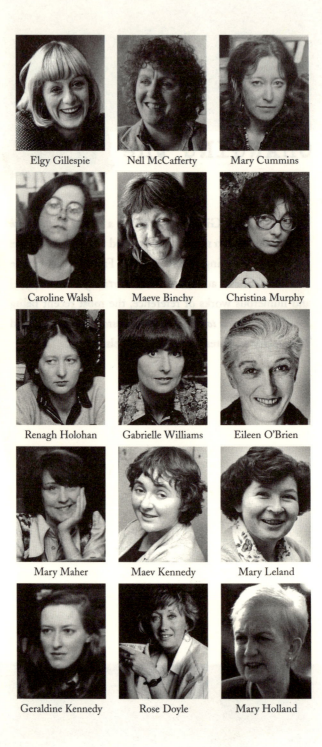

Elgy Gillespie Nell McCafferty Mary Cummins

Caroline Walsh Maeve Binchy Christina Murphy

Renagh Holohan Gabrielle Williams Eileen O'Brien

Mary Maher Maev Kennedy Mary Leland

Geraldine Kennedy Rose Doyle Mary Holland

Contents

Chapter 1 – First Times

Profiles

Chapter 2 – End of an Era

Chapter 3 – Out and Proud

Chapter 4 – Our Bodies, Ourselves

Chapter 5 – The North Erupts

Profiles

Biographies

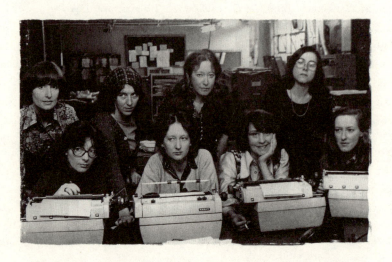

Women of the Irish Times (clockwise from above):
Gabrielle Williams, Maeve Donelan (sub-editor),
Mary Cummins, Caroline Walsh, Geraldine Kennedy,
Mary Maher, Renagh Holohan, Christina Murphy.

Preface

How Irish Women Journalists Changed the Seventies

It all began with Douglas Gageby's news editor. When the founder of the *Evening Press* moved from Burgh Quay to D'Olier Street early in the sixties, he hired Donal Foley, who had worked for the *Irish Times* in London.

Donal was the son of a national schoolteacher in Ring and a native Irish speaker whose loyalty to his culture was matched by his determination to hire diversely, and that included women. To paraphrase Walt Whitman, he sang the Body Eclectic. Gageby had unleashed an unpredictable, intuitive and wholly original intelligence inside the newsroom that resulted in a feminist army of sorts. Yet it was a seemingly random process.

Foley was tolerant and open, interested in the North and in the Language as well as in women. He was interested in everywhere and everyone. Together, Gageby and Foley initiated changes that began with bylines, foreign coverage, investigative reports by Michael Viney, and bringing the ungrateful Northerners a Belfast edition—radical steps now taken for granted. But the most exciting change came in the form of the Women First page, and the women writers who filled it; led by Mary Maher and Maeve Binchy, they penned the ripping reads of the day—first-person entertainments exposing shame, scandal, fear, misery, and abuse. The New Journalism had arrived, and we put ourselves in every story.

Donal really enjoyed our company over those three-to-four hour lunches and drinks in the Harp, and on through those legendary evenings at the Pearl—as we also enjoyed his great explosive laugh and *bonhomie*, sometimes until it was time for us all to jam into the elderly Fleet Street elevator, swaying together towards the deadline din of galloping Facits as we sang "The Rose of Tralee". Or totter home on the bus, still singing "The Rose of Tralee".

We had our talented counterparts in the *Irish Press* and the *Independent,* most famously Mary Kenny, but we knew we had something that they envied and could

never have: absolute press freedom with Douglas Gageby and Donal Foley's support. Donal sometimes shook his head at our youthful idiocies, and he had no interest in the cooking or clothes columns that were expected of women's pages back then.

We drove him crazy. We drove Gageby crazier. I segued to Arts where I drove Fergus Linehan and Brian Fallon crazy too—until the new editor Fergus Pyle invented a history series to spare them. Let's face it, we drove the entire island crazy, especially Mrs Maureen Ahern of Corbally and the Dean of Killala who wrote to the Editor daily. On our gravestones let it be engraved: "We drove them all crazy, especially the ones in Corbally."

Way back in kinder and gentler 1971, everybody had apparently landed there through meandering, Alice-in-Wonderland sequences, as though they'd fallen through a series of upside-down holes into that forgiving, warm, indescribably dusty Dickensian burrow, born backwards from the cruel world outside. Donal also hired men, in a fortuitous but logical way—Lionel Fleming, Denis Coghlan, John Armstrong, Joe Joyce, Andy Hamilton, Jack Fagan, Nigel Brown, Michael Heaney, Godfrey Fitzsimons: equally diverse. But to the consternation of the other editors in D'Olier Street, his women just seemed to wander in off the street.

How on earth did the *Irish Times* find the high-hearted schoolteacher Maeve Binchy, the fine-featured Chicago-born idealist Mary Maher, the effortlessly organized and kind Renagh Holohan, the principled Gaelophile Eileen O'Brien, the bandbox-elegant and bright Gabrielle Williams, the epicurean Theodora FitzGibbon, the rhapsodic nurse from Ballybunion Mary Cummins, the fearless civil-rights activist Nell McCafferty, the tasty Leeside wordsmith Mary Leland, and later on myself, Christina Murphy, Geraldine Kennedy, Maev Kennedy, Ella Shanahan, Caroline Walsh, and more?

How had we all come to be hired by County Waterford's gift to the Street of Shame, Donal Foley?

Or to rephrase the question: how did Irish women journalists come to change the seventies? To revisit seventies journo-speak, this book is looking for answers and means to find them.

31 July 2003 Elgy Gillespie

Introduction

Coming of Age with a Vengeance
Mary Maher

It began, as so many things do, in a pub. On that particular day we were arguing about women journalists, women's journalism, and whether or not a newspaper should have a "women's page". I was vehemently opposed. From the time when I ran for opera tickets and takeaway coffee for the society editor of a Chicago daily, I was conscious of the fact real reporters regarded the field with contempt.

My definition of a real reporter was unclear. At seventeen, I greatly favoured the crime reporter with the dangling cigarette. By twenty-two, when I was officially incarcerated on the society desk, bashing out wedding descriptions and correctly spelling the names of those who were there to be seen, he had been replaced in my esteem by the political correspondent, whose face was thrillingly cynical.

I was more certain than ever that my own colleagues who womanned the society, fashion and club desks of the almighty *Chicago Tribune* were without journalistic merit. Silly twits and dolly-birds, we gushed out a pastiche of florid adjectives, coy advice and moronic euphemisms on cooking, clothes, homes, housework, shopping and other dull subjects. I finally begged my way into the real newsroom to write solemnly about fires and police reports, and took for granted the fact that I'd learned to spell names correctly, to write under a dead-line to the required length, to place facts in the first paragraph, and when in doubt to leave out: all precepts of the trade passed on by silly twits.

Were they all as bored with the limitations imposed on them as the readers must have been? Of course. Could they have done anything about it then? No. The women's pages were designed by male editors with the advertising department, for housewives whom they imagined had only one interest: to buy things to bring home. Female readers who didn't conform could always turn to the rest of the paper (the "men's pages"). When Betty Friedan published *The Feminine Mystique*, with its painstaking and painful analysis of how women's journalism had

reinforced the kitchen and nursery subjugation of American women, I thought the final word had been said, and the only answer was abolition.

So four years later, on a rainy afternoon in Dublin, I found myself battling an illogical but rather attractive hypothetical question from Donal Foley. Why not a women's page with serious articles, scathing social attacks and biting satire, and all that? Why not? Why not combine the real reporter bit with a concentrated focus on the wrongs suffered by women, plus useful factual information for the women whose work happened to be running a home? No point, I said, in creating a ghetto cut off from the real world of face powder, luncheons and marmalade recipes.

I became the women's editor. Renagh Holohan and I, and a handful of contributors, had a whole half page to flail away with every day, and flail we frequently did. Mostly we tried to do more straightforward reporting on the traditional topics: inquiring into the market price of fish and its retail mark-up, and dourly pointing out fraud in the Annual Sales!

There were articles on censorship, slum property, the housing shortage, the class bias of education, exploitation of factory girls, corporal punishment, and a few initial attempts to raise the matter of equality along the order of "Women Drive Better than Men" and "When Will the Unions Fight for Equal Pay?" It was a beginning. Contraception, unmarried mothers, deserted wives, family law, children's courts, prison conditions—all the issues that didn't exist out loud in 1967—were to follow, faster than we perhaps imagined.

Eighteen months later I was exuberant with relief to turn the running over to Maeve Binchy and venture back into the newsroom. The best to be said about that initial period was that a somewhat different women's page did get established. The other national dailies followed suit within months of the inauguration of Women First with their own pages. When the Women's Liberation Movement burst upon us in 1969, Irish women's pages became a forum. Whether what they've said has been totally worthwhile may be debated; but at least it was controversial, and that was a women's page first.

So controversial were they that they have phased themselves out, like the fellow who kept the wheel turning until he'd worked himself out of a job. When the women's pages came of age, they did it with a vengeance; and I think with satisfaction of how shaken up all those real reporters must have been. Served them right, the silly twits.

26 October 1974

Chapter 1

First Times

What Irish girlhood meant in the old days, bad or good, and what it was like for a Dalkey teenager, a budding Derry activist, a Ballybunion schoolgirl, the nubile young women of Cork and Kerry, a Mayo convent girl, a Rathmines Edna O'B-to-be, a London-Irish student at Trinity College, an Irish-American cub reporter, and more.

Maeve Binchy

Baby Blue: My First Best Dress

My first evening dress was baby blue and it had a great panel of blue velvet down the front, because my cousin who actually owned the dress was six inches thinner everywhere than I was. It had two short puff sleeves, and a belt that it was decided I should not wear. It was made from some kind of taffeta, and it had in its original condition what was known as a good cut.

It was borrowed and altered in great haste, because a precocious classmate had decided to have a formal party. A formal party meant that the entire class turned up looking idiotic and she had to provide twenty-three idiotic men as well.

I was so excited when the blue evening dress arrived back from the dressmaker. It didn't matter, we all agreed, that the baby blue inset was a totally different colour from the baby blue dress. It gave it contrast and eye-appeal, a kind next-door neighbour said, and we were delighted with it. I telephoned the mother of the cousin, and said it was going to be a great success. She was enormously gratified.

I got my hair permed on the day of the formal party, which now, many years later, I can agree was a mistake. It would have been wiser to have had the perm six months previously and to allow it to grow out. However, there is nothing like the Aborigine look to give you confidence if you were once a girl with straight hair, and my younger sister, who hadn't recognized me when I came to the door, said that I looked forty, and that was good too. It would have been terrible to look sixteen, which is what we all were.

I had bought new underwear in case the taxi crashed on the way to the formal party and I ended up on the operating table; and I became very angry with another young sister who said I looked better in my blue knickers than I did in the dress. Cheap jealousy, I thought, and with all that puppy fat and navy school knickers, plus an awful school-belted tunic as her only covering, how could she be expected to have any judgment at all?

Against everyone's advice I invested in a pair of diamanté earrings that cost one shilling and threepence in old money in Woolworth's. They had an inset of baby blue also, and I though this was the last word in co-ordination. I wore them for three days before the event, and ignored the fact that great ulcerous sores were forming on my ear lobes. Practice, I thought, would solve that.

The formal party started at 9 p.m. I was ready at six and looked so beautiful that I thought it would be unfair to the rest of the girls. How could they compete?

The riot of baby blue had descended to the shoes as well, and in those days shoe dyeing wasn't all it is now. By 7 p.m. my legs had turned blue up to the knee. It didn't matter, said my father kindly, unless of course they do the Can-Can these days. Panic set in, and I removed shoes, stockings, and scrubbed my legs to their original purple and the shoes to their off-white. To hell with co-ordination, I wasn't going to let people think I had painted myself with woad.

By 8 p.m. I pitied my drab parents and my pathetic family who were not all glitter and stardust as I was. They were tolerant to the degree of not commenting on my swollen ears, which now couldn't take the diamanté clips and luxuriated in sticking plasters painted blue. They told me that I looked lovely, and that I would be the belle of the ball. I knew it already, but it was nice to have it confirmed.

(✳✳✳)

There is no use in dwelling on the formal party. Nobody danced with me at all except in the Paul Jones, and nobody said I looked well. Everyone else had blouses and long skirts, which cost a fraction of what the alterations on my cousin's evening dress had set me back. Everyone else looked normal. I looked like a mad blue balloon.

I decided I would burn the dress in a bonfire in the garden that night when I got home. Then I thought that would wake my parents and make them distressed that I hadn't been the belle of the ball after all, so I set off down the road to burn it on the railway bank of Dalkey station. Then I remembered the bye-laws, and

having to walk home in my underwear, which the baby sister had rightly said looked better than the dress, so I decided to hell with it all. I would just tear it up tomorrow at dawn.

But the next day, didn't a boy, a real live boy who had danced with me during one of the Paul Joneses, ring up and say that he was giving a formal party next week and would I come? The social whirl was beginning, I thought, and in the grey light of morning the dress didn't look too bad on the back of a chair. And there wasn't time to get a skirt and blouse and look normal like everyone else, and I checked around and not everybody had been invited to his formal party: in fact, only three of us had.

So I rang the mother of the cousin again, and she was embarrassingly gratified this time, and I decided to allow my ears to cure and not wear any earrings, and to let the perm grow out and to avoid dyed shoes. And a whole winter of idiotic parties began, at which I formally decided I was the belle of the ball even though I hardly got danced with at all, and I know I am a stupid cow, but I still have the dress, and I'm never going to give it away, set fire to it on the railway bank, or use it as a duster.

12 December 1971

Nell McCafferty

First Dance

The most humiliating years of my life were those in which I tried to be beautiful. An attractive dame I was not. That my childhood was not ruined by the fact that I had (and have) bandy legs, short stature, yellow bilious pimples and no waist at all is due entirely to my father. He called me "Curly Wee", carried a picture of me everywhere, and used to read my school essays to his workmates.

I had a very attractive older sister who wore clothes like a model, could jive like Elvis Presley and had callers at the door. When they did call and I remained behind, my father would engage me in intellectual discussions about greyhounds and odds-on favourites and the amount of fuel required to fill the ships of the Royal Navy, in which exercise he was daily engaged.

When my brother and I went to our first céilí dance at the age of fourteen, my mother took my brother aside and reminded him to treat all women as if they were the Virgin Mary. My father took my brother aside and reminded him to treat me as he would treat all women, and thus I was always sure of at least one dance. If my brother did not dance with me, I went home and told my father, who took suitable punitive action.

Then there was acne. No amount of soap and water could cure it. I had pimples, blackheads, flaking skin, the lot. I was miserable. Nothing, I realize now, could cure it. It was one of those teenage things. But when we queued up every week for our threepence pocket money to be spent on gobstoppers, everlasting toffee

bars and marbles, my father drew me quietly aside and slipped me the extra for a tube of Valderma, designed to give me skin like Marilyn Monroe. It never did, of course, but someone at least was backing me.

Brassières and breasts were always a problem. I once tucked my school blouse alluringly into my tennis shorts, and in the middle of the senior tennis championships when I was two points ahead, the Reverend Mother blew her whistle, summonsed me off court, and informed me that certain appendages stuck out which Our Lady would prefer to remain hidden. I lost all my points including the championship.

Hair, too, was a problem. When pony-tails were in, the best I could manage was long ringlets. Backcombing arrived and I went round like an unemployed Niagara Falls. As for hair on the legs and under the arms! The muffled whine of my father's electric razor used to bring my mother roaring up the stairs, and I was always left with half a hairy leg and one bare underarm. I resorted to the quieter manual razor and used to go to dances cut to ribbons.

It's not that I have anything against beauty treatments, or beautiful people. It's very nice to see pretty people around the world, and I like to look at pictures of the Taj Mahal and the Acropolis, and Sophia Loren and Paul Newman. But the best I can manage is to wash my hair regularly, to stop biting my nails, and concentrate on my eyes, which are a rather nice shade of blue.

Otherwise, the hell with it. If I saved up the money I'm advised to spend on beauty treatment and went abroad I could get a great suntan which would offset my eyes. Also, I could go swimming, which is better than beating myself about the breast every morning.

So there.

14 October 1971

Mary Cummins

All Our Easterdays: New Dresses, Picnics, and a Retreat

With purplish-black ink greasing up my calloused fingertips, I'll be working all over the weekend. My soul soaked in nostalgia and the might-have-been-if-I-had-used-my-loaf. Dutifully, and with a mournful face, I will remind one and all that I am an Easter martyr.

I will remember, teardrops from my craw, changing into summer dresses and the new one for Sundays coming in a brown box from Clerys. A clean church and unfamiliar, eerie statues under purple. A white altar with stark, majestic lilies, white and pure at midnight Mass.

Remember, incongruously, a dancing teacher coming in a big car the day we got holidays. She took the money we were sent home to get for lessons and was never seen again. Remember, remember, fast days and two collations and a mound of saved sweets grown under sweaty, longing glances: gifties, and dandys and cough-no-mores.

Remember Spy Wednesday, a sinister day and sloes on bushes. The silence at three on Good Friday, and the clack, clack of the wooden clappers at the Consecration instead of bells. That morning, the first day for picking periwinkles, patches of people on the strand from early morning with buckets. Concentration. Bending and straightening and putting stones in to heat the others. The swelling smell as they boiled their lives away in a big pot that evening; the sandy scum at

the top of the grey, murderous water. We watched and waited with needles poised.

Smell of grass, luxuriant and fresh, and a picnic on Easter Sunday afternoon back in the sand hills. The girl who didn't get any Sunday money taking a tin of peaches so that she could come. Following the courting couples to work off the layers of sugared bread. Forgetting the time in the first burst of summer evening.

A retreat at school the week after Easter and long holy days getting longer and holier, with heaven and hell and the lives of saints and of mysteries sordider-than-thou tunnelling home to confuse further. And long walks on the cliffs wrestling with a vocation, unable to disbelieve those who said you'd never be happy if you turned it down.

One Easter egg for the five of us and the envy of the friend who had one to herself. Easter is a resurrection, a stone rolled away from a tomb, and a God-man steps out. Easter is a stuffy room and a glimpse of freedom, a long empty beach, boiled eggs for tea, a restful sea in the blue sky above the chimneys on the way to the bus.

31 March 1972

Mary Leland

Two Marys Go to the Dance

The last bus to Blackrock, Cork, gets crowded on a Saturday night. The girls and boys upstairs sing in competition with the girls and boys downstairs, and to the alarmed senior citizens it sometimes seems as if the bus is swinging in rhythm.

The singing upstairs is invariably begun by a group of five or six undersized and possibly undernourished girls, lively and in happy unison. Whatever about anyone else, they are heading for a dancehall. They sing all the way from the Statue, joined at Ballintemple by the rejects from Constitution and outsinging them too. They swear tunefully that they'll never fall in love again, they beg not to forget to remember them, and not to say goodnight, midnight.

Old ladies with queasy poodles avoid the robust eyes of elderly men, normally sedately sober, but who at some time after eleven on a Saturday night are amorously drunk. Girls in their college scarves get off gratefully at Beaumont and the bus conductor asks them, "Would you like to be going dancing with that crowd?"

The singing girls—little, thin, deliberately eyebrow-less, and still wearing cotton dresses and light nylon raincoats in December—clatter off up the road. The boys stand with hunched shoulders among those who have just left the pub. Inside the hall, in the lights and the warmth and the excitement, the girls sit together in the corner nearest the bandstand, smoking and listening. They never

dance unless weaving around their corner with one another. Otherwise they sit drinking in the music and the songs, until it's time to go home. Then linking arms they walk back to the city, spread out across the width of the Marina, singing through its blackness by the river's edge: "Good Morning Starshine…"

I used to love that bus. But one night the girls screamed and bolted down the stairs in an attempt to make the driver stop. There was a fight. There was a knife. There in the back of the upper deck struggled a heaving, shouting mass of young bodies. Conductor and driver raced up and seemed to be sucked viciously into the melée. The noise, curses and the sounds of blows combined in a terrorizing, sickening nightmare; the bus became a double-decker coffin full of hate and curses and savagery. Some of us got off, rang the gardaí and from outside watched with dry mouths and shivering hearts the heads being knocked against seats, wild arms reaching to clutch. Somehow the busmen, struggling up from between the seats, pushed enough of one faction away with them, down the stairs and out onto the road to be able to close the doors against them. A boy leapt against the glass, swinging his chain. The girls moved back upstairs, the singing began again and the bus moved off. And I walked the rest of the way home.

(✱✱✱)

The Stardust Club: public dancehall on the Grand Parade, admission usually around eight shillings, except for Sunday afternoon "teen" dances when it's three shillings and sixpence. I went to the Students' Dance on Friday night, with Tina and the Mexicans providing the music. The dances are well managed and organized, with scrupulous officials scrutinizing the queues for signs of drinking or drunkenness. It must be one of the most comfortable dancehalls in Munster, with recent conversions providing an armchaired lounge and balcony, where everybody watched the Rowan and Martin laugh-in on television for half an hour or so. From the balcony, the hall below—dimly lighted and tight-packed—presented a picture of an immobile throng. The slow dances here are very definitely slow, and during some of these it is hard to believe that anyone is moving at all.

In a slow dance of this kind the boy and girl, or man and woman (girls from sixteen to twenty-five, boys in the same range with some up to and over thirty) stand as close as physically possible, with the girl's arms around the boy's shoulders and his arms around her waist. The shoulder grip keeps both heads within kissing

range, a position taken obvious advantage of, while the waist grip keeps the bodily pressure on. Thus held together, they move over a few square inches of floor, to break apart at the end of the dance and take up the same positions with someone else for the next one.

Nobody pretends any more not to know what "close dancing" is all about. It's impossible to avoid its physical significance, and from what I could see no effort is made to do so by anyone. It's just an accepted alternative to the fast dances, and sex, of course, has nothing to do with it.

The rule of "no pass out" avoids the quick court in the car and then back to the dance for another girl, but the philosophy persists. And the bright little faces of the girls telling one another that they're fixed up for a lift home reflect not just self-congratulation at a successful night but a kind of permissive anxiety.

In the cloakroom, teasing their hair to new heights, they hurl information to one another—what's he like, is he "alright", did she know what to do, what happened last week? And in a welter of giggles they scramble out to take their chances. The crowd is mixed—the college cachet seems to mean very little. The band is electronically identical with all the others, even to the three-deep row of worshippers who never move from the footlights. Tina fingers her Apache headband like a tired nun and the music bellows its echoes of love and longing to all the young people who have nowhere else to go.

It isn't all fun. At the 'Dust, at the "Con" (Constitution Rugby Football Club), just as at the Boatclub, the Shandon, the Arc, the Island, the Majorca, the Orchid, the Lilac, the Majestic and the Industrial Hall in Clonakilty, the girls stand patiently in line and the boys take their pick. Of course a girl can refuse the grip on her elbow, the muttered suggestion, the toss of the young male head. I saw quite a few doing so. But there is still the element of the slave or the cattle market. For a short while one night I remembered just what it felt like, felt the ache of the smile on my face. "It's better to look dejected," a friend said. "They seem to take pity on you then."

But it's a bruising, unfunny experience. The girls stand patiently in line and the boys take their pick. Most girls have no option. They don't pretend not to be there to find a boyfriend. Because they're there, they have to let themselves be picked up or discarded in a mass submission to masculine will. Only a few couples continue to go dancing once the partner is found. Some girls rejoice in the competition, in the challenge and in the trophies. Others retire from the field, congratulating themselves on having escaped a back-seat pregnancy, bitter

at their chosen isolation from a throbbing vivacious contact with other young people, but unwilling to take any more chances.

They are bewildered that their worth hasn't been recognized. It takes years to lose the innocent enjoyment and hope, and I can't help continuing to believe that dancehalls should be gay and happy places. Perhaps they are; perhaps they only seem sad to me, with ten years between my contentment and their strife.

14 January 1970

Christina Murphy

First Love: Teenage Idol

I was pushing my bicycle up Chapel Hill after school, exchanging gossip with my best friend, when somehow we found ourselves confiding in each other who we wanted to marry. We must have been about fourteen, and we had been well and properly drilled by the nuns in such matters. We didn't say we had a crush on him, we didn't say we fancied him or that we'd like to have a court with him. To a convent-educated girl, men meant one thing—marriage. So when we fell in love, even at long distance, we automatically assumed that it meant wedding bells.

I had worshipped him from afar for some months, and I still remember vividly the relief of discovering that my best friend was in the same predicament. The joy of actually being able to mention his name, and in connection with myself, was almost unbearable after all those months of silent suffering. After a long chat about the relative merits of the two candidates and our possible prospects, we went home glowing with the cosy feeling of a shared secret and I think we thought ourselves half engaged already.

There followed a period of passing little notes to one another in class, composing poems in which the loved one featured surreptitiously, and toying with various combinations of the spelling of his name on the back of our Latin grammar.

She fared a bit better than I did. Hers actually danced with her on a few occasions—and I think he even kissed her on the cheek once at a Christmas party. I was doomed to engage in unrequited love for what seemed like years. He was

undoubtedly good-looking, tall, thin and athletic with a great shock of black hair. But he was aloof and more interested in tennis and football than in girls.

I proceeded to adopt the most extraordinary tactics. I cycled home from school by twenty different routes vainly trying to get a glimpse of him. I began to take a loving interest in his little brat of a sister and gave her rides on my bike and bought her ice cream. I bewildered my family by suddenly becoming a religious maniac.

I went to eight o'clock Mass and communion every morning for two reasons: to pray to God to make him fall in love with me, and to position myself strategically near the top of the left-hand aisle, from whence I could watch him praying with bowed head and get a good look at him coming reverently back from the rails. I even toyed with the idea that he might be thinking of the priesthood and I was sure that if he did I would never marry anyone else.

(∗∗∗)

There were some high points in all this depression. When the snow came and the boys' school launched their annual attack on the convent, he singled me out as the object of his aim and I was actually hit by three missiles launched from the revered hand. That kept me in daydreams for weeks. At a party once he brushed past me, and I treasured the smell of his tweed jacket for days.

In February rumour had it that he received half a dozen Valentines, which was three more than the anonymous lot I had sent him. It was worrying. What was more worrying was that the doctor's daughter was reported to be the author of one, and I didn't think I would stand much of a chance against such high-powered social opposition. Maybe if I went out with someone else he would wake up to my charms. I accepted a few invitations to the pictures from other fellows who must have though I was either mad or frigid because I refused to even let them hold my hand.

My God, it would have been tantamount to being unfaithful to one's fiancé. All in vain. It seemed that the saint was incapable of jealousy, too.

Gradually, common sense reasserted itself, and I began to realize that, far from beseeching the Almighty to help him resist my temptations at daily Mass, he was probably praying that silly love-struck girl would leave him in peace to get on with his rugby practice.

I began a campaign of deliberately blotting him out of my mind, and desperately tried to cultivate an interest in the other young boys around town. Gradually I

got over it, but still in the course of three lengthy and more productive teenage romances, the shadow of the unattainable Adonis hung there in the background. We grew up, passed our exams, and went away. Absence finally obliterated all memory.

Then, two years ago, I was walking down O'Connell Street on my own late one night when this balding, rather bloated-looking drunk approached me. "Why, it's Christina Murphy!" said the distinctly unpleasant figure. And my God, it was the teenage idol, looking for all the world as if he had spent the past ten years digging ditches and drinking pints.

He was probably staggering home to the harassed wife and four kids he was never meant to have. And, I thought, maybe all those eight o'clock Masses and prayers were not wasted after all.

For there, but for the grace of God...

14 February 1974

Maev Kennedy

All Write: Portrait of the Artist as a Suffering Daughter

All right, all right, old man, I'll get efficient. No more grim enquiries as to "What did you write today?" No more witty anecdotes followed by a sly glance to see if I look inspired…

You may also spare me the stories about Offspring of your Friends who are Supporting Themselves by Working, and putting their old mothers through college on the proceeds of their first book. And if you'll also promise not to groan any more when I say, "But what will I do for a job this summer?" I will get efficient. After all, that is what I was reared for. You brought visitors into my nursery and when I stood up and rattled the bars of my cot, you said: "That's my daughter, she's going to be a writer."

Three years later when people asked me what I was going to be if I grew up, I did not prettily say "an engine driver" or "a gentlewoman like Moll Flanders", I said: "I'm going to be a wealthy scribbler like—" Well, like a lady friend of ours who has since become a very wealthy scribbler indeed. You set me writing when I was seven, and when I was eleven you reluctantly admitted that my hour was not yet come: I was too old to be Daisy Ashford and too young for anything else. Your hour came when I was fourteen and my One True Love of the carroty hair and the nylon polo-necks left me, and I was sitting on the cold cold kitchen floor and weeping desolately. You said: "There's a story in that."

Nothing ever hurt that much again. But you forced me to see dimly, sitting on the floor by the sink, one leg cramped and the milk about to boil over, that it was excellent material. I didn't write that story, I couldn't until it was proved to me that he was not after all the first and last to love me, but you had nevertheless ruined my life as a human being. I had the marvellous formula for surviving all crises and traumas—such good experiences, and remember that one can't put suicide into an autobiography! How could I ever take anything really seriously again?

(∗∗∗)

You bullied me finally into writing articles out of boredom as a displacement activity, out of abject poverty, without method or system or overall plan, and I couldn't take them seriously because obviously they'd be rejected, but they weren't. You told me this was very bad for me and to get method instead of wasting time, and I didn't believe you because you were very old and you didn't understand me, and in any case why should I take you more seriously than anything else?

Suddenly I'm old enough to see that I'm young, that I will never be more intelligent, that I will never experience as intensely again, and that I had, after all, better get organized.

Father, thy will be done. I've cleared everything off the desk except my typewriter, my sewing machine, the birdseed, my cutting-out shears, my Trevelyan's *English Social History,* an ashtray full of buttons, a flight programme, a ballpoint (defunct) and five notebooks. I've crept downstairs and stolen a ream of yellow quarto—five pages at a time seems somewhat amateurish. I've pinned all my rejection slips to the wall in front of me. I've rescued my desk diary from exterior darkness and I'm all ready.

Now. This week I'm going to write. Expel the small brothers, strangle the budgie, uproot the phone and disconnect the doorbell and who is grating carrots so loudly downstairs? I am writing.

Next week I am changing my distribution methods. Organization and efficiency. At two articles a day, and an editorial on Sunday morning, there will be an unprecedented selection of my work available by next week. Surreptitiously creeping around by post from editor to editor, from newspaper group to newspaper group, is inappropriate. So on Monday there will be a public auction in a certain conveniently central coffee shop, and all editors are expected to attend (dress

optional). Payment in money or kind will be accepted and a minimum bid of three guineas, two cream cakes and one of those nice sticky-topped cherry buns has been fixed. Commission will also be accepted for the forthcoming "What today's politically aware woman wears cooking aubergines."

Oh, kindly do not tip the grumpy grey-bearded doorman. That's no doorman, that's my father.

25 May 1970

Elgy Gillespie

Women Seek Real Quality

In an atmosphere of charged excitement, the Mansion House hall and gallery were filled last night for the first major public meeting of the Irish Women's Liberation Movement. The crowd of over a thousand included a sizeable sprinkling of men, and a wide variety of ages and backgrounds were represented in the audience.

Miss Nell McCafferty presided over the panel of four mothers and one man: Mrs Hilary Orpen, Dr Moira Woods, Mrs Mairin Johnston, Mrs Mary Geraghty and Mr Ivan Kelly, solicitor, who was present to deal with the legal pressures.

Opening the meeting, Miss McCafferty declared the aims of the movement to be: "One family for one house, equal rights for women in law, particularly for deserted wives and unmarried mothers, equal pay for equal labour and for married women who wish to work, justice for widows and equal education opportunities." Audience members were asked to come forward to a microphone at the front and discuss ways of following their aims, to ask questions and to make comments, which the panel would reply to. There were no official speakers.

As the queue of those who wished to speak grew longer and longer, there were jeers from the gallery and occasional shouts of "Shame!" and "Where's your modesty?" among the cheering and the fierce applause that followed speaker after speaker. Viewpoints ranged from the extremely personal to the intensely political. Answering a young girl's question as to whether the movement was intended to be political, Mrs Johnson replied that in the end the price of a loaf

of bread was political and that women must concern themselves about living conditions such as the housing shortage, "because men won't".

(***)

Senator Mary Robinson, who recently attempted to introduce amending legislation on contraceptives, told the Christus Rex Congress in Bundoran that the Women's Liberation movement "constitutes the only radical force in the stagnant pool of Irish life".

According to a supplied script, she condemned our legislators for a general lack of initiative in implementing social legislation. She felt a new vision of society was needed and "the only untapped source of new ideas and initiatives left in the country is its women".

15 April 1971

Thirty-two years later

"If I can't send a man who then? ... Send her along so!" barked news editor Donal Foley to a hugely pregnant Mary Maher. Simultaneously, Foley was peering through thick lenses, the better to juggle seven phones in two languages, including Waterford. "One o'clock in the Harp!" he roared at the Archbishop's press officer. *"Tá sé anseo, cinnte!"* he confirmed for good measure to Jimmy Saville and Lady Goulding; and "I want four hundred words and I told you I wanted it *** yesterday!" bellowed at a high-level ministerial source.

Before him, antique Facit typewriters thundered in the dusk, assistant editor Gerry Mulvey fretted, and newsdesk secretary Josephine McManus deadpanned before sorting it out.

And onto the Markings sheet, at the very bottom, "Mansion House" was added to "Miss Gillespie" in Gerry's own hand.

My first front page news byline, not counting that dreadful Spring Show hazing ordeal! "But I've got a heavy cold," I protested.

"Stick it out, kid, we'll help you," said my surrogate mother Mary, and they did; and I died from happiness and went straight to front-page byline heaven.

Nell now says they sent one new crazy woman to cover a bunch of crazy women. Yet contrary to what the Women First page seemed to suggest, Irish women

were not invented in 1971. Distinguished and brilliant Irish women journalists were writing already. But while the outside world was in ferment, Ireland was a narcoleptic waking from the nineteenth century. Catholics from North and South had begun going to Trinity without bothering to kiss the archbishop's ring first, and the North was rising. Fish were going to fly and the world was ending! Our hour had come; the rough beast was slouching towards the Mansion House by way of the Pearl Bar.

Profiles

Nell McCafferty

A Day I Spent with Paisley

Alone in Crumlin Road Courthouse in Belfast at 9 a.m. on Tuesday, Ian Paisley doggedly began his working day as he had thunderously begun his crowded open air meeting the previous night—in pursuit of law and order. He laid the complaints before the returning officer that a woman had been driving around the Bannside, stealing his postal votes.

He then spent an hour in the offices of the Puritan Printing Company Limited with his youthful election agent, the Reverend Beggs, a charming clerical version of Anthony Perkins. At 11 a.m. he appeared in the village of Ahoghill, Bannside. His local contact man scuttled ahead of him, knocking on doors, pointing back to the big man. Scrubbed and smiling, solid in the drizzling rain, Paisley moves steadily from house to house, forthrightly introducing himself as a Protestant Unionist candidate, "—And here's some literature for you!" He filled the doorway, hands on either side of it, leaning in, looking down, the brief seconds large with his presence. I asked a woman why she was voting for him, and she was astonished at my ignorance: "The Lord's Word must be spread." What did she want from him politically?

"Material things don't matter when we're before our Maker." In slum dwellings off the main street, the occupants seize him with delight. "That Minford never came this far yesterday. You speak up for us, Doctor Paisley."

At 1 p.m., the village covered, Paisley stepped into his car and drove off. A

covered jeep, little Union Jacks on the bonnet and Scots céilí music coming lightly from the amplifier, followed by me and my taxi behind. We lost them at a country crossroads. Later we found the parked jeep and Wesley, the puzzled driver, beside it. A petrol-pump owner from Lisburn, he didn't know the area. "You couldn't keep up with the Reverend. I never seen such a busy man." He talks matter-of-factly to me about the fires of hell. He had been saved from the paths of darkness five years ago. "And I attend the Doctor's church three times a week now. He's a real man of God."

We decided to go to Ballymena to election headquarters, and Paisley himself answered the door there, a sandwich stuck in his mouth. "Come on in Wesley, we've only a couple of minutes." I stood damply behind, dying for a cup of tea, and he closed the door in my face. My taxi driver went away for lunch and never came back. I felt like a lonely little Republican. Wesley came out and invited me to sit in the jeep. He was very friendly and said I could travel around in the jeep with him. Paisley arrived and decided not to use the car as he was going into farming country. He unsmilingly told me that to be honest he would rather I get myself other transport.

Wesley blushed. I stood on the street and I remembered the services I had attended at the Doctor's church on Ravenhill Road. An amazingly personal and personable man, Ian Paisley preached an impersonal sermon—"Salvation is between Christ and you. It will not come through the Roman Church or the Protestant Church or my Church. Salvation comes through Jesus and the Bible."

From the austerity of the Lord's Word we were drawn quickly back to the intimacy of the pulpit politician on the Ulster scene. He leaned forward, grinning, arms on the pulpit, and the country's leaders are lashed, dismissed, belittled with a joke. The eyes close, the head is bowed, and then up again to Christ Crucified. We sing tunefully of Jesus accompanied by an organ, and the man beside me smiles widely, eyes bright, singing to the Saviour. He gives me a Polo mint. The basket is passed, filled gladly with money, and then it is time to be saved. Some people go to the front of the church, returning to the Lord, and then pass on to the back room where Doctor Paisley will afterwards talk to them.

The service over, the organ pumps us out; many remain behind, lingering in the aisles or in the benches, chatting in groups, hovering near the inner rooms where the Doctor receives his parishioners. He moves quickly to and fro, talking, laughing, giving directions. A boy is going to London to look for a job and Paisley gives him the address of a colleague there. Then he says, "Wait a minute," rings

up the colleague and tells him to expect the boy off the boat-train tomorrow evening. He shakes the boy's hand, "God bless you son, drop us a line, goodbye." And puts his arm around a young couple who want to get married. He sweeps them into his office, joking about their impatience. He is a big man with a big voice but he leans quietly over an old woman in the corner, chatting to her while we stand around waiting to get a word with him, a smile from him, and we agree that he is a good man of God.

It is 10 p.m., ninety minutes after the end of the service, but people are still in the church and Mrs Paisley and her children move amongst them. Paisley is in his office on the phone discussing Election Day caravans with his brother-in-law and men are queuing up to sign on as election workers and to offer cars.

I caught up with Paisley in Cloughmills, a quiet country village. The men in the pubs say they are not going to vote. "We're alright here, without them cowboys from Belfast, they never came down here before except that noo they're afeared. Thon Minford can't talk." They chuckle when I ask about Paisley. "He won't come in here for a drink." What do they think of McHugh? They thought a pity of him. They talked about the moon-shot and Leeds United.

Paisley was going the rounds of the doors, apologizing for interrupting at suppertime. He spoke to a worried woman whose mother lived alone in Grace Hill and left her laughing. Farther up the street a man shouted at the sight of him and invited him in. He took off his Cossack hat, wiped his shoes, disappeared inside. His agent was worried about the time. "The Doc hasn't had a cup of tea since dinner hour." It was still raining. I asked Wesley to play "The Sash" to cheer us all up and the agent told me that I'd rather have "The Soldier's Song".

Paisley continued his relentless rounds but at five to eight he decided to leave, jumped into the jeep, then jumped out again to lock a garden gate. No, he told a policeman, he would not be going to Dunlow. "Let the Prime Minister speak there." And he drove off to the first of two open-air meetings twenty miles away.

In Wood Green the crowds were gathering for a night's crack. Loads of them pour out of cars, tapping their toes to the Lambeg beat. Massive Union Jacks wave in the breeze. At the far end of the village, a fife-and-drum band plays "No Surrender" and Paisley, sash across his chest, smiles across his face, comes striding in. We're dancing with delight, we're people now, and the men talk of B Specials, Craig, and the Alien Master Chichester-Clark. "Sure, he won't be able to do much, he's only one man, but he'll tell them what we're thinking, he won't let them away with things any more."

Paisley gives a rousing speech and promises full use of the Parliamentary privilege. He quotes a number of houses without water. "But nothing", he says, "can stop the rising tide of Loyalist opinion." He answers every question afterwards. "Chichester-Clark says you're not British, Doctor Paisley."

Paisley snorts dismissively. "Isn't that ridiculous?" and we laugh, and know they'll tell any amount of lies on him, they're that frightened. He steps down, in amongst the crowd. His mother sits inside the jeep, waiting on her son to go to a local house for tea. He is very open and intimate, and the men stand more proud and convinced after talking to him, and the women cluster around him, nodding their heads and giving him little white envelopes. He thanks them. He is confident and bulky in the dark and quotes the Bible and it is very reassuring. He sends you away with a joke and you aren't afraid any more. You can't be wrong if you're on the side of God and Ulster, with this big strong man in front of you. No one will sneer at you when the Reverend is around.

And that's Ian Paisley, Protestant preacher-man, possible and improbable MP. For a wrathful God and an orderly Ulster where all the men are sinners and the wages of sin are death. In Christ Crucified is Salvation. Then he grins and you don't feel so bad about it.

16 April 1969

Mary Leland

Return to Bowen's Court

"Miss Bowen," they said, "I'm so glad to see you."

"I came down specially to see you," an old man said, and sat next to her and talked and talked, until she knew she was trapped into dismissing him. And a woman went back to her family in the parish hall, with the news that "she kissed me and gave me a big hug when she realized who I was".

Elizabeth Bowen was not playing the grande dame, not the lady of the Big House. She was just a tired woman, about to go on stage to talk about Irish writers, back again in Doneraile.

She is not a stranger to the place at all, not now or ever. Certainly not since Bowen's Court nearby was sold in 1959 and razed two years later, for she comes back at Easter, Christmas, for her summer holidays, and perhaps some other time in the year. This occasion, taking part in a symposium organized to celebrate one hundred years of Christian Brotherhood in the town of Doneraile, she described as a sort of extra treat.

Being interviewed from the front seat of Donncha Ó Dulaíng's Jaguar can hardly have been relaxing, yet she took up all the questions and answered them as thoroughly as if she had been in a warm and comfortable room, at her ease.

She was glad that I had liked *The Little Girls*: it was a book she had always wanted to write but which had to be written fairly well on in life. She remembered being on the London Underground, watching a woman sitting opposite her,

suspecting but being not quite sure that she had once known her.

"I wondered if, somewhere in that rather alarming blonde person in furs, there was the scraggy little girl I knew quite well. I never had the nerve to ask her, and then one or other of us climbed out of the train. It kept on turning round in my mind. I became so much intrigued by the thought that it began to work on me in an odd way. And it's the only story I ever wrote that you could only do if you had lived a certain amount of time."

She's Mrs Alan Cameron, and she's seventy. She thinks she has written about ten novels with six or seven books of short stories. "If they're far back enough in time I feel almost as if someone else wrote them. *The Death of the Heart*—that seems immensely far away, much more remote than *Eva Trout*. I feel more of a personal tie with the last one or two of my books."

(✳✳✳)

I spoke about Bowen's Court, how it had become for me the embodiment as well as the soul of every Big House in literature. And of how searing the end had been, that chapter of epilogue, which despite the cool prose, hit with all the shock of any modern thriller. That afternoon she had been where the house once was, sheltered by the Ballyhoura hills.

"It was the first time I had been back there since it was pulled down. It was a nice way to go; with a party of a hundred schoolchildren, we all trooped down the avenue." She did like that book, she was awfully glad she had written it. "I'm almost impersonal about it now, but I think that it's the way the history of parts of the world at least should be written, by following the history of one family in one place."

She hadn't meant that people should have a strong reaction to the fate of Bowen's Court. "But they would, of course," she said. The book had been written in 1942, and when it was republished nearly twenty years later she had to write the epilogue. She knew too that some people had taken exception to the calm words in which she told of the destruction of the house, calm words, whose bareness made easily imaginable what that destruction must have meant to her.

"But you don't cry all over the thing, all over the truth. It must be said, a house in a story is indestructible. A house in reality is not. During the air raids in London I used to think of Highbury in Jane Austen's *Emma*. You'd hear the bombs whistling down and I used to think, 'Well, you can't drop bombs on Highbury…'"

She was married in 1923 to Alan Cameron, a highland Scot who made a career in the administration of education in England before joining the BBC's school broadcasting service. He died in 1952. "We'd always planned to come to Ireland and live in my house. He died in his sleep, just as he said he wanted to, when we had just moved in and started to have a life there, so I think of that. I stayed on in it. It meant a great deal to me to have the house at any rate. But it was absolutely impossible to grapple with."

The idea had been that he would run the house and land while she would go on and earn. "It became simply out of the question. The last few years were really a nightmare, so when I decided I felt almost relieved. The worst was over. It had happened. But it hasn't left any sort of a bruise…"

Reflective, searching, Elizabeth Bowen's words are sometimes seized by a gripping impediment, but she does not falter or shrink. Her tongue controlled again, she goes unerringly on. She was an only child, living half the time in Dublin, the other half in County Cork. Religion played a very large part in the lives of her parents, whom she loved and who were gay and loving.

"There was nothing priggish in their religion. I could see it as a sort of joy in their lives. I think this must have made a difference to me, but I don't have very strong *religion*, as such. I wish to love God, I really do."

There were other questions to ask her, about America, about Ireland and England. There would always be questions to be asked of this strong-minded, gentle woman, an only child and childless herself. A friend of hers said, she remembered, "that he most wanted to believe in God when he needed someone to be grateful to".

I think that's true. I know that very grateful feeling. Although a number of things have happened to me that were intensely sad, I never had a really horribly sad situation, something that really eats into one's nature like a canker. That must be the test of faith in God…

"No," she said, "I feel that God has been very kind to me…"

27 October 1970

Elgy Gillespie

First Ink: Visiting Tony Guthrie

I t was just the way I had remembered, walking down through the trees three winters ago past the graveyard. Spooky country, fearful country: the wind blows the cold mists around the tiny doldrums hummocking down from Newbliss. A tree thrusts itself at you out of the mist when you turn a corner. Tempting to go back to warm, friendly Enniskillen…

This time I came in a car from Clones, with a man who knew Guthrie and the way by heart, yet we managed to miss the turning several times. We passed the gingerbread cottage with the diamond panes and sugar-biscuit tiles and finally went on, on up the curving drive till suddenly we were in a huge clearing in front of a vast Victorian, neo-Gothic mansion.

It faces a green sweep down to the lake. The first day I awoke there three winters ago it was first light and a stag was sniffing the wind with two does at his heels. When I looked again, he was gone. The house is named something nobody remembers the meaning of, Annaghmakerrig.

We banged on the door, and it swung open onto the large hallway, glowing red with welcome from the mighty collage, studded with all the photos of Tyrone Guthrie's fifty-year theatrical career, at the head of the stairs.

His ancestral home has been parcelled out into farms: a good and sensible arrangement, he thought. His greens were growing under glass beside the drawing-room window and a boiled egg from a hen that was scrabbling somewhere nearby

was produced for tea. Music was put on the black box gramophone in the corner, and later the very nice Bechstein piano was played; it had a most lovely tone.

I didn't know Guthrie well, and I must be careful not to make it sound as though I did. But when Doreen Burns took me around the empty house it felt strangely inhabited again, as though they had never left. "Oh aye, they were always going off for months, to Canada or Israel or Australia," said Doreen. "So we often just think they'll be coming back again any minute now..."

That brings back the real flavour of that first visit: the strongly Presbyterian and patriarchal presence of Guthrie booming away: "Of course education should not be completely areligious—wouldn't you want your children to learn the story of Joseph and his coat of many colours, of David and Jonathan, of Benjamin?" while we leafed through books in his study. Yet he never had any children.

On the shelf in the hall, a bird's nest still sat beside the telephone (it was found by Judy Guthrie on a walk). Even in the weather-boarded box-rooms, full of old stage props and bedsteads, it was still a place where people should live and be happy, despite the stagy resemblance to an Agatha Christie house.

(*******)

It's over a year now since Judith Guthrie died. Tyrone Guthrie had died suddenly not many months before—he'd been working on Jack White's "The Bullfinch Today" for the Abbey. A letter was in his hand. In Clones and Newbliss, the story goes that it was a creditor's letter for some huge sum needed for the jam factory that Guthrie began with friends in order to create local employment in the desperately depressed border town. It's true that the jam factory mattered a lot to him, but the story is not true. In fact, the letter was a small cheque. It's not likely he saw it.

In his will, Guthrie left Annaghmakerrig in trust to the Minister for Finance. It was, Guthrie said, ideally built and situated as a retreat for writers and other artists from north and south whose home circumstance made work difficult, if not impossible. As a childless man and a philanthropist, Guthrie was very afraid for Annaghmakerrig's future, and he was always concerned for the young and poor men and women labouring against the forces of the established empires.

It was said that he always picked the amateur and the inadequate over the posh and professional.

Doreen Burns keeps the house aired and scrubbed. The beds are made, the

books are still in their shelves, the dagger belonging to his ancestor Tyrone Power is still in its glass case.

The grand and echoing room under the eaves at the end of the house has theatrical possibilities. But whoever comes to live here must have a strong Presbyterian sense of order, must realize it's a place for being quiet in, a place for working, a place for listening. Only this way can Annaghmakerrig survive as a house rather than as rabble and rubble.

2 July 1973

Thirty years on

How the eagle stare and beak of Tony Guthrie come back on reading this, along with the many local stories of his and Judy's fondness for cats and the jam factory ("The Jam Sir Tyrone Makes!") and other projects around Cootehill. He was no saint, but he was a Gulliver in Lilliput in many ways. The lakey country around Newbliss is of drumlins, not doldrums, of course. I'd been reading Estyn Evans, a man forever hot on drumlins, while I was in the doldrums.

I first visited Annaghmakerrig for the *Sunday Times* colour magazine in 1970. It was the second or third commission I won, after coming second in their Young Writer Contest when I was seventeen, the miracle that catapulted me into journalism. The paper sent me to interview Guthrie when I was nineteen and at Trinity College, Dublin. ("I suppose they're looking for an old-person-meets-young-person kind of thing," grumbled Guthrie.)

I hitchhiked there in terrible weather but the piece wasn't used, so I salvaged bits for the *Irish Times*. I revisited Tyrone Guthrie's Victorian Gothic pile again in 1971, and once more three years after his death. A decade or so later it became the nation's art centre.

Years on, I went to Annaghmakerrig often. I didn't write a work of value but I cooked if Mary Loughlin wanted a respite: grilled mackerel for Sebastian Barry on *The Steward of Christendom*, Irish stew for Allan Gurganus' hatching *A Confederate War Widow Tells All* and the first draft of Colm Tóibín's *The South*. I do remember Guthrie saying that nothing happens if "the bush is not cut back from the yard". He meant the small but necessary acts of maintenance that keep house and head from decay.

Guthrie's philanthropy was the Victorian kind and generously abused. I've

heard a famous writer boast of peeing in jars of Tony's signature jam and, no, I
didn't laugh when another peed in Mary's cooking sherry in protest against the
house ban on alcohol. I can't say how sad that makes me.

Chapter 2

End of an Era

Tirelessly, and with more than a whisper of lyricism, the Women First fashion editor Gabrielle Williams poured out commentary on the *haute couture* scene of the day, descending from her County Wicklow fastness to the hurly-burly of the newsroom, adding whiffs of elegance and irony. Her past life included racy stories about the Via Veneto nightlife with *principessas* in Rome and her wardrobe intrigued us. The rest of us were swaddled into anoraks or Basement Boutique print from Liberty's. Gabrielle also wrote on antiques; seemingly she could write on anything. The page also carried a less convincing window on Men's Fashions.

Women First also had three regular writers on its weekly cookery page, all more than mere recipe pedlars. Post Monica Sheridan, Theodora FitzGibbon (1917-91) was the diva *inter pares*, but times were tougher for foodies back then, especially a feminist foodie. Women's Lib was born at the tail-end of the sixties in America and reached us with the Irish women's movement and the contraceptive train by the first years of the seventies.

From our mothers' housekeeping to the birth of gender politics, we began questioning the accepted norms. Suddenly the homemaking arts smacked of anti-feminist wifeliness and seemed embarrassing. Motherhood itself was becoming politicized, especially unmarried motherhood. Mary Cummins had worked in the Rotunda and eventually became a single mother herself. Although Mary Maher was a mother of two, for a period it did seem as though she was permanently pregnant.

Then, when decimalization came in, the women of the *Irish Times* and Women First descended upon the shopkeepers of Dublin, monitoring price changes and totting up the shopping baskets of the nation tirelessly. Vigilance on the cost of living was maintained by Mary Maher, resulting in pieces on whether living on ten pounds per week was possible, where to get good but cheap food, and how to budget. Just what our mothers needed; and how could this be old-fashioned, we argued, when we all need to eat?

So, because I never missed the fish prices on RTÉ and was once misguided enough to teach Nell how to joint a chicken, I was often given the cookery pages to proof. I'm still upset about that Wexford honey mousse—nice idea, doesn't set—and the "Dublin Lawyer", where boiling the "lawyer" wasn't mentioned.

But nobody else gave a flying fisherman's about fish prices and all was forgiven, because every week we looked in the filing-cabinet for the neatly stapled four or five pale green pages that were Theodora's column, and there they were, yes, sent weeks ahead in batches, and oh so very welcome to her editors. Theodora was far more than a mere food writer; she was a food historian with an encyclopaedic breadth to her knowledge of life and love. She was also a good psychologist who understood.

Ms Mary Maher

How's the Ms?

Why let whether you're fortunate or unfortunate enough to have a husband dictate your prefix?

I suppose "Howya Miz!" will never have the ring of "Howya Missuz!" and Dublin will no doubt be the last spot to cave in on the issue anyway. But whether the purists like it or not, the traditional titles accorded to women in English-speaking countries are in their death-rattle stage, and by the time our daughters reach maturity they will be "Ms", married, single, or otherwise.

The purists don't like it, of course. They point out that "Ms" doesn't mean anything, has no origin or precedent, and is even more deformed as a term than "Mrs", which has no correct form apart from the abbreviation. Still, until such time as we can drop all titles in favour of some egalitarian and universal appellation, women will have to put up with something—and the women's movement sees no reason why it should be something determined by marital status.

Two months ago, the British Foreign Office reluctantly conceded the point. Even in the good old liberal UK, where the practice has been to allow any title or prefix on passports, or none, depending on the choice of the applicant, the first request to use Ms was refused. Campaigners promptly picketed the passport office in London, and after the case was reviewed, the Foreign Office admitted there was no logical reason to exclude Ms.

This puts women on the same official footing as men whose title "Mister" is

never revealed, single or married. Ms Julia Tant, one of the organizers of the campaign, said that what was acceptable to one government department must be accepted by others, so Ms could now be taken as legally permissible on all documents. No one has yet challenged her.

But it may take a while before Ms comes into common usage, although in America it's at least as frequent as the other feminine titles, thanks largely to the women's liberation magazine *Ms*, which promoted the Ms idea in the first place. It's not only unfamiliar but abrupt and rather harsh on the ears—but what's so pleasant about the prissy "Miss" or the awkward "Mrs", which is only a respectable version of "Mistress"?

Ms will catch on, if for no other reason than it's practical—because there are more women around now in a position to get letters from people who don't know whether or not they're married. Unless you're in the breezier branches of public relations, you can't address letters to strangers on a first name basis.

But the real significance of the bravely emerging Ms is its fundamental meaning to the women's movement: much more important, I think, than all the other non-gender terms being pushed to replace formal male terms. Substituting "person" everywhere "man" now prevails, as in chairperson instead of chairman, may be non-sexist; but it's also unwieldy and leads to severe semantic difficulties— personning the barricades, every person jack of them, arrested for personhandling, charged with personslaughter, "Person alive!", *The Rights of Person*, The United Irishperson, "Person Bites Dog…"

Then there's the problem of what to do with the collective noun. "Gentle-people" has to be a retrograde step. "Friends" is matey and usually inaccurate. "Dear People" is autocratic. "Dear Sirs and Madams" is musical comedy. They are puzzles, but not as important as getting Ms accepted; and neither is the frequently debated subject of whether or not women should take their husband's surname. Anyone who's had both can vouch for the fact that people in dry-cleaners look at you suspiciously when you say, "Nothing under Murphy? Oh, try under O'Brien!"

We've already established that double-barrelled names are no answer, since in another two generations we would all be strung out with surnames. Anyway, all any woman has to call her own is her father's name and, however fond you may be of him, you didn't choose him, whereas some measure of selection is usually involved in acquiring a husband.

No, the heart of the problem is Miss and Mrs because therein lies the definition of a woman in society: the property of a man. Since the first primitive

communities abandoned their collective way of life for the competitive hoarding of private property, women have been chattels. Chastity and fidelity became prized female virtues only because it was necessary to ensure belongings descended to the natural offspring of the father. Thus it was essential that women should be publicly described as the virginal property of their fathers, valuable in terms of barter on the marriage market, or the faithful property of their husbands, producing heirs for him alone.

Changing the title isn't going to change the laws, but it will have a psychological impact. I think with relish of the dilemma on the society desks of certain pompous newspapers, where the ritual of correct labelling is the first lesson for neophyte reporters. A woman could never be Mrs Mary; she could only be Mrs John Doe, legalized mistress of her owner. A divorced woman had to put her maiden name before his, and prefix the lot with Mrs indicating that, although legally free, she was also damaged goods, having been discarded by a previous owner.

We've never been that rigid here. But it wasn't all that long ago that this newspaper was persuaded to stop using "spinster" in news stories such as "Miss Mary Murphy, 38-year-old spinster, was found guilty in the Central Criminal Court yesterday…"

I can't see why anyone should object to a change now. Ms's of the world unite—in order to explain ourselves, we'll have to redefine ourselves!

2 January 1971

Nell McCafferty

My Mother's Money

The way my mother sees it, "they" have her beaten every time. She sat with her grocery book on Saturday night and worked out her weekly bill. The shopkeeper had marked the goods in "English" prices, as she calls them; but the total, line by line, was marked in decimals. My mother calculated, with pencil, glasses, currency converter and the blank edges of the *Belfast Telegraph* that she was being diddled to the tune of a halfpenny a line, but by the end of the page she was out tenpence (in pounds, shillings and pence, that is). Then she added the total up in "English" money. The three pounds eighteen pence was easy enough. No diddling there. And on the extra threepence, she lost only three-fifths of a penny. So my mother wants her total in "English" money from now on, and she'll convert it herself.

Then there's the coalman. He charges her nineteen and ninepence per bag of coal. If she gives him a pound, he will give her a penny change. Thus, she loses a ha'pence per bag. He told her that wouldn't break her. No, she pointed out, but with five hundred customers, those extra halfpennies will make him richer to the tune of one pound tenpence per week.

"So what do you want me to do?" says he. "Divide a bag of extra coal among five hundred customers?" My mother sat in the house on Saturday night and thought over the problem.

He can give the bag to an old-age pensioner, she decided in the early hours of Sunday morning.

My mother is currently working on the difference between the banker's converter and the shopper's currency converter. Apparently the bankers get more value. She is using proper notepaper to work out that system. And she hums, "I'm the dame who broke the bank at Monte Carlo."

1 March 1971

Mary Maher

Night of the Killer Cabbage

I was more astounded than anyone else when it suddenly became important to know how to cook. For such a long time it had been important not to know, one more aspect of not being even slightly domesticated. Then all at once the whole Emancipated and Equal bit had to, if not collapse completely, at least leave somewhat in an accommodating manner.

Then came the Night of the Cabbage. Recklessly, I zeroed in on this weird cabbage recipe. It sounded highly unlikely even to my ignorant ears, involving an egg, sour cream, nutmeg, sugar, a dash of salt and pepper. On cabbage? But then, I reasoned, didn't all recipes sound insane? Who would ever have thought fifteen Jacobs cream crackers would make a lovely pie crust (aside: now there's a gorgeous recipe for you. Self-addressed stamped envelopes please…). At least it might take the taste out of cabbage.

It did that, certainly. I followed the steps dutifully, blending the eggs, sour cream et al. into a nice sauce and adding cabbage at the last minute. It tasted quite nauseating. "What ever made you think of putting custard on cabbage?" asked the man in question, in front of the guests who were woefully choking down forkfulls.

I've looked at that recipe a dozen times since, and it's exactly as I've said. I'm convinced now that the experts who write them are sneering at amateurs like me who use them to deceive people. They feel honour-bound to trip us up at least once per book.

They *are* sneering. Why else would they put in those insulting instructions like "Place a clean dry cloth over the pan." What do they *think* we'd put on it? A filthy floor rag? But what I hate cookbooks most for is the fact that they finally interest me. As a matter of fact, I can cook pretty well now. But I've long since discovered that the man in question knows damn all about it and cares even less, responding with identical enthusiasm to a dirty great feed of fish and chips and to *Boeuf Bourguignon*.

19 October 1971

Theodora FitzGibbon

Liberation Is a State of Mind

I am possibly the wrong person to write about the liberation of women, because ever since by various manoeuvres I managed to finish my formal schooling by myself, I have been liberated. I find the stove and chopping board far from being restricting influences, and indeed a relaxation.

Liberation, according to the Oxford dictionary, means "released" and apart from a few isolated occasions, I have certainly been "released"—from the age of sixteen. Personally I'd do anything rather than go out at a regular hour to a job. If I was widowed or otherwise abandoned, I'd infinitely prefer to go to extreme lengths—even to learn Bantu and teach it—to make my home my place of work. For brief periods in my life I have had regular jobs, and in retrospect they were the only utterly miserable times of my life. I dislike generalizations, so this is an *ad feminam* point of view, but it is the only one I can honestly write from.

The present campaign seems to me to be more a campaign against injustice than against release from housewifely duties. Certainly there is a strong case in Ireland for more amenities and help for those women who are unable to help themselves. Yet this is not liberation in the strictest sense but lack of social services, and can apply to both men and women. Injustice is not purely a feminine prerogative; many young men who marry at an early age are equally trapped in a job they hate but must keep on because they have a wife and family to support.

I like being a woman. I think, basically, we have a far better time than the young married man with an increasing family, low wages and sparse employment. I actually *like* cooking and running a house. In fact, if I am particularly depressed, I often retire to the kitchen with an old or unfamiliar cookery book, pick the weirdest recipe and proceed to make it. Halfway through, I have forgotten my depression and have become totally immersed in the creative side of what I am doing. I have done this at the strangest hours of day or night and it always works as far as I am concerned. This is why I say that I am the wrong person to write about liberation from the home.

I am not for one moment suggesting that home is the be-all-and-end-all of a woman's existence: far from it. There are books to be read and music to be played. It's a matter of self-education, of going to the subjects that interest one.

Over seventy years ago, my grandmother had to bring up a large family, more or less on her own, and with next to no money, when conditions were far more difficult than today. Education for a farmer's daughter in those days was sparse, yet she persevered. In her seventieth year she took her degree as an architect. I realize that she was exceptional, yet it shows what can be done with determination. She was a suffragist but never a suffragette, and firmly believed anything she undertook was possible.

Let us hold the liberation idea in perspective: women should certainly get equal wages for equal work and be accorded the same rights and privileges as men, if they are working wives with a career they have chosen for themselves. Most importantly, they should be allowed to decide for themselves the size of their families. I am not talking about the Pill, about which I have reservations from a health point of view. There are many other alternatives with no hazards. It must always be a personal choice, one of conscience and thought. If a wife wants to pursue a career, it should be taken into account. If, having married and had children she is unable to provide for properly, she should find congenial work to do at home to supplement the family income and add vital interest.

So long as nobody forces me to work outside my house, I am willing to help any woman in any way I can. But please leave me at home with my books, my kitchen and my typewriter!

9 October 1970

Maeve Binchy

Our Compliments to the Cook

If you thought Theodora FitzGibbon was just a pretty recipe you haven't heard about her life story.

I've been terrified of Theodora since the time I was Women's Editor and used a picture of open-heart surgery to illustrate one of her articles about veal. What I thought were forks and spoons coming out of it were actually forceps and terrible surgical instruments from the medical correspondent's photograph file.

Also, she's been everywhere and knows everything and has written twenty-one books and taught herself Serbo-Croatian. And she never uttered a word of abuse to me in her life, not even when I misread one of her articles and thought you were meant to put twenty-three pounds of tomatoes in something instead of two to three. She just said that I had given the nation diarrhoea and ruined her reputation as a cook.

She lives in a house in Dalkey, where you would think you were in a ship because the sea seems to come up to the window, and she has an extremely nice husband, the filmmaker George Morrison, who is very fond of her and thinks she's the most entertaining woman he ever met. Her ex-husband Constantine FitzGibbon lives on up the road, and is still a great friend of hers, and she gets dozens of letters from Anxious Young Wives thanking her for saving their marriages by teaching them how to cook.

I said that it sounded a grand sort of life. Theodora agreed; there wasn't a thing

wrong with it, and it was restful. Not everyone would think that working five hours a day at a typewriter, cleaning a house, cooking, lecturing on food, demonstrating and teaching other people to cook is restful, but it's positively soporific compared to all the kinds of things she was doing when she was younger.

She wasn't even born nicely and gently. She started to arrive on a boat, and that caused a lot of angst until they got to Southampton in the nick of time. Her education was a series of convents in England, most of which she thinks she was expelled from.

"Not really expelled but you know the kind of thing. 'We think little Theodora would be happier somewhere else.' Very unsettling. And all for very minor things really. I think they can't have had much sense of responsibility towards children in those days."

One of the minor things that got her expelled from a school was her regular betting at the age of eleven, in a convent where infant gambling wasn't approved of. She used to give the gardener a shilling to put on the Derby and once she won twelve pounds.

"It was beyond the dreams of avarice and I'm afraid I got carried away. I lost it all again, and more, and finally the gardener came to me one day and said that the bookmaker was turning nasty.

"So I did the only thing possible. I wrote the bookmaker a letter in my round childish hand saying, 'My daughter is abroad, she will settle with you on her return.' I thought it would keep him at bay but he was up to the convent in a flash, and the Reverend Mother nearly went into shock, and there it was, little Theodora was off to be happier in yet another school."

When she was sixteen her father was living in Calcutta and working as a vet, and Theodora set out to see him. She got off the boat at Bombay because she thought somebody there would tell her where to find him. Weeks later, when she had found him, he said she could certainly stay there for a while since she had gone to all that trouble to get there, but she must work.

And work she did, up at 5 a.m. helping with Maharajah's horses, then back to house to plan menus for dinner parties. There used to be at least twenty guests three or four times a week, and Theodora says she could have stayed there forever. But it was decided that she must get some more reasonable education, and she was sent to what she thought was the most unreasonable place on earth, a French Finishing School.

"You have no idea the kind of things they taught us to make us ready for life,

simply no idea. Every Thursday, we would be taken out to a small suburban house outside Paris where ex-Queen Natalie of Serbia lived. Ex-Queen Natalie hadn't a bean but she made money by teaching the daughters of rich idiots what were called 'The Basics of Court Life'.

"She had a large shabby chair in the window, which she pretended was a throne, and she sat on it and we all learned the kind of thing that was going to be essential in life.

"We learned how to walk backwards, we learned how to eat without making crumbs. That's very useful actually. Seriously, I don't make crumbs. George has only to look at a potato crisp and it breaks up and falls on the floor. Then it was assumed that we would all marry ambassadors and be in places where the food was foul so we used to have to practice eating little savouries made of mustard and petrol, I think, without grimacing. I mean, it was all insane, the whole thing, and even at that age we knew it. If we completed the course to her satisfaction, ex-Queen Natalie would give us a huge signed photograph of herself."

At the school Theodora met a girl whose father, Edward Sterling, ran the English Players, a touring company that played in French provincial towns. So Theodora became an actress. This, she recalls, was backbreaking: mainly packing up and unpacking and being on the move. Back in England she still wanted to act. She went in by mistake for the wrong audition and got Fay Compton's part in *Secrets* and made it in the West End.

But she hankered after France and went back to Paris to enjoy herself, and in fact to fill in the time when she was "resting" between plays. She couldn't have chosen a more extraordinary time to go to Paris. After a couple of weeks the Germans arrived and there she was: no friends, hardly any money, and no way of getting back. So she bought a bicycle and decided to cycle to Tours.

"It wasn't that I thought Tours was an especially sensible place to cycle to, it's just that there was going to be a little money waiting for me there.

"But of course when I got there, there wasn't, and then on to Bordeaux and there was none there nor help either, so people said keep going because you might get a boat at St Jean de Luz, and well, I kept going and got there, and on the quay I met an old friend of mine who had just done the same, and he'd sold his bicycle for a bottle of Pernod because they wouldn't let us take bikes on the boat. And I sold mine for two bottles of Pernod and we were so drunk they nearly refused to take us on."

Back in England she joined the Free French Army and was worn out working

all day in the Propaganda section writing captions on photographs. She says it was a bit difficult because one installation picture looked pretty much the same as another, but she did her best. Then she married Constantine FitzGibbon and she started writing. She wrote a novel called *The Flight of the Kingfisher* which she says was very romantic and sugary and she never thought it would be published, but it was, and not only that, but the BBC bought it and made it into a play, and that was even more unexpected.

She never thought of a life where you didn't work, probably because she had such an unstructured childhood and adolescence. But she never had a job that would bring her in a nice retirement pension, so she hopes she might get that from her toughest and hardest job yet. This was a mighty encyclopaedia, *The Food of the Western World*, which she began in 1960 and which was published finally a few months ago.

"You have no idea what an undertaking it was. It began as a tiny little book, a companion to a wine book, but I discovered that when I had done A and B, I had written almost twice as much as the whole Wine Book. Then the publishers got alarmed and began to think that it was too big for them to handle. But there's no point only having a few things in a dictionary or an encyclopedia, you must have everything."

She bought a tiny little filing-cabinet and started to work on a card index system. When the cabinet became useless she got a huge steel filing system installed and, as well as her other work, she pounded on, letter after letter, dish after dish: chop suey, chorba, chorizo, cholito, choron … what they were, where they came from, how to make them. Sixteen years of it, and she wasn't even sure if it would ever be published because by now the original crowd thought it was too huge.

But of course it was published. It was bought in America by the *New York Times* publishing section and in Britain by Hutchinsons and now it's on sale everywhere. "No, it's not coffee-table, it would break a coffee-table in half," she said. "It's a kitchen book and a bookshelf book.

"I have this great fantasy that people will put it on shelves with their big dictionaries and, where there's an argument about food and somebody says that 'powsodie' is one thing and someone else disagrees, the argument will be solved by saying, 'Let's consult FitzGibbon.' You know, I think I like that fantasy better than anything, people getting up and taking my book down for the final word on something."

She has a Henry Moore which she once bought for £40 because she liked it,

not a giant one but a little one on her table. She has a house full of treasures that she and George have picked up; neither of them ever throw anything away. She has always had a work-room of her own, with books and files and things on the floor if she wants them there.

"Well, I mean, I've had to have somewhere to escape, haven't I? I was married to Con for sixteen years and he never went out to work and I've been married to George for sixteen years and he never goes out to work either. My husbands have always been wandering about the house all day. It's like having been married for a hundred years, when you come to think about it, compared to other women whose husbands go out to work and are gone all day.

"I need a work-room, or I'd never get anything done."

15 November 1976

Mary Maher

How Much Mothering? Noel Browne's View

When Dr Noel Browne wrote in a series of articles for Women First that women who wish to have careers should not have children—"Motherhood is necessarily a full-time occupation!"—Women First found itself addressing a heavy mail-bag.

As students of modern political history will tell you, the man doesn't compromise. He meant what he said about working mothers, and a great deal more as well. Being Noel Browne, however, he speaks in terms of Utopia.

"Of course, I'm talking about the ideal society. That's the one we should be aiming at. I don't believe in working fathers, either. The only kind of work human beings should be doing is creative work—painting, writing, music—and everything else should be done by machines, as it some day will be. The whole concept of hard work being good for you is a lot of Victorian hokum, invented by capitalism to keep the working class in their place. What I'm saying sounds odd now, but in a hundred years it will be the accepted view."

So, he believes, will be his theory on motherhood, which is that very few people are capable of being good mothers, just as very few are capable of being good nuclear physicists.

He reacts unequivocally to the proposition that most mothers instinctively do a fair job of mothering: "Absolute rubbish. There is far too much sentimentality in our idea of motherhood. It is really a very expert and professional job. If I

handed you two hundred tiny and delicate parts to a Swiss watch in a paper bag and said 'Go off and make a watch!' you'd be horrified. But this is exactly what we expect women to do with children, and the work of creating a mature human being is far more complicated and far more important.

"Our sentimental notion of motherhood is a man-made myth. There are hundreds of women who shouldn't have children, who would be better off and do better work as scientists or writers or whatever they wanted to be. Now that the Pill is here, conception is a deliberate choice, and a woman who takes this choice should take it as deliberately as the one who decides to be a nuclear physicist, and should prepare for it with the same dedication.

"What I am saying will horrify people here because we still accept the family of ten or twelve as a good thing. In England, where the family of two or three is the accepted ideal, the suggestion that some women have no children isn't shocking. And it will be less so as time goes on."

The society Dr Browne hopes we are evolving toward is one in which those who choose to be parents will approach the task professionally, and will be able to spend virtually all day, every day, with their children. If you ask him what the great majority of adults who are parents in the present circumstances are to do, he offers a wry, rather sad smile, and says, "The best they can, of course." For a mother, he believes, this means devoting herself exclusively to her child, because the evidence indicates that a permanent and continuing early relationship with a mother is by far the most important factor in establishing an integrated human personality.

And what of the uncomfortable fact that 90 per cent of mothers find the unrelieved companionship of their children both boring and trying?

"Only because they don't understand how fascinating it can be to raise a child. As I said, it's a job for experts and a job too demanding for most people to undertake."

Dr Noel Browne is not speaking about today. But the points he raises about his vision of the future will have to be analysed some time: why women have children to begin with, presuming that they now have a choice? Why they have as many as they have, and how many they should have to serve the interests of each child best? And whether, in the world he talks of—without economic pressure and with the freedom to work at creative pursuits—the constant interrelationship of parents and children would be, in fact, a problem?

It is one of many ironies facing women today that while the past decades have seen the first real progress in releasing women from the strict confines of their

traditional role in the home, the same period has yielded the most conclusive research into how vital the span from birth to five years is in determining the child's adult character, and the consequent importance of the work of the mother.

The usual explanation for the new restlessness of young mothers is their improved education, and sharp distinctions have frequently been made between the mothers who choose to work (normally thought of as those in professional fields) and those who must work, usually in work considered semi-skilled or unskilled. But more recent studies have shown that the line is far more blurred, and that many of the mothers who take "twilight shift" factory work do so partly for the companionship of other women and the few hours of release from their own four walls.

Meanwhile, mothers must face the world with the children they've brought into it, and deal with the limited choices open to them. Right now in Ireland, their problems need more serious attention than they have ever needed before.

23 February 1971

Mary Cummins

A Nurse at the Rotunda

When I came to work at Dublin's oldest maternity hospital, I had expected an old building. I knew that the Rotunda was one of the oldest midwifery hospitals in Europe, but the actual realization of steep, stone stairways, gloomy, cavernous corridors; the wards high, wide and yet dark with eight to ten beds each, complete with big coal fires, removed any vaguely romantic notions I'd had about working in an ancient hospital loaded with tradition.

I came fresh from the fairly equitable National Health System in Britain, where expense is not spared and mod cons are accepted without question, and I spent my first week alternately being shocked and revived by seasoned colleagues. "You'll get used to it", they said, "after a few more weeks."

We started our training on the postnatal public wards, so my first day was spent among tired women and screaming babies. From the time they leave the labour ward, the mother and baby are inseparable. The baby's cot hangs at the foot of the mother's bed and she is in constant attendance twenty-four hours a day; a foetus *ex-utero* situation, where neither is out of screaming range of the other for very long. The real crunch and ultimate test of maternal feelings came at night, when the wards get cold.

Though fires couldn't be renewed after 9.30 p.m. and I understand the hospital authorities have since dropped the rule about renewing the fires, I was told not to add fuel after 9.30 p.m. The babies cried piercingly, keeping their mothers awake.

Each mother feeds her own child. The last feed of the day is given at 11 p.m., and she is awakened again at 6 a.m. for breakfast—a cup of tea and one slice of bread and butter—to start the routine all over again. Her next meal is lunch at midday, which consists of soup, brown meat, two veg and a sweet, or stew, two veg or cold brown meat, two veg … and so on.

At 6 p.m., the last meal of the day, she gets crackers and bananas or crackers and cheese, or sometimes sausages and mashed potatoes. This is the postnatal diet in the Rotunda. We spent the morning making beds, a frustrating experience when there is a permanent shortage of linen, taking temperatures with one thermometer for every four or five patients, and bathing babies. Tearing up and down those long corridors to the kitchen for a spoon, forgot the knife, back again. To the milk kitchen for a screaming baby's bottle, back again for another one. Leg muscles developing inches on inches.

"I'd love a bath, nurse," said the little woman in the corner of the big ward. "Certainly," I said, anxious to be of some help to somebody. It was one of those days when one is constantly getting in the way. And I set off to find the bathroom. I couldn't; it did not exist. "There's only one shower, love," said a knowledgeable patient, "and she'll have to queue." She queued for half an hour for the one shower provided for thirty to forty patients.

My shock resistance lowered by this discovery, I made an inventory of the toilet facilities. After locating only two staff toilets in the whole hospital and hoping at the same time that I'd never be caught short, I discovered that the patients were slightly worse off. There was one toilet for approximately every twenty plus one accompanying tin bin for used sanitary towels.

The patients hung around the wards all day, in bed and out of bed. They had nowhere else to go. Looking at their own and their neighbours' babies, comparing them, admiring the various coloured matinée jackets, gossiping and complaining about the food. They were glad it was all over and were looking forward to going home.

"Ah, sure you'll be back again next year," the nurses joked with them, and they laughed back and said, "You'll never catch me in here again!"

One morning I was awakened at the usual unearthly hour of 6.30 and told to report to Prenatal—just when I was getting used to the first place. I muttered and shivered all the way to the ward but stopped in my tracks, speechless again, when I was confronted with one big ward. Instead of the normal two beds, there were mattresses all over the floor. Nurses were rushing frantically around. One

saw me standing, moronic and stiff with fright, and said, "Quick, pull the screen round, she's delivering!" She was indeed. And a minute later there was a horrified yell from the mattress as yet another human emerged into the rat race.

When we got organized after that little incident, I looked around and saw women with mountainous abdomens everywhere. Tall ones, small ones, fat ones, thin ones, old ones and young ones, all with that big bump in common. Some were talking, some smiled at me. Others lay there looking into space. I felt sorry for the ones on the mattresses. They seemed so far down and out of things. They propped themselves up on their elbows, or just lay there and stared at the ceiling. Their belongings were scattered around them on the floor and they looked like refugees from some awful disaster.

"A deadly night," said one of the night nurses, as she got ready to leave. "One of the many," said another.

"One too bloody many. I'm giving my notice in." I was going to follow her to the mysterious place where the notice was given in but someone shouted, and true to training I ran.

I didn't like Prenatal. There were no babies, only bumps, and a terrible air of anticipation as everybody waited for something to happen. The wards were newer and slightly more cheerful than the others and the food was more palatable than in Postnatal. But I didn't like it and was glad when the time came to move on to the Labour Ward.

The Labour Ward consisted of four curtained-off cubicles and a few outlying wards. I went into the first one to escape notice and found a young girl quietly muttering through clenched teeth, "I want my Mammy." I held her hand and when the pain had gone she told me that this was her first baby. She was plainly terrified.

From outside we could hear shrieks and screams, and she stiffened and held my hand tighter. "It must be terrible, nurse," she moaned. "It's been like that all night. Oh God." We held on to each other for a while, neither, I suppose, doing the other any good until somebody came and told me to go and do some work as I was only making the girl worse by taking notice of her.

One day they sent me to the Private Labour Ward. I opened the door. It was like a different world. Silent, muted, cheerful, spotless. Each ward was separate and comfortable. The delivery room took one person at a time. I supposed that they were too polite to rush and confuse things by two of them arriving at the same stage at the same time, and I had a momentary hilarious giggle all to myself at a mental picture of each writhing woman saying, "You first." "No, I insist, my dear.

You go first."

They had a choice of food that was served on trays and could have visitors any time they pleased. The babies were taken away at night. The mothers probably went home refreshed.

Across the corridor, the women from Corporation Place and Seán MacDermott Street all screamed together and were told not to be silly. They had made their bed and now…

Us nurses? We didn't leave, because we didn't see any alternative. And we suffered out the year, counting the days. Like nurses in most Irish hospitals, afraid of that horrible faceless thing called victimization.

20 January 1970

Mary Maher

Baby Factories

Margaret G, an unmarried mother who described her labour as "nightmarish", spoke a year afterwards as if it had just taken place. "I was put in this ward with no window, only a sort of stained-glass partition at one end, and I was in there for twenty-four hours." The father of the child was not allowed in to see her. He asked several times how she was getting on and was met with a cool non-response.

When she finally reached the pushing stage no one would help her. "I asked the nurse could I hold her hand, just to have something to push against, and she pulled her hand away. Then the Sister came in with students and they all stood around me. It was because I was unmarried, I'm sure of that, then she said: "Come on now, give a big push!" and I said—I was so mad!—"I fucking well will!", and they all laughed. It was horrible, horrible.

"Then she said to the students, 'Isn't she pushing very well now?'—to the students and not to me. Why couldn't she have given me a little encouragement?"

When the baby was born, Margaret asked to hold her, but the nurse on duty simply held her up for a moment or two, and as Margaret reached the nurse turned away and hurried off with the baby. It had a very distressing effect on Margaret. "I got so frightened of the baby later, I couldn't bring myself to pick her up for a whole day after that. They ruined my relationship with my own baby for a long time. If I ever have another one, I'll lock myself in a room where no one can get at me."

Maura D., who'd had two children at home before booking into hospital with her third, arrived at 1.30 a.m. on a Bank Holiday, with contractions every five minutes, and was left sitting in the admissions office for half an hour. She was put to bed and brought to the delivery room at 7 a.m. A new Sister examined her and asked briskly, "Who told you you were in labour?"

Maura promptly replied that having had two children she knew when she was in labour. It did not set a good tone for the relationship that had to last on an intimate basis for the next six hours. During the next few hours, the Sister commented frequently to her that she "was not breathing properly", which understandably annoyed Maura, who had delivered her other children without drugs or stitches and was enthusiastic about the psycho-prophylactic method. "I told her I was breathing as I had been trained to and I'd go on breathing that way, and she said, 'You'll do as you're told!'"

Maura was eventually put on a drip, and at the final stages she too found no one to help her sit up to push. "This nurse kept shoving the mask at me and I kept knocking it back. It was a struggle between me and the nurse." After the baby was born at 12.30 p.m., Maura was left for nearly an hour, uncovered and shivering, listening to a woman in the next cubicle screaming unmercifully.

"I found out later that she had had twenty stitches and must have been in terrible pain. The nurse never stopped telling her to 'Shut up!'—'Shut up!'— not even 'Be quiet!'—and, 'You're acting like a child!' It was dreadful. I had to go into hospital to find out what labour was really like. They made you feel degraded, disgusting … never again."

"Difficult patients," the doctors would sigh. Neither women would get far with a complaint on medical grounds, and both went home with babies in perfect health. But for both the experience had been traumatic.

4-6 June 1973

Gabrielle Williams

What's in a Bag?

Women seem to be extraordinarily dependent on their handbags. Ask a woman what she would grab if the house went up in flames and in all probability it would be her handbag first and the baby second. Both, one presumes, would be an automatic instinct. Yet bag-snatching is a fairly new reflex, for looking back at old fashion plates of the past hundred years I see very few bags being carried—an occasional little velvet thing with a draw-string and a well-placed tassel, undoubtedly called a reticule and obviously made by the imaginative owner herself, but most of the girls seemed to spend their energies carrying around baskets of flowers or frilly parasols.

There is no question about the importance of the parasol at the beginning of the century. It was no pretty gimmick, but a vital protection against freckles and sunburn—the great beauty killer of the time. Those were the days when a girl would have had very little to put in her bag—no makeup, driving licence, cheque book (everything on account), old bus tickets, old bills or old dust. Her face, innocent of cosmetics and her total dependence on her male escort (he was obviously reliable in the old days) made the presence of the bag unnecessary.

One of the most traumatic experiences in a woman's life is losing her bag or having it stolen. The latter calamity is much the more likely of the two mishaps. What sane woman could ever actually lose her bag? The responsibility of a crocodile affair stuffed with Cartier compacts, pound notes and French scent must

outweigh any advantages. My sister has had twenty-three bags stolen, she tells me. For some reason, obviously sinister, I have never suffered this, and the rather painful conclusion is that mine are just not worth the taking.

Trammelled to a bag is the feeling of protection when clutching the thing, the awful panic when it can't be found. All this has become part of a woman's life. A friend, while registering the rows and rows of women on a number 10 bus, each sitting seemingly resigned to some unknown but not very thrilling fate and clutching a bag on her knee, hands waxily resting, considered the dilemma of a future archaeologist. If for some unknown reason the whole gathering suddenly became encased in ice, it would surely pose a delightful riddle.

Why must we carry bags? Hasn't the Brave New World nearly arrived when we can dispose of them and invest in a belt that contains pockets for the few small items necessary to a modern woman's life?

In *Our Hearts Were Young And Gay*, Cornelia Otis Skinner gives a description of her mother's plan to foil robbers when her daughter and friends went on a voyage to Europe. A belt had to be worn under the dress and from this dangled a bag at knee height. This lumpy, swinging object gave dancing partners the strangest ideas about girls. My grandmother used to make large pockets in her petticoat in which she kept her valuables. I used to ask her if it was not embarrassing to have to rummage in her underclothes in public for small change, but she never answered questions. Later in life she took to a large, black, satin home-made bag, but the only valuables it contained were tidbits for stray cats.

Every woman's ideal bag is probably something like the one Mary Poppins had—from which came forth, as far as I can remember, a folding bed, six flannel nightgowns, and a suspicious bottle. All these things would be invaluable in an average day.

And of course, Americans never desist from calling them a purse, even after a decade in Europe. I can only conclude by warning that when I asked for my bag in the States everyone thought I was looking for something along the lines of a sack.

1 May 1971

Nell McCafferty

All Our Yesterdays: Coat Tales

Here, readers, is the story of my coat. I think it might make you cry. When I was eight years old in Derry and my father worked in England—reader, are you crying yet?—my mother's rich American sister sent us a parcel of clothes that had been collected by her cinema-manager husband, late at night in the cinema, after people had left them behind.

Anyway, one day a parcel arrived in which there was an emerald-green coat, fur-lined with brown buttons. It was given to me. I was a sickly child, about to make my Confirmation. It being a cold day, the coat was put over my former first Communion dress, and I was taken away to be slapped on the cheek by the bishop and made a soldier of Christ.

My coat was lined with medals: Sacred Heart, Virgin Mary, Saint Philomena (now demoted), Roy Rogers medallion and hairy scapulas scratching my not yet nubile chest. After the boring ceremony, I went up the lane behind our street and began to play marbles.

It was the beginning of the season. I had beautiful marbles, bought in Woolworth's with my Confirmation money, which was not as bountiful as my first Communion collection. I kept the marbles in my white bag along with my rosary beads. I lost a few games, attributing it to my dog swallowing one.

He recovered, so did I. We were a sacred trio, my dog, my coat and I. We stayed together, played together, prayed together. We loved each other truly. One day

my dog died. My mother put a Wagon Wheel chocolate biscuit in my pocket and sent me to see the *Wizard of Oz* in the cinema where my aunt was manageress.

I pined for a while, and they decided I was growing up. They decided to dress me up according to the advice of the fashion editor in *Women's Own,* to relieve my depression. Coming home from convent school one grammar-filled afternoon, I changed out of my uniform and sought my lucky coat. I was due to play handball on the gable at the foot of the street with my best friend Joe.

I went out to the tool shed where my coat was kept, and it was not there. "Nell," my mother told me in her wisdom, "today we go to Paddy Bannon's, and we get you a new coat."

"Where's my lucky coat?" said I.

"I gave it to the ragman," she told me.

"Where is the ragman?" I said.

"Going the round," she replied.

I went to the foot of the street and told Joe. We went to look for the ragman. Up and down many streets we roamed, asking people if they had seen the ragman. We found him, finally. I asked for my coat. He refused. I said all my medals were on it, and looking him in his Catholic eye, I got my coat back.

Two weeks later, before a game of baseball, my persistent mother said she had given my coat to the bin men. She had bought me a new school blazer complete with proud coloured badge. I went looking for Joe. We got the bin men and their lorry, and my friend Joe climbed inside; after some time he emerged, Pal Joey with my lucky coat. I wore it all the way home. My mother said it had germs and could not henceforth be worn. I asked her to wash it. She did. Then one day, there was no coat. I do not know what happened to it. Nor did I miss it.

24 December 1971

Gabrielle Williams
Fashion Correspondent

The Timeless Little Black Dress

Whenever I get depressed about not having any money to spend on clothes, I think of the women on the isthmus of Tehuantepec in southern Mexico. These so-called primitive Indians are fanatical about fashion and never feel it necessary to justify the buying of beautiful clothes. It is an interesting society, run by women for women, and they work hard to spend lavishly on rich colourful materials, the principle being to arouse envy in other women and attract men.

Western women, of course, have been at pains for centuries to rechannel their desire for clothes into the more mundane aspects of living. Nowadays one hears women, dressed in revolting duffels and corduroy trousers, chatting about their deep-freezer as though it were an exciting new garment. Of course, it's simply another sign she is curbing her natural instinct for the sake of her family. Think of the sumptuous clothes she could buy for one deep-freezer.

Nor are the "primitive ladies" likely to make blunders such as those we in the West make over clothes. Their style of dressing is constant, and richness and magnificence is the only yardstick. We have to cope with extraordinary, self-inflicted complications—an ever-changing silhouette that generally bears little resemblance to the human form, and this awe-inspiring virtue called "simplicity". Every time a famous beauty is questioned about her style she comes out with this totally meaningless word "simplicity". "I love simplicity," she'll say.

Bah! The richer and more beautiful the beauty, the more she swears she likes to be and look simple. This, however, doesn't mean she won't freely admit to spending three to four hours a day achieving the simple look. It's unkind on the humbler members of mankind or womankind to deprive us of a decent spectacle. I think we could learn a lot from the ladies of Tehuantepec in this respect.

All this meditation came about when I was thinking about the "little black dress". It's sweeping the continent like the Plague. And we are so far removed here from the lovely gay matriarchs of Mexico that the wearing of a "little black dress" is considered the very height of chic and sophistication. The plainer the dress, the cleverer, is a safe general rule.

I rather think it was Coco Chanel who endorsed the black dress as the chicest uniform possible. It became a part of the Chanel legend, the idea being, as with all her clothes, that it must be easy and pleasant to wear, luxury with intellectual taste. Today I see some of Chanel's same ideas on the mass market—stark little dresses with handkerchief points for £7 at the nearest chain store, and not bad at all.

So black is back and that means women will still look good *en masse*. Like men in dinner-jackets, there's nothing much that can go wrong in the choice of a black dress. Though of course there will always be the one who is too anxious to attract and will favour a slit to the navel or no back or a vast key hole cut out across the bosom. I've seen it all. It's amusing to see how many variations can be got from the one colour, like a game of chess, always with a possible new move.

I must confess I have three of the breed, and no one would ever guess that deep inside the impeccable plainness is a primitive woman longing to be gaudy and gay, arousing envy and excitement. Needless to say such freedom of expression is so deeply buried in most Western women that even alone on a desert island we'd be deciding that black was best. Yes, civilization gets one in the end, but long may the women of Tehuantepec be primitive, proud and magnificent.

My best black dress was bought by means of bartering, which I like for its wholesome, primitive tones. I gave hundreds of English lessons to the son of a Roman composer whose wife was always going to premieres and having to have a new "little black dress" to uphold her husband's position. I got the one made of countless little lace ruffles. It came with a respectable black taffeta underdress, which I threw out for the sake of impropriety.

It was, is, a marvellous little black dress.

24 **November 1973**

Nell McCafferty

What Will the Well-Dressed Man Wear during 1974?

The well-dressed man should wear clothes this year because if he does not he will be very cold. One of the reasons why he will be very cold is that we are suffering from a fuel shortage. One of the reasons why we are suffering from a fuel shortage is that the miners who get their clothes dirty while digging underground are not being paid enough for the work they are doing, and are certainly not being paid for removing their dirty clothes, and washing themselves in the interests of hygiene.

If the miners were paid more, we would have more fuel, the miners could afford clean clothes themselves, and men in general wouldn't have to wear so many clothes throughout the year. That is all I have to say about men's fashions.

14 January 1974

Profiles

Elgy Gillespie

Muhammad Ali

Just about every last journalist and photographer—150 of them—has gone to the airport to greet Muhammad Ali. They can't believe it's actually going to happen. The last time Dublin saw a heavyweight champion was in 1922, when Mick McTigue knocked Battling Siki out inside sixty seconds at the Capitol. Black marketeers were still selling the tickets outside, minutes after the fight was over. Outside, the Civil War was raging in front of the General Post Office.

Today the Capitol has just been reduced to a pile of rubble to make way for the "Irish" Home Stores. Another war rages; and it's just over two weeks since Muhammad triumphed over Jerry Quarry, calling in the referee to stop the fight. And less than a month since Butty Sugrue told the Dublin pressmen he was having trouble getting promoters to lay down the the $25,000. They didn't believe it could really happen either.

But it has. The man who will fight Al "Blue" Lewis on 19 July 1972 at Croke Park, Dublin, is here. Opperman's Country Club has been open for two weeks and a huge black Mercedes is waiting for him. Meanwhile someone—rather tactlessly—has discovered that Mrs Clay's maiden name was Grady; nobody seems sensitive to the socio-historical significance of this fact, that a slave owner named Grady some two hundred years ago or less exercised *droit de seigneur* over his slaves.

Muhammad steps off the plane and dances over this gaffe charmingly. "Well, there was a lot of *sneaking around* in them days!" There was. His skin is Tate-and-Lyle

syrup, pale and unmarked. He doesn't know anything about the North and says so. He is respectful about Al "Blue" Lewis, beautifully disrespectful about Frazier. He is as obliging as can be to 150 assembled pressmen. He is his old beautiful, cheeky, witty 1963 self.

(✱✱✱)

Except that he can't be, not really. Since 1963, when Cooper felled him for the first time in his professional life, he has beaten the old bear Liston, twice. The first time he accused him of putting liniment on his gloves, to blind him (see below). The second time he fixed Liston in one round with one punch: the "linger on" punch, as he calls it, because it doesn't send them off but they linger on. If the fight had been a fix, claims Ali, it wouldn't have been wise to fix it with that punch; and a photo from *Sports Illustrated* shows the shadows beneath Liston's lifted feet clearly.

He has become a Black Muslim, changed his name and studied for the ministry. "Telling the truth is more important," he says. He's been told he is not mentally fit to fight in Vietnam. He has been sentenced to prison and fined £4167 for refusing to go to Vietnam. An all-white jury in Houston, Texas found him guilty in twenty-one minutes. He has been stripped of his championship by the New York State Athletic Commission and his passport has been taken from him.

He was forbidden a local licence to fight by each boxing commission in every State. Finally Georgia was persuaded to give him a licence by Hal Conrad (Governor Lester Maddox is furious, he said) and in October 1970, after four years of non-violence, he faced Quarry. He finished off Quarry in five easy rounds; in Chicago the black elite come out to watch him on closed-circuit television. The projector breaks down and they tear the cinema to pieces.

Ali has started a chain of Champburgers in Florida to dissuade young black kids from eating pork, forbidden by Islam. He has divorced his first wife, Sonji Roi. He has lectured in universities all over the United States, been granted Conscientious Objector's status in New York State, and plays for five days in a flop Broadway music called *Big Time Buck White*.

He goes down under Frazier, his first lost fight. His second wife Belinda gives him his fourth child, a son: Muhammad Ephraim Ali. He announces that he will perform only exhibition bouts before retiring in 1972: by which time he reckons—having gone into a few property deals including a 300-unit apartment house in booming Atlanta—he will be able to keep himself comfortably.

Instead, Ali is thirty years old and he is, of all places, in Dublin. In the Gresham Hotel, Hal Conrad is occupying the top floor suites and running the ultra-efficient American dream machine. A long-renowned sports journalist, novelist and promoter in the USA, he invented slot tennis—where you place a coin in the posts and the net slides up; it did away with the labour and made a fortune. Conrad is tall, thin and dark, with a strange look of Groucho Marx that may be his moustache or my imagination.

Why, I ask, Dublin? "Why not?" asks Conrad back. "I'll tell you something else. It will make a big impact on world news when people look at their papers and see Muhammad Ali walking around Dublin in perfect safety. A lot of people who won't know much about Ireland think you get shot on the streets down here. This will show them that that's not the way it is."

I ask if Muhammad is really going to donate his profits to charity. "Well, the fees are $215,000 and promotion alone is costing $30,000. If there's any left over … well, we'll see."

(✱✱✱)

Ali is visiting the Dáil and talking to the Taoiseach; he has been there for nearly three hours signing the senators' autograph books. Aide Roc Brynner is amused. He has been described as Muhammad's "bodyguard" on a newspaper front page: "*Telephone* bodyguard, maybe. My job is to foil all those telephone calls all day long. That's what I do." With him he carries a small Gladstone bag with an Indian scarf tied around the handle. He says it's the magic bag that contains the solution to all the world's problems.

Today Roc is wearing an aubergine-pink floppy felt hat, a large gold earring, and a glazed expression. A method actor and graduate of Trinity College, Dublin, he last appeared professionally in Dublin when he performed Cocteau's *Opium* at the Theatre Festival two and a half years ago. He is small and light-boned, and bears practically no immediate resemblance to his father, film star Yul Brynner.

"I was promoting Ali's fight in Switzerland last December with Hal Conrad. But the dates kept switching and finally it was fixed for 26 December of all days. I withdrew. So one morning Hal knocks on my door and says, 'Roc, come with Ali and me to Dublin.' And I said, wow, Ali and Dublin? Ali and Dublin just did not seem to, uh, synthesize. But, like, here we are."

He scans a menu and orders—to my surprise—hamburgers. Out of a spirit of perversity I order gammon steak.

"Ali calls himself the People's Representative," continues Roc. "And that's what he really is, it's beautiful. Wherever he goes, one thing you always notice..." He pauses theatrically. "Everybody's smiling. They didn't smile for Sugar Ray, oh no. They bowed and scraped when he drove up in his big limousine, but they didn't smile."

He tells us one of Ali's jokes. Ali is fond of betting the people around him that he can go out of the room and swallow half a glass of water on the windowsill without walking back in. He puts the glass down, walks out of the room, opens the door again, then crawls back towards the glass on his hands and knees. And drinks the water ... but not too much because he's training.

Pretty corny, we say.

"Yeah, but man, that boy *is* corny. He's so corny it's ridiculous. Why, he's the corniest thing alive, he's so corny."

Later on, we questioned again: *"Corny?"*

"Well, I meant his sense of humour. Like a little child's."

He shows us a burn on the back of his hand: Ali burnt him, he says, with his deep powers of concentration...

"He said, 'Stare deep into my eyes.' I did, and all of a sudden my hand's burning..."

Yeah, like *hell* his deep powers of concentration, I think privately.

(✷✷✷)

Angelo Dundee is dark and sparely built: origins Italian. He has the kind of eyes the Spanish call *listos*—ready, quick, perceiving, communicative brown eyes. Sitting at the breakfast table he says he doesn't know what's happened to him, he seems to feel tired all the time this trip. He was even too dopey to rub Muhammad's back this morning.

I remark that if Muhammad is back in bed again he can't be too worried about the fight. "He never is. He never worries about anything or anybody or anyone."

As a sixteen-year-old, Ali would come into his boxing club and pester him for advice. That was two years before the 1960 Olympics. "He told me he was going to win. He used to watch all the boxers, analyse their moves, ask me questions.

He studied boxing, he's an analyst. He would ask me the deep questions. At first he did everything wrong but he still won. I said, well, he's doing it wrong but he must have something." Ali's breakthrough in Rome was the Gold Medal he won in the third round against the Pole, Pietzykowsky.

Dundee can imagine training another boxer after Ali, "because every fighter is different. There's a different child in each." But for Dundee the most efficient organization is the smallest one. He's up at 4.30 a.m. for Ali's roadwork even when Ali isn't, which is almost always.

<p style="text-align:center">(∗∗∗)</p>

Ali arrives; immediately people radiate in front of him. The gardaí queue up for Ali's autograph; endlessly civil, he signs for them all, carefully and with a great sweep. Ali is photographed spoof-punching a garda, thrusting five gardaí back, his arms round their shoulders, their first on his jaw, with a golf ball in hand, waving the golf club in the air, knocking it into a cup.

"Jeez," whispers our awed photographer. "He's great. If you asked him to stand on his head for you, he would too." He poses again and again. But what Ali is really interested in doing is spoof-punching a nine-year-old boy who has wandered in. The boy is utterly unselfconscious; he's not asking him for anything, nor is he intimidated.

"I've seen him play with children for a whole day," one of his party tells me. "He never gets tired of it. Never."

Ali offers to demonstrate his deep powers of concentration on me. First he asks me to concentrate on my packet of Carroll's. I do. And then he asks me to tear the foil from the top. I do. He licks both sides of the foil, folds it square and small, and then places it on my hand.

"Now stare deep into ma eyes." I do, and a burning sensation begins on my hand. What had Roc said? Refusing to believe it, I stand there till my hand is smoking. Mrs Clay is quite alarmed; "Cass! She gonna *sue* you!" When I knock it off there's a cluster of small blisters. He holds his hand up and waves it in front of my eyes; is that, I peer closely, white powder on his oddly slim and artistic fingers?

Back at the office nobody knows which powder will react with tinfoil and spit to make an acid. Nothing that a fighter would risk on his fingers anyway. It's more original than an autograph, anyway.

(✳✳✳)

Muhammad sleeps late next morning, having gone back to bed after roadwork at 6 a.m. "That boy sure loves his sack," mutters someone. He comes in from more sack still muzzy at 11 a.m. "Bored … boring … boring," he mutters, sitting akimbo on a shiny new winged chair. He's wearing his familiar old grey tracksuit with the rip in it.

"I have no power … what power have I got? I've a heavy cold, which I can't seem to get rid of. Who made the sun that warmed me so's I ran this morning? Who made the milk I drank last night? Who made the steak I ate? Who made the grass to grow so's the cows could eat it? Not me, I couldn't make it. I ain't got no power. When I'm the biggest man in the world I could be struck down by a germ or I could be crippled by disease. And I know that. I know that I'm nothing, same as everyone else."

He tells the story of the King and the Treasure House Keeper; he's a born storyteller and a born actor and he tells it with full racial emphasis. He finishes with a small lecture about how people should eat the right foods and be modestly dressed, like (was I hearing right?) Roc and me. "I got cars and a house, sure, but I only got one suit. When people see me, they say, 'Why aren't you driving around in a white suit in a limousine with two girls on either arm? Why are you dressed modest?

"But I don't mess with a limousine and all that. My place is on the sidewalks and in the ghetto and sitting back on the garbage cans with the drunks. That's where I am. Because I want to be bigger than anyone, but I want to stay big and strong with my own. I want to be on top of the great big mountain but at the same time not … not sell out, as they say."

(✳✳✳)

Which is Ali's biggest dilemma. Half the time he's telling you he's the same as everyone else—and he really feels it, just as crazy and just as mad and just as ordinary as the people whose autograph books he signs. The other half of the time he's saying, "It's hard for me to be humble because I know I'm so good." And all the people around him (except for Angelo Dundee and Ali's mother, Mrs Clay) loudly agree. So is he the Treasure House Keeper or does he think he's the King?

"It's my fighting, my lecture tours and my high moral standards made me big. And if you think I'm big here you should see how everybody treats me over there, man."

He goes on to talk about white women. A friend of his in the party came in late the night before with four blondes on his arm. "Man, he had four blondes on his arm. I don't hold with that. You see these big black fighters, they always go for white women." (I have it on good authority that Muhammad "the pelvic missionary" Ali himself was getting good offers in his time.)

"Did you know that out of all the prostitutes in New York City 10 per cent are white and 50 per cent black?" No, I said, I hadn't known.

"Well, there's my aim, to take my sisters back off the street. You see Diana Ross, she married a white man, and a whole lot of others. Any blacks made it big, I mean really big, they've always tried to make it with whites.

"I want to be bigger than any of them and stay with my own people."

Ali's friend who spent the night with four blondes appears, looking a little sheepish. The hotel manager teases him, squeezes his arm, and asks him if he's feeling a little weak today?

"I saw you, man, I saw you last night," Ali says very sternly. And then looks at him out of the corner of his eye from behind his towel. He's joking and half winking at the friend who sits to one side, trying to guess his mood.

I ask him if he's never sick of autographing. "No, see, I think like this. I get a little fellow coming up to me, asking for my name. He's little and to him I'm big. I'm real big. And when he's got my name he's real proud and happy, he runs off shouting. And to me it's just a little thing, no more than a couple of seconds."

(∗∗∗)

What I ask, does he feel about violence as one who fights for a living? "When I was called up I thought I can't go and shoot those poor people I ain't never seen, I can't do that, I said. In the old days I fought wild, I landed a punch—*wham*— (he flails the air) and I said 'I got you' and I go in (raining blows on his imaginary foe). Oh, I was mean. But now I don't want to hurt the man. You seen me in the Quarry fight? I asked the referee to stop him; I held off. Now I make the big hit, I see I've got him and I hold off so's not to hurt him."

Herbert Muhammad appears, the son of the head of the Black Muslims, Elijah Muhammad, and his little boy runs past. "You gonna give me a kiss? Come here,

you gonna kiss me?" The little boy runs over and kisses him on both cheeks. "What's my name, what's my name, what's my name?" He once asked the same of Sonny Liston in the ring.

"M'hammad Ali" says the little boy.

And Ali goes out to be photographed by a lady from Foxrock.

19 July 1972

Mary Leland

Dr Lucey: A Rock against Change

Cork's Bishop, the Ne Temere *decree, mixed marriages, the Church militant and the closure of Cork's Catholic Marriage Advisory Council*

Change is all around us, but Dr Cornelius Lucey, Bishop of Cork and Ross, is the man he always was. He is, as he believes the fundamental Catholic Church is, unchanging. This is what he stands for in Cork. He has a tremendous security, and it has isolated him. He is the epitome of immovability, the Rock.

For the entire month of October a General Mission for Catholics was held in Cork; ninety-two priests were imported to insist on the fundamentals of the Catholic faith. Earlier in September he told me why: "A lot of good people, good in the Lord's eyes but miles off-beam in their religion, think that some particular devotion is the whole of religion. They're really off course and we must put them back.

"Also, in this particular time of change, people—I've heard it so often—say things like, 'I'm a Catholic but I don't hold with what the Pope or the bishops are saying!' You might as well say I'm going to play golf, but according to the rules of hurling!"

The mission was to show that there were certainties in religion. "We don't make the faith. It's given to us by Christ. It's not what we want to do either in conduct or belief, but what God tells us we are to do, and we take it or leave it.

We're not trying to make anything up, just trying to say that this is what we've got, and this is how it looks applied to your life today."

As a child, seeing him in procession was like seeing God. So steady, so remotely glorious, gowned in gold and dusted with incense, he walked beneath a fringed canopy and became, in Patrick Street, the Body of Christ. It never seemed possible then that it could be his words that struck black sparks from the *Cork Examiner's* pages; could be him who interceded or intervened in strikes, who warned against bakery monopolies, who challenged the Savings Banks, who defended the small farmers, and who was just a man.

He was all those things, and still is. He had all that power, and still has. He has all the authority that comes from knowing that when you speak you will be listened to. Neither reform nor ridicule has changed this, and his public mistakes have been criticized in public by few of his own people. But there have been times, there have been times.

They included the *Baby Doll* episode with the Cork Film Society, something similar with the Film Festival, some over-publicized comments on *Richard's Cork Leg*. More importantly, the disciplining of Father James Good, DD, who criticized *Humanae Vitae* when it first appeared and whose immensely valuable pastoral and academic work was subsequently lost to Cork. Or the recent criticism of the Synod of the Church of Ireland, or his attitude to mixed marriages—"*Ne temere*", a friend said, "is alive and well and living in Cork"—to ecumenism, to liturgical changes. Above all, he lends the emphasis of conservatism to all those areas of life he touches as bishop, so that Church affairs in his diocese are imbued with an almost palpable caution, understood but never defined.

It is hard to realize the tragedy of this, standing at his window and looking at his garden, listening to him talk about his only recreation, his hours in the greenhouse. Beyond the garden the valley slopes down to the city, and beyond that again another hill rises thronged with new housing estates. Among them, directly facing the red-brick modern house in which he lives, is the circular steel skeleton of his new church. It will be the fourteenth church to be built since he came to the diocese twenty-one years ago.

The tragedy of this pervasive caution has been made more obvious by the closure last week of the Catholic Marriage Advisory Council in Cork. The result of this caution is seen there, not in the fact that Dr Lucey withdrew his sanction from the Council for what might after all be good reasons to a man of obdurate principle, but that without his sanction the Council Committee felt they could not carry on.

The closure damages both the Council and the bishop, but most of all it damages the people who were using the service, for whom there appears to have been little thought on either side. By ceasing to operate almost overnight, the Council has encouraged people to look for a guilty party. The published statement from the Council seems to identify him, and there has been no attempt to share the blame.

Yet in Cork it is possible to suspect that the Council itself has been trying for too long to operate under difficult terms of deference and that it should long ago have been attempting to define its future role. Perhaps, indeed, it would have been impossible for them to continue as a Catholic counselling service without the bishop's recognition. What is certain is that they did not try. And they do not seem to be prepared either to try to deal with the problem they have themselves defined: the clear and pressing need in Cork for a Catholic family-planning service.

(✱✱✱)

Dr Lucey was fifteen when he left the family farm at Ballinora, near Cork, to enter the diocesan seminary Farranferris, a few yards uphill from where he now lives. From there he went on to Maynooth and later took his Doctorate of Philosophy abroad. On his return he became Professor of Moral Philosophy and Politics.

"I was at the pen too long," he said. Reminded of a criticism that, like many bishops, he had no pastoral experience, he said that he had spent eighteen months in Bantry as coadjutor before succeeding Dr Coholane as Bishop of Cork in 1952. "If I hadn't been there, I wouldn't have as good an idea as I had of what the priests have to do." He accepted a suggestion that bishops should have some experience of parochial work as "reasonable" and added, "I cannot write myself off as a failure because I haven't come that way. Maybe I am, but that's what I leave to you and the priests and the people of Cork to decide."

It always a rather startling thing to see grown men and women kneeling to kiss a ring on the bishop's fingers, but the gesture is theirs, not his. His dignity is superb, but it is also innate, a part of the man and not just of his office. He does not mount campaigns or get on bandwagons, but makes his point with what can often be a single electrifying speech and then an unremitting adherence to the principle he has stated. People love him for this. He is loved in Cork, and where there may not be love there is certainly respect.

There is also abuse, of a sophisticated kind, for few things are harder to live with than someone else's principles. Dr Lucey has made life difficult for some

people in Cork, and since Vatican Two this is no longer so readily accepted. People do not always understand, for example, why the altars were so slowly altered, or why the Mass in Cork is still different to Mass in Cloyne.

"In fact there's an excellent rule for all these things: 'Be not the first by whom the new is tried, nor yet the last to cast the old aside.' All the same it does seem strange to me that for so long Mass was said in a certain way, and now all of a sudden the only right way is facing the people. But it is just the fringe of a fringe of a mystery. It should not be built up into something by which you decide whether a person is a progressive or a conservative."

(✱✱✱)

Although people speak bitterly or wittily of his attitude to mixed marriages, it is not generally known that he grants approximately forty dispensations a year, and has done so for the last three years or so. "You start from the premise that there is no dispensation unless the children of the marriage are brought up Catholics. You must have made up your mind that the family will be a Catholic family before a dispensation may be granted. The Protestant party no longer has to sign a promise but does have to state his agreement and the Catholic party has to guarantee it as far as possible."

He believes that mixed marriages are not desirable in themselves. "If a couple are firm and true in their own religion, they can't be that united. My duty is to the Catholic people: the average family don't want a mixed marriage, or their grandchildren to be other than Catholic, and what I have to stand up for is my own people."

As he sees it, the problem is not being presented as it should be: "It isn't just Church opposition. If mixed marriages were favouring the Catholic parties, then the parents and clergy would be all for them. But we keep warning against them and preaching against them because experience shows if you follow the family of a mixed marriage through two or three generations, a whole lot of them have lost religion altogether. There is a dilution of beliefs in both directions."

The only solution, he said, is that the family should be of one religion, one mind. "And for me that is a Catholic mind."

He views ecumenism as right and good, but only so far as it encourages good relations between people of different religions. He does not believe that different Churches should participate with one another and does not agree that one Church is the same as another. In that case, he says, none of them would be worth anything.

"I believe in my own religion and try to practise it, and I credit all the others with doing the same. But I don't think pretending we are one when we are not is a service either to ecumenism or to truth. One can be friends with every kind of non-Catholic, but that we should go into their places to worship should never be regarded as the right type of ecumenism anywhere. You have to be yourself, you must not gloss over what you stand for."

In private he speaks slowly, with a slight hesitancy that is absent from his public speeches. In both cases he can be humourous, self-deprecating, and affable; he is always courteous, answers his own letters, and works long and hard at administering his diocese, which has a rapidly growing population. There is something very fine about him, as though he had long ago learned to live with the threat and fact of misunderstanding. He is seventy, revered, and venerably authoritarian, yet it is still possible to see in Dr Lucey glimpses of the young priest he must have been.

15 November 1972

Eileen O'Brien

Mosley Foresees a United Ireland within the European Community

Sir Oswald Mosley, the former British fascist leader, on Saturday called on the British government to transfer the Catholic areas of Tyrone and Fermanagh to the Republic as a preliminary to union between the North and South of Ireland within Europe.

He condemned imprisonment without trial and the ill-treatment of prisoners. The sooner the British Army got out of Northern Ireland the better, he said. Sir Oswald was himself imprisoned without trial in London during the last war. In 1920, when he was the youngest MP in Westminster, he resigned from the Conservative Party in protest against the behaviour of the Black and Tans in Ireland. He was in Dublin to talk about two books: *Oswald Mosley* by Robert Skidelsky, and his own re-issued *My Life*.

Sir Oswald broke with orthodox politics during the slump of 1930 and today's economic crisis in Britain is, he maintains, even more serious. In 1930, he favoured a drawing in of the British Commonwealth; now he sees salvation in the European Communities.

"The basic problem is to balance, to equate production and consumption in order to give the people the means to buy what the people produce," he said. "For that you need a government with power to act within a viable area where effective action is possible. When I was in the government it was the Commonwealth.

Now it is Europe."

Expressing his admiration for the way Ireland had embraced the European Community, he spoke of his fervent hope that his country would decide to stay in. "I stood in 1948 for 'Europe, one Nation'. I think we will have a European Government. I stood strongly for the Commonwealth. It was lost in the war, as I foresaw. I was against war. I foresaw what would happen if Russia and America were brought in. Now the only effective action is in Europe."

Sir Oswald advocates European government on three levels. First there must be a democratically elected European Parliament, strengthened "to go beyond the officials in Brussels" in order to handle defence, foreign policy, and the main economic questions. Next would be the national governments, like those of Ireland and England. At the third level would come self-government for Scotland and Wales.

"This is where Ireland comes in. The union of Ireland can ultimately be achieved within Europe," Sir Oswald declared. "What has prevented unity is the fear of minorities of losing their culture and being oppressed by a majority. If you have devolution so that everything they mind about is run by the minority themselves and—this is most important—their rights guaranteed by the whole of Europe, those old fears will be dissolved."

This, he forecast, could happen in time without riding roughshod over anyone. "Gradually, economic logic will bring these peoples together, particularly as they live in one country."

England, Scotland, and Wales too, could come together, he contended, once national and local feeling found full expression and minority rights were guaranteed. "In Ireland, you can come together within Europe in a way that was not possible before you both became members of Europe. The Irish have had the good sense to go very strongly for Europe."

Economically, he considers it vital for Britain to remain within the EC. "To sell a third of its production on the markets of the world if it is outside Europe is virtually impossible. Some of them imagine that they can have the best of both worlds, that they can stay out and still have the European market." Why, he asked, should Europe buy British goods when she was a nuisance and had broken her treaties? If Britain stayed in and made her industry competitive, she could not be adversely affected by tariffs or exclusion.

"The further I go in life, the more convinced I am that the creative individual must be assisted, and bureaucracy, wherever possible, avoided." Sir Oswald spoke

of his life-long affection for Ireland, which began when he was here as a young professional soldier towards the end of the 1914 war. "When the professional army was withdrawn, the Black and Tans were introduced. I was then the youngest Member of Parliament and began the parliamentary fight against the Black and Tans."

Sir Oswald went on to say that he had always been against terrorism of civilian populations and the torture of prisoners. "As a professional soldier I have a great pride in the army, and we did not do those things when we were here in Ireland. That is perhaps why we were withdrawn and irregular troops introduced. The irregulars were not only brutal but incompetent—600 of them were killed by Michael Collins' men in six months."

The treaty, he went on, was due to the success of the guerrillas, the parliamentary opposition party's exposing of the atrocities committed by the Black and Tans, and American public opinion. Would he condemn the ill-treatment of prisoners in the North today as willingly as he condemned the Black and Tans? "I am reluctant to believe that the professional army does anything wrong like the ill-treatment of prisoners," Sir Oswald replied. "It never happened in my day. It was because we behaved properly and honourably against honourable opponents that we were withdrawn and the Black and Tans recruited all over the world.

"Nothing is worse for a great professional army than to be used for dishonourable purposes. I have no evidence that it is so used. I'm not condemning the Army in Northern Ireland, because I know nothing about it, but certainly in my time these things were not done by the professional army, but were done by the Black and Tans."

Condemning imprisonment without trial, Sir Oswald recalled that he had suffered from it himself. First he was detained in Brixton, then with his second wife in a special wing of Holloway for husbands and wives. He had, he said, committed no offence and it was admitted in parliament that he was detained, not because he might act against his country, but to prevent him from persuading the people to make peace.

"Imprisonment without trial should never be allowed," he declared. "*Habeas Corpus* is always there—except when it is wanted most, in a time of emergency. It is pure humbug. It should be made a reality."

At Sir Oswald's first wedding to a daughter of Lord Curzon, former Viceroy of India, the King and Queen of England were among the guests. He was widowed in 1933, and his second marriage, in 1936 to Diana Mitford, a sister of Hitler's

friend Unity Mitford, was celebrated in Berlin; the reception was given by Frau Goebbels and Hitler was a guest.

"The reason for marrying in Berlin was because I was daily threatened with assassination and I was marrying a woman [Mrs Bryan Guinness, née Diana Mitford. *Ed.*] who lived alone in the country. Merely to keep the wedding secret we chose Berlin. By reason of a treaty, a marriage there was equally valid. Hitler was well disposed towards me because I did not want war. That was my only relationship with him. I did not see him after 1936. I did not want war; he wanted to drive east; so we had nothing to quarrel about.

"All he wanted from Britain was that we should not jump on his back when he was fighting Russia. I wanted to preserve peace and not have Europeans fighting each other."

Did he perceive Hitler as either evil or insane? Sir Oswald answered that Hitler was very quiet and calm when he met him, so he could not judge him when he was excited.

14 April 1975

Chapter 3

Out and Proud

No single-issue journalists we. With New Journalism came the notion that you are always your protagonist and all experience was grist to the mill.

Mary Cummins

The Christmas Rush: Once More with Feeling

By Christmas Day some 76,000 people will have come into the country. Today, tomorrow and Friday, trains, and boats and planes will be crowded and overflowing.

I remember going to meet the boat, thinking nostalgically back to Christmases spent away, the excitement of the ones spent at home, the saving up and preparing and getting the sailing ticket in time or booking a flight in October. And I remember the Christmas of the foot-and-mouth when no one could come home, and the sodden parties in Earl's Court and ringing up on Stephen's Day and hearing Wren Boys in the background.

And I remember the suppressed excitement of the boat-train, the sudden bursts of laughter and shoulders held rigid with the weight of bags. Out of the darkness, inside the door of the ferryport terminus at the North Wall, the heat and the light, the piped Christmas carols and the waiting uniformed men remind you of all the wearing times you passed through similar places lugging suitcases to taxis and buses.

The Christmas tree and the tinselled decorations make you feel better; at least you're on land and halfway home. And you put the train journey that has to follow out of your mind, forget the maybe eight hours further traveling and gnawing hunger pains that won't be appeased by fruit or chocolate; the tired headache, the crowded trains and the apprehension that your case might be stolen; dropping off to sleep, wrinkled and crumpled, and nodding awake suddenly.

Last Monday morning over four hundred passengers arrived on the B&I ferry *Munster* from Liverpool to Dublin. Almost two hundred had cars and the rest were ordinary passengers. The boat was almost an hour late. We waited, looking blearily out at the dark Dublin Bay and the bracelets of light pointing out the land. Then the ferry moved slowly up into the port; lights blazing from it and figures standing on the decks.

It sidled alongside the ramp, the gates were opened and the crowd with suitcases and armfuls of children surged out. There were young men with open-necked collars and good suits, overcoats over their arms; young and middle-aged women, some with elaborate hairstyles, others holding on to blinking children, and some older women on their own, wearing hats and mackintoshes over winter coats.

One fellow with long oiled hair was on his way to Leitrim. He worked in a shop in Regent Street and hadn't been home since last Christmas and had to be back for the Monday after the New Year. He was supposed to come on Friday night and said he was "right fed up with himself", because he met some friends of his after work and they had persuaded him to stay in London for the weekend, so he had already missed one weekend. He said he never came home in the summer and saved his holidays and his money for Christmas. He wouldn't come unless he had one hundred pounds in his pocket.

Two girls, one married, carried a small, cranky child between them. They were going to Sligo, they had been sick most of the way over and looked tired and pale. The married girl's husband is coming over on Christmas Eve. They hurried from the terminus and into a taxi to be at the station in time.

A young girl, a nurse in Lewisham, asked me where the Gresham Hotel was; her parents from Kilkenny were meeting her there at 11 a.m. She said she hated the boat but only found out a few days ago that she could have nine nights off and she couldn't afford the plane fare. She said she would be doing her finals next summer and would come home to work then.

A family, mother, father, little boy and baby were humping cases off the moving baggage-carrier. They were preoccupied and hurried; said they were home for good, and had to get all their trunks out of the bowels of the boat. The man was about thirty and had been over here for a few weeks, and had fixed up a job in a factory in Cavan. They had a house to move into and the woman said: "I wish we were there now with a good hot cup of tea." They had lived for five years in Birmingham.

Everywhere people hurried and scurried, shoulders drooping from the weight

of the cases, all colours and shapes; some with bags, others with heavy airline bags, heaving them onto the Customs' counter and off again, marked with white chalk.

But the boats have changed. Inside the entrance of the ferry there was a shop and beyond that countless lounges and two restaurants. None of them in the old beige and green that made you sicker than you were, or the hard chairs deep in the heaving bosom of the boat, where you could hear the dogs whining, and babies cried all night, and the wind whistled through countless cracks.

In the restaurants some of the people who didn't have trains to catch were sitting around drinking coffee. Three priests from Louvain in Belgium, home for a few weeks; and two lorry drivers who were only over for a few days on a job.

The night was lifting when I came off the boat and Dublin showed through, grey and cold. The customs was empty, a few stragglers were still left in the lounges and the last bus pulled away.

22 December 1971

Elgy Gillespie

On the Road Again

Is hitchhiking in Ireland dangerous, people sometimes ask me. From my sentimental reminiscences I reply at length. *Well,* I say, bringing to mind a three-hour wait in front of a corrugated tin shed on the outskirts of Galway City, while car after car changed from hope-raising gear only to then vroom away in fourth…

Well, I say, through the memory of two lungfuls of exhaust. Well, I continue, recalling how the sky turned upside down onto my head and another fifty-five cars containing single drivers skimmed past: mothers, priests, farmers, and all of them certain from the look of me that I was going to savage them to a bloody pulp round the next bend and make off with their petrol stamps…

Yes, I answer. You can catch pneumonia, and your faith in human nature takes some body blows, too. But, being curious, I want to see human nature as she is displayed from Rosapenna to Ballydehob. And without a car or a 650-cc Harley Davidson with wraparound shades, that leaves you no alternative but to stand on a grass verge covered all over with baggage like a Gurkha, with a double-jointed thumb and come-hither smile to hide your pot of pepper, your innate modesty, and your boy-scout penknife.

And it gets harder all the time. Like everyone else I started hitching unbeknownst to my parents. When I first arrived in Dublin I was directed to Trinity Hall, where I was given a room with bars on the window and a cabbage growing

outside the sill. I looked at the bars and then I looked beyond, at the cabbage.

Uhuru!!!! The call of the wild… After a short daydream, I shouldered my pack and hitched to my Granny's in Belfast. It took me three hours and two free cups of tea to reach her doorstep (these days it would take at least six).

"Who was that strange man?" asked my Granny as the large and sleek car I had stepped out of reversed and streaked backwards down Connsbrook towards the Albertbridge Road. "A … friend," I replied enigmatically.

"Oh, aye!" said she cynically, dispelling several pairs of eyes behind blinds with one fierce sweeping glance.

It was the start of a long and intimate relationship with the highways and byways of the thirty-two counties. Back in Dublin I would take to the western road on the Maynooth bus whenever the stone walls of college seemed to close in. My one and only Dangerous Incident occurred my first time thumbing in Connaught when an elderly Morris Minor (what is it about those cars?) shuffled to a stop midway between Headford and Cong.

"Where are you going to?" I asked the driver (tip to beginners: always ask where the driver is going to first, never say where you're going). He didn't answer. He was a large farmer with hairs growing out of his nostrils, coat tied with string, no teeth.

"I'm going to Cong," I said, throwing caution to the wind. "I've always wanted to, ever since *The Quiet Man.*" I climbed in.

The car shambled along while I made desperate attempts at small talk. The weather was nice—God, desperate day, wasn't it—the roads were well-surfaced— the roads were murderous—I was heading for my long-lost third cousin seven times removed—I was Maureen O'Hara getting away from the Empty Glamour of Life at the Top. You find yourself spinning fantastic fictions while hitching in an effort to keep the wheels revolving sweetly. But the farmer replied nothing but occasional grunts.

Finally the car came to a full stop, just past Lackafinna. The farmer turned and put his two arms around me. His muscles were like plaited cables and he squeezed ever more tightly, like a boa constrictor. "Um," I said (this had never happened before).

"Excuse me, would you mind, er, letting go? Well, I must be getting along; my uncle's waiting for me in Cong," I tried desperately and improbably, opening the door with my left arm. Still he refused to let go, and we sat at a total impasse, me pinioned by his plaited cables and him staring impotently at the side of my

unyielding head. We stayed in this position for ten minutes while I alternately pleaded, excused myself, laughed helplessly, panicked, tried to imagine for myself the years of repression and sexual deprivation. Would I be there forever or till next birthday, I wondered aloud?

There came a tapping at the window. "Oughta be ashamed of yourself now!" came faintly through the window, "… and you a grown man!" A little lady carrying a basket with a cloth over it (gruel for an invalid? new-laid eggs?)—was making faces at us. Instantly I was released. I stepped out a free girl.

Taken home by my deliverer, I was given a huge fry-up, patched up and dusted, and tucked into a truckle bed for the night. Hers was an old cottage with cream in a bowl in the window, bread dough rising by the fire and a blackened kettle on a huge range steaming away for our tea. You would think Bord Fáilte had laid it on special, except that next door was a modern bungalow, ready and rateless for seven years, waiting to be moved into so that the cottage could become the grain store.

Whenever I hitch past the modern bungalow nowadays I stop for a cup of tea from an ordinary kettle on the new electric cooker. And I thought of the little lady last year while sitting in a large sleek car in a lay-by near Shannon. My driver wore a suit, a tie, a punk shirt and a full set of gleaming false teeth.

"Give us a kiss, luv," he said. I looked the other way and said I had to be getting along, my fiancé was waiting for me in, er … Ennis.

"C'mon, love, my wife's waiting for me in Limerick." We stayed at an impasse for ten minutes while I demurred, pleaded, excused myself, laughed helplessly, panicked, tried to imagine for myself the years of sexual repression and deprivation. Would I be stuck up the lay-by forever, I wondered aloud?

Because it is, you know, the most common and godawful dilemma of womankind. One that Women's Lib failed to really comment on: a man who has grown up to assume that a girl beside the road is there for his diversion alone cannot be blamed. Nor can he be blamed for placing all his confidence in his ability to make passes. He has been reared to think of it as his social obligation. To kick him there is to kick him inhumanly hard and though it would be quicker to say, "No, because I don't fancy you. You've got the face of a leering rhino, a nose like a giant strawberry and the size of your paunch would inhibit you from dancing the conga, let alone …" most girls are far too kind. Instead they trot out the same old lame excuses.

I waited for a little lady with a basket. Several articulated trucks rolled past but no little lady. Finally I roared with impatience, seized the door handle, jumped

out and marched off. I felt soured for the rest of the day; and no doubt he did too.

May he drive in peace and may he some day find the hiker of his dreams. And may the coal-lorry driver who runs through Celbridge and who also loves dancing find one also. And may the priest who ejected me once because I insisted *Ulysses* was the great classic of the century find one also.

And may the Provisional IRA man who drove for three hours around the Pontoon scenic route, denounced my lack of feminity for drinking stout, and finally put me on the road five miles behind where I started, find his nemesis.

And may the aperitif salesman intent on drinking half a bottle of Campari while driving onto the Lisburn roundabout also come to his Epiphany. And may the bread-van driver near Tuam who asked me if I went with strange men find his own stranger. Also the veterinary surgeon who wanted me to cook his supper for him near Gort.

And the grey-suited gentleman with the face familiar from the television news, who hid a revolver under my feet near the Newry border two years ago—then, threw me out without apology once we had gone past the army patrols, him too.*

May they come to empirically understand the misery of the wayside wanderer with a heavy load and no certainty of shelter, short on excuses and politeness. I know it looks very different from behind the wheel.

But may God bless the Bandon doctor, the Dungannon garage man, the Castlerock RUC man, and the numberless gentle lorry drivers and van drivers who have looked after me like fathers. Long may they drive in peace.

12 January 1972

*I think that man was Neil Blaney, TD. He certainly resembled his photos.

Nell McCafferty

in New York

Mugged, Raped, and Killed

The Statue of Liberty is a junk addict, and if she stepped down off her pedestal to go to work, she'd get a job at half-pay and be mugged, raped, and killed on her way home.

This I discovered after five minutes in North America, on my way from the airport to a waiting car.

Eleanor Roosevelt Jr, daughter of the former president, was of similar opinion. She had been attacked in Washington outside her apartment block by some coloured children. "They did not even want my pocket-book," she reported indignantly in a newspaper article. "They just called me whitey." Eleanor Jr proceeded to call for the return of the death penalty, armed security guards on every apartment complex, and chained dogs to combat the rising tide of violence.

I was warned not to step outside my hotel on Washington's Capitol Hill unless there was a policeman visible. I was warned not to step outside anyway if it was dark. I began to ask my advisors if they had personally experienced such attacks themselves. "Of course not!" I was told indignantly. "If you don't step outside your door, you don't get mugged, raped, or killed."

After three days, the atmosphere was getting to me. I knew that I personally had been singled out since my arrival in the United States to be mugged, raped, and killed. Life became a clever, terrifying, silent struggle between them and me.

I stayed in my hotel until the air-conditioning made me dizzy and then I drew the curtains, put out the lights, knelt on the floor and cautiously reached up to open the window just a little. There was a protective wire mesh on the outside and I was four storeys up, but why take chances? My sheltered life had only exposed me to British paratroopers after all.

In New York, I beat my advisors to it. The first thing I asked stepping off the plane was if anyone had indicated an intention to mug, rape, or kill me. I was alert, wary, on the ball. I had planned ten days of non-stop television to keep me occupied and informed. I was determined to survive.

Air-conditioning and commercials every two minutes drove me out to the streets. I clutched my handbag, travelled in taxis, spoke Irish, and walked behind policemen. Once I risked travelling on the subway and was arrested for smoking. I explained to the policeman beside whom I sat that my nerves were ahead of me. He asked me for identification and I asked him for his. He produced a gun and I put out my cigarette.

In Greenwich Village one night, very late, around nine o'clock, I got lost. I knew that my life on earth was nearly over. Everybody wore jeans and had long hair. I wished I'd bought a pair of iron knickers. A man approached me and I gave him a dollar straight away. He asked me if he could help, and I gave him a packet of cigarettes and asked him to please drop dead. He told me that Jesus loved me, and that the Lion's Head bar was only two blocks away, and he gave me back my dollar and cigarettes. He did not attempt to rape me. He was obviously a nut.

Then I went with my friend Michael to see a dirty movie in Times Square, which is really dangerous territory. It was two o'clock in the afternoon, and we were terrified. If our mothers could see us now! If the junkies spotted us now! We chose the most expensive theatre, nearly thirty-five shillings admission, and the movie was definitely dirty. I turned to Michael to remark on this fact and he clapped one hand over my mouth and one arm round my shoulder.

"Don't talk," he hissed. "The place is full of men. They will hear your feminine voice, and we will be mugged, raped, and killed." I turned to look round at the scattered audience. "Don't look round," Michael groaned. "They will see the whites of your eyes and descend upon us." We bent down to the floor and lit cigarettes over a low flame and concealed the glowing ends in our fists. Then we fell asleep with exhaustion and boredom. Outside the theatre we checked our wallets, but all our money was still there. Obviously no one in the movie had spotted us. We had escaped once more.

I began to relax a little bit. I used the subway more frequently. Once, on a platform under the ground, I found myself alone with a junkie. I knew he was on drugs because he was giving himself a fix. He sang a song by Melanie about city people and he was lost, and I put him on the right train. I was ready to take on Harlem.

We went down there, Michael and I, on the overhead railway one Saturday afternoon. The advertisements on the train had pictures of coloured people. There were slogans on the tube doors exhorting one to join the Young Lords, the Black Diamonds, the Sharp Spades, the Black Panthers. I figured I would perhaps eat hominy grits and molasses and soul food. I might even take in a riot or two.

We got off the train and went straight into a bar. Everybody was black and brown and dark. There were coloured lights above the counter flashing red and yellow and blue in time to the jukebox music. One man had a broad-brimmed felt hat and a fur-trimmed leather coat. "Definitely the Mafia," said Michael. "The Mafia are Italian," I said. "Italians get sun-tanned," said Michael.

We went out of the bar and moved down 125th Street, the main shopping centre of Harlem. Saturday afternoon and everyone shopping. We went into a takeaway food shop and ordered two pieces of chicken with French fries and coleslaw salad. Each item was placed in its own greaseproof container. The plastic cutlery was individually wrapped. The salt, pepper and salad dressing came in separate silver bags. Everything was placed in a large paper carrier. Fish and chips in newspaper have not taken America by storm.

Suddenly up ahead in a doorway were four tall men, wearing berets. "Cross the road," hissed Michael. "Why?" asked I. "There's four big black men," said Michael.

"Everybody's black," said I.

"Except us," said Michael. "We're white, we're small, we're on our own, and we're going to be mugged, raped and killed."

"Nonsense," said I and marched on. The men smiled and Michael relaxed. I looked down a side street and saw overflowing garbage cans outside tenement houses and people standing on the steps, or stoops, just like in the movies. "There's the ghetto," I said, "let's go in." The sun was shining.

We moved off the main road and entered the broad quiet street. Michael told me he had learned that one in every ten persons in Harlem was on dope. "You know what junkies are like," he said. "They need a fix, they don't ask, they kill you for a dime." We walked on. "You know what we're like here," said Michael,

"we're like two Catholics up the Shankill." My heart began to pound. "Or like a Protestant in the Bogside."

"The Bogside is not sectarian," said I. "I know that, you know that," said Michael, "but the wrong man could wander in at the wrong time and meet the wrong person. If a Shankill man came into the Bogside you'd naturally be suspicious." "Nobody here knows we're from the Shankill," said I, "this is a ridiculous conversation."

"Of course it's ridiculous," said Michael, "because we're not from the Shankill. There's a hundred thousand people here, they're all black and there's you and me and we're white." Suddenly it hit me. I was a white person in Harlem. I went over all the old slogans in my mind. These people are human beings. They're behaving perfectly normally on a Saturday afternoon. They are not out to kill every last white man. They're worried about jobs and houses like everyone else.

What did I mean, everyone else? Did they not think everyone else was white and had jobs and houses? Six black men loomed up ahead standing around a car. "That's it. We're done for," said Michael. "I'll fight them, you run on and escape."

"Where'll I run?" said I. "I haven't got a disguise." "Hide your face," said Michael. "But my legs stick out," said I. "They'll see my white legs."

"Oh dear God," said Michael. "Let's tell them we're from the Bogside and maybe they'll forgive us. We stopped and told the man we were from the Bogside. They smiled politely at us, like we had said we'd just come from the moon. "We're from Ireland," I said, choosing a slightly bigger location. They smiled politely again, and asked how were we doing, and turned to resume their conversation. "We just want to talk to people, we're strangers here," Michael burst out.

"Ah knows that, baby, ah can see that," said a black man with a wide grin. Then, like everybody else in America, one little old negro pointed out that we should be careful who we talked to and where we went. "There's some mean streets here," he said. "Ah knows that, ah can see that," said I, lapsing into the dialect. We hurried on.

Instantly the street was filled with negroes. Big mommas, young bucks, bitter ghetto dwellers. Funny how I hadn't noticed them before. They weren't average Americans now. They were black and baleful and out to mug, rape and murder me. At the traffic lights ahead there was a group of twenty negroes. I wanted to cross the road but they were on the other side too.

There was no escape! I saw a group of black boys standing around a bonfire on a vacant lot. Would they burn me alive? I was near hysteria, who cares about

slogans? Why hadn't I listed to my advisers? If I could get out alive, I would vote for George Wallace!

A taxi drew up at the lights and I jumped in. "Take me to the United Nations and step on the gas," I beseeched him. He started to laugh. I locked the doors and was about to lie on the floor when I remembered Michael. Too late. The taxi had gone round the corner and I wasn't about to go back and look for him.

Five minutes later I was arguing with my white taxi driver that negroes were a suppressed race with normal human aspirations. "The trouble with you," I told him as we coasted through lilywhite Manhattan, "is that you don't know what negroes are like. You never meet them, you never talk to them, you suspect the worst of them. They're herded into a ghetto and left alone there, and no-one ever goes in to see how they're doing."

"Lady," he said to me, "how come you jumped so quick into my taxi? How much do you know about the black man?"

Widgery never did go into the Bogside. Captain John Brooke entered the Falls on an army lorry during a curfew. No opposition member strolls up the Shankill. Jack Lynch doesn't cross the border. I didn't get farther than one block into Harlem. How much do we know? What are we afraid of? Was I a white woman in Harlem? Or did I act like one?

I never did get mugged, raped, and killed. Like everyone else, I didn't go forth much to find out.

22 March 1972

Geraldine Kennedy
in Africa

First Encounter with a Leper

Isolda, lost in the highlands of Ethiopia, is literally off the beaten track. The truck driver pulled in to the tiny mountain village for a "brief business meeting" around mid-afternoon. We had been standing precariously on sacks of empty bottles in the back of the Toyota for six hours of the sun's peak heat, clasping the rails overhead for life, surveying the giant anthills that rose into the blue sky. Our clothes on this fourth day were irrevocably filthy, and we were both suffering from comparative exhaustion and starvation. It was our first stop in Ethiopia.

We had crossed the border that morning through two towns, both called Moyale. Kenyan Moyale proved a major disaster, firstly in the superficiality of the Martini and Cognac bottles tastefully displayed on the shelves of the boarding-house, all empty, undusted souvenirs; and secondly, in the armed Israeli hitchhiker we encountered and swapped maps with, indicating another 600 miles ahead on the road to Addis Ababa.

Five minutes inside Ethiopia in Ethiopian Moyale, the armed military were obvious, whether enforcing the curfew restrictions that permitted entrants to cross only during the specified hours per day, or else "be severely penalized by shooting", or watching for smuggler traffic into the highlands.

Our first stop at Isolda was about thirty miles cross-country off the mud track alongside the Grand Ethiopian Highway, which is tarred in parts but for strict

military use only. It consisted of a tiny flat square on a mountain peak with a row of wooden huts, topped with a remnant of zinc which often didn't cover the roof, and with an opening for a door and no windows, laid out on each side. There was one shop with a battered Coca-Cola sign in Amharic—Ethiopia's first, Hebrew-like language—hanging from the roof. There were very few people around. The most striking features of Isolda were its stench of decay and its thousands of flies.

We hopped from the truck onto the hard red earthy ground and entered the shop for a coke. There was none. Eventually the assistant laboriously brought one bottle of undiluted orange from the floor. There was no drinking water, or any water for that matter since the rains were long overdue, but we unscrewed the rusted cap and drank.

Outside again the villagers, maybe fifty or sixty, had gathered in the square at the sound of the engine. They were a nervous, emaciated-looking bunch, devoid of any expression or feeling. The elders, and there were very few over thirty years of age, were dressed in shabby rags which smelled. The children were immediately identifiable as the big-eyed, swollen-bellied black babies for whom the nuns collected money in my schooldays.

(∗∗∗)

Then we saw him. He was edging his way towards us on his bottom, tatty trousers covering him to his knees and a sack completely covering his head and upper body. As he came nearer, his quiet groaning could be heard from inside the sack: sad, painful, subdued groans rising from his feet. But then, he had no feet at all as they had been eaten away by leprosy, and when he stuck out a hand from the sack to beg he had nothing but stubs.

His groans became more persistent now and he tugged at that heavy stinking bag to remove it, showing us a huge open wound down his chest, which was fly-infested right up to his neck. I bent down to put some coins on the ground some feet away, not wanting to touch the poor dying man for fear of contamination, and met his eyes. There were no eyes as such, only the empty sockets that should contain them which were open, uncovered and festering. The poor man could not see the coins at his feet. I nearly died for that man who was dying so slowly. Hopefully he's dead now, but if only my shame could die with him…

<center>(✳✳✳)</center>

There were many others in Isolda whose hidden hands behind their back were not hands at all but rotting flesh, whose eyes were also gone with the ravaging eye diseases that abound and whose chests and bodies were afflicted by external tuberculosis. One wished the kids one saw had been among the 50 per cent who'd die before reaching three years of age.

We drove out of that village after half an hour, wondering what brief business meeting could possibly take place there, only to realize some 200 miles later that the police were questioning us as leopard-skin smugglers.

20 December 1974

Elgy Gillespie

Midnight Cowgirl: New York on a J-1 Visa

Alright—I was biased. I'd never meant to go to New York. So much had been said about it, written about it, sung about it; nowhere intrigued me less. No, I was obsessed with Mexico, and my plan was to put a deposit on a £50 round-trip student flight and work for my ticket and the fare south.

But unlike the Lobster Langoustino Bisque in the subway ads, this is not easier done than said. Settling down to the obligatory two-day "orientation course" for students in a midtown hotel, I could just make out the new Madison Square Garden building. It seemed the only thing that wasn't falling apart. The hotel was. When I pulled the pink plastic curtains, they fell off. The window hadn't opened in decades. The air-conditioning was bust. Yet the twenty-four-hour multi-channel TV was in excellent condition; there was a Bible in every room, and this was no Avenue D flophouse. Billy Graham lived on the 22nd floor with the laundry. Like Manhattan itself, the hotel must have been magnificent in the thirties.

The sky, when visible, was yellow, about half the public phones worked, it seemed you couldn't park without being fined, and the public libraries were closing down. Inside the Graeco-Roman GPO on 34th Street was a "Wanted" poster for Eldridge Cleaver. Outside was engraved: "Neither rain nor snow nor heat nor gloom of night shall stay these couriers from the swift completion of their appointed rounds." But Americans expect letters to take days, and sometimes never to arrive at all. There seemed to be more beggars, radiant homosexuals,

and publicly deranged here than anywhere else in the world—except perhaps for Port Said. "Give me your poor, your huddled masses, the wretched refuse of your teeming shores!" Sodom and Gomorrah themselves couldn't be less concerned about public welfare, despite Mayor Lindsay's inventiveness.

But running along Brooklyn Bridge towards Wall Street at dusk, seeing old Humphrey Bogarts at the Bleecker Street cinema in the Village, where the doorman was always too stoned to charge you admission, eating lox and cream cheese at Ratner's, where the waiters prided themselves more on rudeness than Jewishness, or noodles at Hong Fat's in Chinatown, where the phone kiosks are little pagodas; and especially the Orange Julius stall on Eighth Street: then even I couldn't deny New York a highly distinctive lunacy, a deadly fascination.

In the school I visited, a junior high on the Upper East Side that had been rigorously integrated, all the white children except the poorest had left. Many were still illiterate at the age of fourteen (on the teachers' admission) while Puerto Ricans could still speak only Spanish. The children bopped into class to Blood, Sweat and Tears on a transistor, dressed with gorgeous flamboyance. They ignored the teacher—my friend Sheila—and were ignored by her in return. Suddenly, "There's a fight!" cried a voice, and the class rushed to the windows. "I've lost all control here since the National Federation of Teachers' strike against community control," said Sheila. "John here goes off for a fix in Central Park every lunchtime, don't you?"

"Ah, but teacher," said John, a handsome fifteen-year-old, "deep down in your heart you love me."

"Deep down in my heart I hate your stinking guts! Now get back to your seat!" Nobody heard. She turned to me: "Their parents encourage them to despise us because we're white. And most of the black teachers are NFT-supporting Uncle Toms, scared of losing their jobs."

(***)

On the first Monday I rose at seven, chose the first of several hundred agencies that caught my eye in the *New York Times* classifieds, and took the uptown subway, making the usual detours in the wrong direction. Outside it was in the nineties. Down below it was tropical, and I understood the insistence on deodorant in the USA.

Opposite me was an ad: "I was so happy I cried," said Mrs Bea Schnafler, crying

her eyes out because she had just won $50,000 on the state lottery. Not me; I was busted. I emerged onto 42nd and Madison, the advertising heartland. There was a preliminary four-hour wait in the plush but American-informal bureau. Finally, when I was ready to fling my disintegrating *What Maisie Knew* at the muzak-gushing speakers, I was called.

"Your visa, Miss Gillespie?" Aha. The dénouement. "J-1," said my passport. "Temporary working visa."

"It's going to be difficult," said Just-call-me-Keith Herzog. "Most of our positions are permanent. Come back after lunch, huh?"

His colleague intervened. "Listen, Miss Gillespie," he said. "You will have to learn a few facts of life—and frankly they won't be pleasant. You are obviously not attempting to adapt to the American way of life. You must meet us halfway. Firstly wear stockings, or you'll be unemployable. I don't care how hot it is. Secondly, shave your legs..."

"But they're not hairy. Anyway, they're blonde hairs."

"I don't care if they're green hairs. It's a question of first impressions. Then you *must* get longer skirts: Macy's, Gimbel's…"

"But I..."

"Then borrow one! Why let a thing like that stop you? And get your hair done. Listen: you can make it, I know you can; but you must look like the chic sort of secretary every executive would like his customers to see."

I giggled, hysterically.

"Maybe it doesn't matter where you come from if a girl has hairy legs, and her hair's all anyhow, but it does here."

"Excuse me." I rushed to the ladies and vigorously splashed my face with cold water. He followed me inside with two pieces of Kleenex.

"Listen ... if you're really desperate, I have a friend who does photographs for, uh, underwear modelling."

"Never, thank you!" I replied. And it took me two weeks of waiting in that office, occasionally translating "Invest stock at five percent" in Import and Export offices to learn that I was unemployable as a secretary in New York. So then I combed First and Second Avenues from the Forties to the Sixties for barmaiding jobs.

Back among the decomposing brown façades of the Lower East Side I would buy 40-cent sugar-stick double ices from Gems Spa, the ever-open sweet shop, and feel happy. I loved the long dark skinny railroad flats. I loved watching the

Puerto Rican kids bombing down cars with a skilful jet of water from the fire hydrants. I loved my new home on St Marks Place over the Electric Circus, where I had met a filmmaker, Jon Davidson, who worked with the Joshua Light Show at the Fillmore and was Scorsese's student at NYU, and a Russian anarchist, Josef. I moved in with Jon and Josef.

At night, we would watch St Marks from the fire-escape, knowing it wasn't the axle of the world, but thinking it came nearer to it than Wall Street or Times Square. To the left, across the slums where rent-controlled flats were as little as $45 a month and no one was safe after dark, you could just make out Brooklyn. To the right, across the expensive Rabelaisian charms of the West Village where a studio could cost you $200 per month, you could almost see New Jersey. Such a tight little over-loaded strangled strip of an island, Manhattan. No one, not even the rich, has enough space. No wonder, I thought, that everyone tears the flesh from each other's bones. No wonder this flat had two locks on the inside, two locks on the out, and we leave the radio and all the lights on when we go out. Every evening Jon showed *Porky Pig, His Girl Friday, The Perils of Pauline* or *Flash Gordon* on the sitting-room curtains. Inevitably, other orphans started moving in too.

I applied for a job in the Sugar Shack, East Ninth Street. Although the proprietor never got around to employing me, he became a proxy father. Nick Giglio, a Sicilian of venerable age, had painted the walls himself with Tuscan landscapes, strolling lovers and a perfect facsimile of La Gioconda. "What you want?" he would say when we came in, "Coffee? Egg cream? Cigarettes?" He would cram Sicilian licorice biscuits into my hand, waving aside my purse. Then he would show me hand-tinted daguerreotypes of himself, as a fifteen-year-old in World War One.

The café was a pick-up place for old queens. A black boy called Stevie would come in wearing drag. "Only fourteen, that boy!" Nick would tut-tut. Stevie told me that in every new school he was sent to, the kids beat him up on the first day; also that he was often hauled in by the police, who would let him off if he obliged.

"How ghastly! How do you escape?" I asked.

"*Shee-it*. I don't. What can you do, man?"

Another friend there, Tony, showed me a picture of his girl who was in prison for stabbing two negroes who'd tried to rape her. Recounting the incident with gusto, he flicked out a jack-knife, then remembered himself and put it back. He

also gave me many numbers of underwear-modelling agencies, and an agency that specialized in ugly faces.

"That's no good," broke in Stevie. "She ain't pretty but she ain't ugly neither." Losing out again, *shee-it…*

Finally I found a job in Romero's Bar, First Avenue and 59th.

"Right now," said Romero. "Go right out there and show them, little Miss Pretty Legs. Ask him if he wants a nice fresh drink. 'Would you like a nice fresh, drink, sir?' That's always a good one. Go on and ask him. And flash those ankles, huh!"

Gripping a plate of pumpernickel toast grimly in my right hand, and a pot of marmalade in my left, I went right out to the sidewalk tables and showed the only customer my long and freshly shaved legs.

"Er. Fresh drink?" I asked sweetly. He was reading Asimov and flushed me away with a look.

"No," I reported back. Romero frowned at the three decrepit divorcees inside, flirting hopelessly with the barman over their Tom Collinses. He smiled viciously.

"Listen, honey. You got no idea. It's the *poisonality*. You wanna do business, you gotta work it, know what I mean? *Surround them with loving concern.* They're like sick children: give them love and attention and they'll want club sandwiches all over the joint."

He bulldozed over to the lonely toast man, exposed both dentures, greased lavishly, and returned in triumph.

"See what I mean—one black coffee. It all adds up. Now stay out on that sidewalk and lure them in. And make your hair look less, er, fluffy." I hid around the corner and went back to the classifieds in the *Village Voice*.

After that I was due for the 11 p.m. to 6 a.m. in a pseudo-Victorian ice-cream parlour.

"Right then, er, get changed, dear," a shattered sub-manager whispered through his moustache.

"Where?" But already he was mediating in another quarrel between the boss and one of ten waitresses. In the fly-ridden basement I struggled into my $18 costume: saucy apronette, plastic fishnet tights, leotard and easy-wipe Gladstone collar, cuffs and bow tie, plus clip-on bunny tail. I scraped my hair into a rubber band and decided I looked revolting. Afterwards I discovered the boss got a substantial cut on the uniform.

"You!" cried the boss. "Tables 4, 10, 16 and 22."

"Which?" I asked a waitress, but she was hassling it out with a soda-fountain boy.

"What do I do?" I asked the dishwasher. "Honey," he smouldered across the plates, "you don't learn. You just *do* it, honey."

"What's it all about?" I asked a sympathetic-looking queer cook, who was reading *Narziss und Goldmund* against the lift-shaft. He peered over it and reluctantly registered me.

"In case you didn't know it, honey, you're *large*. You're *big*, honey; and you'll have to move."

Stung, I wondered whether to shout, "You dirty faggot!" but he was back in his Hesse.

Outside, two customers wanted two Gibson Girls, one with butter pecan, rum and raisin and hot fudge, and the other with peppermint stick, peach ripple and butterscotch, topped with whipped cream, sprinklers and roasted almonds.

"What's this?" snarled the counter-hand, screwing up my bill. "Add it up so's I know you're not cheating."

I went out with two Gibson Girls melting all over my arms, and an unreadable bill drowning in the hot fudge; then two more arrived.

"Jesus Christ!" shrieked the other waitress and burst into tears. "I'm sorry … it's just that … this is my sixth consecutive night and—"

The boss arrived. "And you're another who's been here too long!" he cried, and sacked her. I took the extras back and ate them behind the fridge. They were great, I admit. None of the waitresses lasted, which was lucrative for the boss since you weren't paid for the first two nights. The boss's father stole our tips. I hadn't even paid off my costume when, laid off for having the wrong kind of leotard, I gave up.

Sonia, my sister, had $70. I had none and there were now six people in the flat. We were all depressed into a state of suspended animation. I wished I could die till it was time for our return flight. Finally we persuaded the landlord, an ex-SS Pole, to sublet us the next-door flat.

The caretaker ("Supe", as he was known to the house) lived six floors below. He wore a filthy Wesleyan College T-shirt and smelt of stale whiskey. Putting his teeth in, he informed us we could not have the sublet, but that as a special favour we could have another one that some hippies had just been evicted from. The gas, electricity and water had been turned off to encourage them, so everything was filthy. "Private arrangement," said the Supe. "Just you and me. If you don't like it go back to the floor upstairs."

Sonia and I shoplifted two scrubbing brushes and a cockroach spray, and cleaned it for two days. We picked two bedsprings off the pavement and one

mattress that smelt of pee. There didn't seem much point in emptying the rubbish when everybody else threw it out of the window, but we did.

I slept on naked springs and woke at six with an aluminum coil in my ribs. Wearily I would crawl to the kitchen to find our food crawling with cockroaches. Maddened, I would reach for the spray and blast anything that moved. When I had a cramp in the trigger finger, I would fall back, shattered, onto my springs. The landlord came round one ninety-degree morning, while Sonia's mattress steamed and propositioned her. "I give weekend parties on Long Island," he said. "Call my office after hours and I'll take you out."

By now our money was zero. Selflessly, Russian Josef and filmmaker Jon ladled out yoghurt and black coffee for us. Sonia had just been held up at knifepoint on her way back from the jazz club, Slugs, by two men who'd said they would "cut her heart right out of her body!" if she didn't give them her last $2.50. She did. I had just been sacked from another place. "Sorry, dear," said the manager. "But I can see you're not going to make it. I feel bad about your uniform. Here—take these for expenses."

"These" were three dollars. I decided we were going to get out of the stinking city even if I had to hijack the South Ferry bus.

"Oh, Elgy, you're not going to … " said Sonia.

"Yes," I said, "underwear modelling!"

The office was just off Broadway; the secretaries wore false eyelashes and lame hot pants. I walked the gauntlet in home tie-dyed vest and Sonia's grey flannel C&A skirt. In the inner office was a fat fifty-year-old with sideburns and flowery tie.

"What sign of the zodiac are you?" he growled.

"Er … cuspal Leo and Virgo."

"How about that! So'm I. That makes you dynamic, artistic, sensitive, extravagant, influential, peace-loving, generous and proud like me. I'm very proud. Know who I am? I put Allen Klein on the road. And Petula Clark. Good thing you aren't Pisces, baby, 'cos I just hate Pisces. Yeah. Whaddya want?"

"We've had bad luck." I gritted my teeth. "I'll do anything."

"Mm. That right?" he unwrapped some gum. An exquisitely dressed girl came in. Even her hairpiece was colour-coordinated.

"Hey, Carol," he said. "This girl says she'll do anything."

"Stand up," said Carol. I did.

"With boobs like that," said the man, "you ain't going nowhere."

"All you can do is pose for porno magazines," said Carol. "We just do *haute couture;* and don't mind me saying so, but your eye makeup is awful, just awful." (Pronounced "offal".)

"Baby, you're not as desperate as you were. Go marry a farmer." We parted on strangely amicable terms, and he asked me to ring him again. But I knew that if I had to join the panhandlers on St Marks Place, I would leave the city the next day.

A month later we flew back from Los Angeles, still on borrowed money. It was my twenty-first birthday, and Dvorjak boomed through my earphones. "The Staten Island ferry!" I thought with rapture. "Sam Goody's on Broadway! The Apollo Theater! Open-air concerts in Central Park!"

The ease and suburban comfort of the West Coast, where you could get away with poverty and a ten-word vocabulary, and where San Francisco was unspoiled, had obliterated the bitterness and left slapstick comedy. Back on St Marks we found Josef the anarchist. "Josef!" I cried. "Did you get our bags and rent money?"

"What bags? What rent?" said Josef. I stormed into the flat where the Supe was lying senseless, still in his Wesleyan T-shirt among mountains of confiscated clothes, books, radios and TVs.

"Put your teeth in!" I roared. He did.

"Go away. How should I know where your books are?" Finally he said that "that Jewish girl" had taken them. What Jewish girl? Perhaps he had been in the SS with the landlord.

Later that afternoon, in desperation, I went for an audition as a topless go-go dancer at Grinza's in Midtown. It entailed sticking two mauve pasties onto my boobs with a tube of glue and dancing in a cage to "River Deep, Mountain High". I passed. It was going to be $200 a night, but in the end I could not handle the shame. Debt was preferable.

We returned to Jon's floor, having decided that New York was not the place for innocents like ourselves. The odd thing is that I can't wait to go back and be spat upon, shat upon, and kicked in the teeth all over again. No, really.

Sunday Times Colour Supplement, 21 September 1970

Profiles

Caroline Walsh

Seamus Heaney: "A situation both gross and delicate..."

When Seamus Heaney won the Duff Cooper Memorial Award, Caroline Walsh interviewed him for the Irish Times. *Walsh was twenty-three, Heaney thirty-six. He had already won more prizes than any other Irish writer, and the conditions of the prize held a clause that allowed the recipient to choose who would present it to him. The list of possible names suggested was composed mostly of the British Royal Family, of whom Seamus Heaney was wary.*

The administrators were equally wary of his own initial suggestions, for a variety of political reasons. He now hopes to have P.V. Glob, author of The Bog People. *Heaney discovered this book, which he was to use in his work, in 1969—the year his collection of poems* Door into the Dark *was published, and perhaps more relevantly the year the recent spate of killing began in Northern Ireland.*

" My poem "Bogland" in *Door into the Dark* was an attempt to link, in a symbolic Jungian way, the bog—which is in a sense the repository and memory of the landscape—with the psyche of the people. There were photographs in *The Bog People* of victims who'd been ritually murdered, and according to Glob were sacrificed to a goddess of the territory.

"I saw in these pictures the archetypal symbols of territorial religion and in some ways I think Irish Republicanism is a territorial religion. There's a woman that

presides over the whole ground and she's even enshrined in the Constitution. There's a sacral territory for what used to be called the poor old woman, Cathleen Ni Houlihan, the Aisling figure. This is just a metaphorical, mythological way of looking at it, but it's a better way for poetry than the constitutional squabbles."

<p style="text-align:center">(✱✱✱)</p>

Seamus Heaney was born in the Mossbawn townland of County Derry. "The farm lay between Toome Bridge and Castledawson. I had Roddy McCorley at Toome Bridge and I had the Chichester-Clarks at Castledawson and since then I've thought of this as a symbolic placing for a Northern Catholic to be, in between the marks of nationalist local sentiment on the one hand, and the marks of colonial and British presence on the other."

He was not distinguished for his verbal gifts at Anahorish Primary School but unconsciously he was taking in the atmosphere of life around him. He was experiencing what he described as "The Early Purges" in a poem of that name; Dan Taggart drowning kittens in a bucket, Dan trapping rats, snaring rabbits, shooting crows "or, with a sickening tug, pulled old hens' necks". He remembers listening to bits of local lore, the remnants of the oral tradition when his father's cousin came to the house. This rather fantastic figure in the poet's childhood landscape might be described as one of the surviving hedgerow school-masters whose wont it was, when he had had a few drinks, to recite a long poem in which Henry Joy McCracken figured. Heaney was taking in "the subculture of Nationalism/ Catholicism, which I supposed everybody in the minority imbibed".

When a teacher at St Columb's College, Derry, where Heaney was a boarder for six years, heard of his pupil's literary endeavours, he commented, "I'm not surprised, that boy had a mind like a machine." Here he met Seamus Deane, who was also with him at Queen's University Belfast. He published the odd poem in student magazines, "but I didn't take myself seriously, I was afraid to". Oddly enough, it was when he began to teach at St Thomas's Secondary School in Ballymurphy, where Michael McLaverty the writer was headmaster, that he began to discover contemporary poetry, which led ultimately to the decision to write, expressed in "Digging":

> *Between my finger and my thumb*
> *The squat pen rests.*
> *I'll dig with it.*

He identified with the unsentimental treatment of rural life in poems like Robert Frost's "Out Out," and Ted Hughes's collection *Lupercal* and Kavanagh's *Soul for Sale*.

"Kavanagh's great achievement was to make our subculture—the rural outback—a cultural resource for us all; to give us images of ourselves. That's what a poet does, he gives us images of ourselves and the more the image can draw into it of contemporary psyche and political and public reality, the better.

"These poets gave me a trust in my kind of background. I had thought that modern poetry was a sort of inverted commas concept; it meant Eliot and Auden, and though it had a sensibility that I could understand and appreciate, it didn't enter me with the same intimate shock of recognition that these other poets did. I began to feel that my own equipment, both in experience and in language, mightn't be so inadequate and so I began to write, in November, 1962."

He was invited to join a literary group run by the Queen's University lecturer Philip Hobsbaum. It was "a tight exclusive ship" conducted like a seminar, where poems were read and criticized. Michael Longley, Derek Mahon and Stewart Parker occasionally frequented the group.

"There'd been a literary texture of the forties in Belfast, with McLaverty publishing *Call My Brother Back* and John Hewitt and Roy McFadden writing and John Boyd editing a literary magazine *Lagan;* but the bottom fell out of it in the fifties.

"Then in the sixties there was this mysterious quickening of the cultural pulse. It happened at the same time as the group and as O'Neillism. It was a sense of well-being that expressed itself at a civic level by putting on two weeks of cultural events in the Belfast Festival."

(✱✱✱)

"But essentially I identify with a whole Irish tradition. This is my heritage. I can't deny my Derryness, my Belfastness, my Northerness, just as a Corkman would think himself part of the whole Irish experience—so I think of myself as an Irish writer. I went through the Daniel Corkery *Hidden Ireland* revelations in my teens, grew up with Wolfe Tone, Hibernian banners and all that.

"Of course, it's undeniable that because of the political history in the north, one's sensibility is different." He talks about the British papers on sale in the North and listening "as much to the BBC as you do to RTÉ, and of course if

you're a Unionist listening only to the BBC. The timbre of the culture is British; Ulster is British, so that the Catholic minority has always conceived of itself as a resistance movement, you affiliated to Ireland as opposed to the notion of Britain."

After the year in St Thomas's he taught for a while in St Joseph's, the teachers' training college he had qualified in after Queen's. Then he taught in Queen's itself for six years. During the early seventies he was guest lecturer at Berkeley in the United States. "I got there through the back alley of poetry rather than through the front door with a doctorate. California was an exotic place after Belfast.

"Its openness and freedom was enhancing. It had sunlight and money, which was a change. But I discovered there that, in this highly technological society, the whole movement was back to a kind of reality that I had known in my childhood. There was a terrific nostalgia and a compulsion to reverence the primitive kind of life. I mean, every undergraduate in Berkeley in some ways wanted to be a Red Indian.

"America gave me confidence in my work being able to transcend the borders or barriers of Ireland. I got the feeling that life didn't always have to be lived as part of a natural conveyer belt, from school to university, from university to training college back to school, back to training college and back to university. Berkeley loosened the soil round the Ulster tap root."

Even though he had had collections published he wasn't sure until then if he was a poet. "I didn't know what being a poet was, though I now know that it is a dedication to this art and a determination to make the meaning for your life through the art and then to make the art in some ways the meaning of your life. But until 1972, I was writing poems on the edges of my life and when *Wintering Out* was about to appear, I felt a sense of crisis and the need to clarify for myself whether I was a teacher or a poet." He came to live in Wicklow, and has spent the last three years there working freelance and writing the poems for his later collection, *North*.

About Belfast he says: "I had something approaching guilt in walking out of a situation which was dangerous and violent, but it was a natural decision. I think a poet cannot influence events in the North, because it is the men of action that are influencing everybody and everything, but I do believe that poetry is its own special action and that having its own mode of consciousness, its own mode of reality, it has its own efficacy gradually. I think the business

of the poet is to write poetry with as much efficacy as possible; to make his poetry potent. There was a great uncertainty for poets from the North as to whether they would address themselves directly, in a prejudiced, committed, politically naked way to things or not. I, in a sense, have done both in *North*, where I appeased myself."

He talks of Osip Mandelstam, a non-political Russian poet who was persecuted by Stalin for a few untypical couplets he wrote. "His poetry didn't deal in any obvious way with political messages, it brought the sense of terror, oppression, suffering into images, into music, and he died in a prison camp in the late thirties without having published anything for years. But when his wife preserved and published some copies of his work she could have published hundreds, even thousands because of the exemplary purity of his life, the purity of his devotion to his art. He had a moral purity, never mind a political reality, and this is why he has attained a kind of inspirational status."

(✱✱✱)

North is basically about the dilemma over the value of the artistic enterprise in the face of the historical reality. More specifically, when talking about certain strains of unhappiness in the last poem "Exposure", he says: "Although the poem canvasses the notion of uncertainty about the artistic enterprise, I would hope that the overall drift in the book and in my life is toward a belief in it."

Does he ever get tired of writing? "Yes, I feel impatient, but I always know it's the only thing I really want to do. What one dreads is that it will leave you rather than you leaving it, which would be a kind of infidelity. You are married to it."

He quotes from *Timon of Athens*: "Our poesy is as a gun which oozes from when 'tis nourished, the fire i' the flint / Shows not till it be struck; our gentle flame / Provokes itself, and like the current, flies / Each bound it chafes."

But, he adds: "As you get older, the ooze and nurture can't be relied on for everything, the intellect and self-knowledge have to begin to enter the business, especially if you believe that poetry is the means by which you will walk the tightrope to extinction. Every poem begins with a lifeline to the subconscious, but there has to be technique to untrap the doors of that resourceful, energetic life. A poem can be an expression of private feeling, but it has to have something to grip on."

He and his wife Marie and children Michael, Christopher and Catherine Ann (partly named for Katherine Anne Porter), have been happy in Wicklow: "I am very pleased with the uncertainty of the last three years and that I was standing on my own two feet as a writer." Now that the ritual of proving to himself that he is a poet is over, he is delighted to be embracing teaching again at Carysfort Training College and he plans to settle in Dublin. And what of the long-term future? His poem "Gravities" describes people always gravitating back to some central point, but for himself, he says, "I always go by the sixth sense, by intuition, and I have to trust in the arrival of a direction."

6 December 1975

Elgy Gillespie

Robert Lowell in Kilkenny

Melodrama lent Robert Lowell's last reading in this island the status of the heroic feat. He came to Belfast in November. His briefcase was searched and books seized. It was that pitiless week when the number of assassinations shot up to eleven; when taxi drivers looked you up and down before opening the door, and you looked back at the taxi driver before shutting it.

Generous with his time—he took tutorials in Queen's University, comparing Thomas with Frost, letting the implication that Thomas won in some way ride a little—he looked pleased with the reverence he was accorded. I admired the way he took the reading, stopping to amplify, as in a tutorial.

He read in Belfast those pieces of his work that reverberate with the New England inheritance that gave Lowell his blue-veined, versifying antecedents, including the Imagist Amy Lowell—who may, he later said, have talked only to Cabots and certainly didn't talk to any other Lowells.

This summer Lowell came south to Kilkenny. I was in Kyteler's Inn when the Poets came in. They wore capital P's on their heads, so to speak, because they were all lodging together in the house of Barrie Cooke and Sonja Landweer, artists who esteem and know poets and poetry. The Nunnery, another poet called it, while we speculated on them all at breakfast together—Heaney, Mahon, McCaig, and Murphy, with Lowell as Master.

The present writer saw the rounded form and white tousled hair of Robert

Lowell talking earnestly to the spare frame of Richard Murphy. Seamus Heaney, whose two most outward qualities are tact and a desire to please, offered to introduce her to Lowell. But she was very happy talking to Heaney and friends, and thought that Lowell might very well tell her to jump in the River Nore. Heaney smiled and said he understood. Then she reflected that she might never again get an opportunity, and that her great-grandchildren might thump her, crying, "What did he say, Gran, what did he say?"

So she touched Seamus Heaney, who again said he understood. He took her across, and she leaned across the long hair of Murphy and mumbled something incoherent. She was just phrasing an unintelligible question when another poet threw her off the chair and onto the floor with a sidelong tackle. Not wishing to disgrace herself or anyone else, she countered by tickling rather than punching him. They rolled into a struggling mass at the feet of the most celebrated poet on both sides of the Atlantic.

Recovering enough, she asked Lowell for an interview. He said vaguely that he would think about it. She said she would ask again.

(✱✱✱)

Next night, she found herself sitting beside him at dinner. Fifteen other poets, writers and celebrities, were circling the long table, peering at the cards which bore their typed names amid a complement of heavy Kilkenny silverware. Lowell wore a tired corduroy jacket with sleeves that were too short, and talked to Máire Mhac an tSaoi. He had known her and her husband in New York a long time before.

"How old is Conor now? Fifty-eight too? He's worn better than I have," said the world's most famous poet. A dilemma; but we said he hadn't. Seafood cocktails and fine white wines arrived. The poet and I fell on both with enthusiasm and I asked about his wife.

"Huh?"

"Your wife, Caroline Blackwood."

"When people ask me about my wife I always ask which one." Last year Blackwood published a book called *For All That I Found There*, which contains scarifying episodes from her childhood in the countryside near Belfast. He reached for his squashed packet of Consulates, and talked about her work with pride.

"And one of the people who reviewed her book said, 'The trouble is that Miss Blackwood doesn't really like people!' "

The din increased and then the songs began: "The Croppy Boy" and "The Last Rose of Summer" arrived with the coffee, brandy and cigars. One of the poets wanted the Minister for Posts and Telegraphs to sing, but his wife didn't.

"Richard ..." said Lowell, reaching across to talk to Richard Murphy on my right. "I've just read your poem about the shipwreck."

"You mean, 'Pat Cloherty's Version of *The Maisie*?'"

"Yes," said Lowell. The din swelled. "I've just noticed. It's in *terza rima*."

Murphy smiled. "It is."

The din swelled again. "I liked it!" yelled Lowell.

But it was Derek Mahon's night, and his poetry reading was in the mock-Tudor room of Kyteler's with its black Kilkenny cats on the carpeting. White-faced, hungover Mahon sat on a window ledge and accepted the succour of Heaney's arm and a drink. "Dainty and playful" is how Heaney described Mahon's work, and so it was.

(✱✱✱)

Next morning, a friend and I drove sweating to Thomastown. The Cookes' living-room is a cool and clean arena containing a massive and colourful carved toucan that the artist brought back with him from his recent visit to Borneo; every other object in the room is rare and exquisite besides. Looking for an ashtray, I'm handed one of Sonja's pots—biscuitware of such frail beauty and subtle glazing that I'm afraid to hold it. Shoving the chairs together, Lowell and I peruse Balthus nymphets in one of Barrie's books. Lowell understands and likes painters. Cooke talks to him about the process of interpretation as if there were no barrier of medium.

Lowell has now been to Ireland six times and feels this last visit is very, very different from Belfast. He left America in 1970 in order to accept a Fellowship at All Souls in Oxford for a term "and play footloose in England. It seemed very odd, like being sent back to boarding-school.

"I didn't like boarding-school and this had none of the pain and none of the reality. I didn't use the library, I wasn't writing a book, but it wasn't the way I wanted to live. Then I taught at Essex and lived in London. What I was really doing was getting married, I suppose."

Now he teaches at Kent and lives in a house with fifteen rooms, surrounded by one of the surprisingly ample green belts that London has managed to hold

on to. The couple have five children between them, three of hers (he has another daughter, in America) and their own son, Robert Sheridan, is four, named for Caroline's playwright forebear … "And usually Sheri-*dan!*" Caroline has a new book of three short stories about here and New York coming out soon, superficially less black (Lowell says) than *For All That I Found There*.

She is a Blackwood of Clandeboye, a lineage as blue-veined and versifying as Lowell's own (his includes Longfellow as well as James Russell Lowell and Amy Lowell) and she will in the fullness of time write about this part of her life. It will be much the same area as that covered by Harold Nicolson in "Helen's Tower"—though not in any sense similar, Lowell suspects, as Nicolson's book strikes him as being "a funeral oration". Lowell's previous wives were writers, too—Jean Stafford and Elizabeth Hardwick.

Kilkenny poetry readings were a real Fest, he felt, very lively. "You wouldn't find it anywhere else, really, because if you went to London everyone would scatter afterwards to other rooms. You might in Scotland but then it wouldn't be made up of Irishmen."

Two poems he was reading here were entirely new, one not really finished.

(✱✱✱)

"How long were the poems gestating? Well, it's so hard to say what gestation really is, isn't it? If I wrote about this room in three to four days' time it wouldn't really be about this room at all. Say I always wanted to write about Caesar and finally I do—that might be something else again because you're always searching for past intensities and they may not be something … something contemplated." He reckons on around three years gestation for a book of poetry. Of his favourite contemporary, Philip Larkin, and Larkin's penchant for a ten-year drop, he says "Philip had twenty-two years for *High Windows* and wanted to keep it going for another thirty years. But I thought twenty-two were enough."

After the boarding-school in Ohio that he hated so much, Lowell went to Harvard and became friendly with Arthur Crowe Ransom and Allen Tate. His early book, *Lord Weary's Castle*, appeared in 1946.

That "full of old Protestant hymns" stage of his early development contains nearly as much rhyme and metre as "For Those in Peril on the Sea". Well, not quite; but they do appear formal. Yet at the same time, these poems of formalized shapes carry a content savage in imagery. "The right kind of poetry for a young

man to have written," he said. He quarrels with the description of "formal".

"Metre is an art unto itself and in itself is something imposed. You could have, say, quatrains repeated ten times—but then they might be nothing to do with the subject. The medium must come together; the plot flow with the form."

Later I asked what he felt of his "confessional" verse, of which Ian Hamilton wrote "simple, shoddy, in one or other of the ways in which Lowell can now be so". He did, he admitted, mind. But then when *History* and *For Lizzie and Harriet* and *The Dolphin* emerged, Lowell rearranged the order in the new book and Hamilton recanted somewhat.

And what of this term "confessional" anyway? "I don't think the term "confessional" could ever be entirely accurate, do you? I agree that it might be better to write the *Iliad* than Rousseau's *Confessions* even if you do say anything you like about marriage and meals, you change the facts here and there, you just can't tell it in a sloppy way. I don't think anybody wants a case history. You tell it obliquely."

Asking him, then, about those poems written from a woman's viewpoint—indelible lines from female experience like these from the desperate "To Speak of the Woe That Is in Marriage":

> My only thought is how to keep alive
> What makes him tick? Each night now I tie
> Ten dollars and his car key to my thigh.
> Gored by the climacteric of his want
> He stalls above me like an elephant.

Lowell says simply, "I suppose I must have seen that somewhere." There are several written from a woman's viewpoint, indeed an unhappy woman's viewpoint. On this, he answers as obliquely as in his poetry. "I once asked Ford Madox Ford what he thought genius was and he said, 'Memory, of course.' And I thought, well, that would be an odd way of writing Shakespeare's sonnets—would he say that if he were a poet? But to a novelist I can see that memory would be of enormous advantage. Intensity is hoarded up in dialogue."

(✳✳✳)

Sprawling on the grass we watch a record number of tortoiseshell butterflies at work in the hedgerows, as well as a fancied Red Admiral and a number of cabbage

whites. Lowell talks of past interviews: "So, next thing, I open this glossy and he'd written out *everything* we'd said and it was just terrible! But there was nothing I could do."

I ask him about Ezra Pound's last days, after he'd emerged from the prison camp thin and beautiful and possessed with a desire to talk about economics. Lowell brought people to meet him and he was affable and tried to help them. Then there was Eliot, with whom he shared much and felt a bond.

In the heat, we made for the River Nore, which to me felt like brown consommé and to Lowell felt polar. He paddled and stalked miserably near the banks, while Cooke's small daughter and I hunted for eels and water-boatmen together. Drying off, we talk about his teaching poetry in colleges.

"Let me ask you a question. Do you think there are very few poets, or do you think there are lots of poets?"

"Er, um. Lots of poets, occasional poets. Nothing makes anybody a good writer except the doing of it, just everything coming together. Horace says there was absolutely no need for poets who were doctors. Let's say, no need for bad poets."

"What was the other thing?"

"The opposite of that, which is that poetry is everywhere—in songs and prose and so on. But then you have Valèry who said that genius without competence was nothing."

"So what do you think?"

"Oh, poetry is all over the place! Very good poetry isn't. No class could produce very good poets, I should guess."

(✳ ✳ ✳)

On the way to his reading the van breaks down and all the poets have to push it. Then, at the reading, before he begins the mike fails. Heat rises from the cat-printed carpet to the Tudor beams as he starts, addressing his remarks over the head of the Russian ambassador who has taken his seat near the front.

"This poem, uh, is about an old Boston aquarium where I used to go as a child. After I wrote the poem they built a much grander one. It's also about the underground garage and the first black colonel to lead a company against the Confederate troops in the Civil War—oh, and it's also about the atom bomb."

The audience is getting a tutorial; remember the Lowell that campaigned with Mailer and Spock in the anti-war Moratorium, says someone. We are all

sitting very still so as not to create more heat. Lowell asks for windows to be opened, trafficking with air at the expense of our hearing. "I'd rather not be heard than melt." Naturally iambic speech.

"I hate to say anything good about Russians," Lowell goes on, while we all turn and look nervously at the Russian Ambassador. "But I do have to say that they are wonderful in Russia at keeping their houses." He goes on to talk about architecture and the two ways of looking at the big country house: that it was a flaring and extravagant expression of the functional hierarchical order which gave rise to social communities that outlived the houses itself. Or that it was a symbol of the slavery of those who worked in them.

His new poem was unfinished, he said, at 170 lines long so far. One line echoes: "elephantiasis of the country house". The next new poem began with the lines:

> *What is more uxorious*
> *Than waking at five*
> *With three hours to spare?*

It is, as usual, about many things; but marriage and sharing a bed are certainly among them. A Kilkenny mother in front of me sighed deeply at the end: "B'dad, that puts Molly Bloom in the shade now, doesn't it?"

After applause, we liberated our bodies for a dose of the local bandleader Noel Power and his Four Aces. Lowell hovered in the courtyard, inscribing books for cocky undergraduates from Antioch University. He breaks from the shadows. "How do you think it went?"

Looking at his white face behind the spectacles I see that he is really vulnerable, seeking assurance. I supply it, best as I'm able. Then the fans close in again; Lowell is once more the victim of those whom he seeks to please.

1 September 1976

Chapter 4

Our Bodies, Ourselves

From the contraceptive train in May 1971 onwards, Ireland as a whole and the *Irish Times* Women First page in particular became obsessed with contraception and fertility. The women on the train were led by Mary Kenny and Nell McCafferty and their counterparts on the other newspapers. They bought condoms in Belfast which they declared at Customs, and protested loudly when these were seized by young, red-faced Customs employees. Film crews and foreign media turned it into a media circus and put contraception into the news headlines.

Everyone held strong views. As Mary Leland put it, "The sacredness of the female reproductive system vanished forever with the publication of *Humanae Vitae*. From there on ovaries, wombs, and menstruation became acceptable items of popular as well as clerical obsession."

Long, nitty-gritty descriptions of the Billings Ovulation Method featured in the papers, even though Leland added that it "defies delicacy and will never, ever in Cork be talked about out loud in the bus". Contraception *was* illegally available in the South. Despite the 1935 Criminal Law Amendment Act that prohibited it, certain friendly doctors were known to prescribe the Pill at the drop of a knicker to middle-class students. But the National Maternity Hospital at Holles Street was only advising on the rhythm method at its Marriage Guidance Clinic, and Billings was on its way.

In 1969 a group of dedicated doctors opened the first Irish family-planning clinic in Mountjoy Square, adding a second in Merrion Square in March 1971. Wrote Maire Mullarney, "We had our plate outside—'Fertility Guidance Clinic'— two warm and pleasant rooms, a cubbyhole, and a telephone, but we had nothing to do except discuss the likelihood of a picket once the news of our presence got around. We hoped no bricks would be thrown, since the windows in front were not ours."

A volunteer, and regular contributor to Women First, Mullarney spoke to groups around the country as a member of the Irish Theological Association. "But we had no trouble at all, just the difficulty of keeping up with the demand. "My purpose was not to persuade anyone to use contraception; just to make it clear that it was in no way immoral or sinful. I remember one woman who

exclaimed, 'But then what'll I have to say in confession?' Women were sent by friends, hospitals, sometimes by priests, even by their own mothers. Many husbands came as well, which didn't help the space problem."

When Mullarney came to write her three-year anniversary report for Women First, she quoted from the queries: "We badly need your help, but being out in the country it is hard to get to those clinics." One from a mother expecting her ninth child: "My husband is very considerate during pregnancy but I'm afraid that when it's over he will forget the dangers involved and want intercourse again. We did not have much since the last birth, but it seems as soon as I do I become pregnant, whatever part of the cycle."

Maybe it wasn't talked about on the Cork bus. But Billings versus Pill dominated the newspapers in a manner that seems quaint from thirty years' distance. Senators Noel Browne and Mary Robinson wrote a pro-contraception bill in 1971 but were defeated. Archbishop McQuaid wrote a pastoral letter against; and Oliver Flanagan TD talked of "godless people introducing the laws of the jungle". Taoiseach Jack Lynch famously wanted to put contraception "on the long finger"— all of which led up to the series of referenda that preoccupied the electorate into the next decades.

Mary Leland

Father Marx and Abortion

The fact that the abortion controversy in Ireland has blown up around an anti-abortion campaign seems to me to be totally due to the personality and tactics of the Reverend Paul Marx. This American Benedictine tutors students in sociology and even lectures to marriage counsellors—in North America. Understandably, because it was bred out of the current American medico-social lunacy, his rigidity was also inexcusable. And of course it meant that anyone who disapproved of his methods of getting a simple message across to the Irish people risked being tarred by the abortionist brush.

During his brief visit to this country Father Marx went to Cork, where the "foetus-in-a-jar incident" took place during an afternoon lecture film show to Leaving-Cert schoolgirls. More than enough has already been written and pro-claimed about that awful occasion in which, it seemed to me, Father Marx was being used by the schools involved in order to get a whole lot of sex "education" into one gruesome and unforgettable episode.

But a week later I met some of the girls who had been at that lecture and had seen the foetus; they went straight to the point. They wanted to know, one of them said, if any boys had been given the lecture or shown the slides. They resented the way that the burden of information and responsibility had to be borne by the girl. They were not shocked by the film and slides, and did not feel they should not have been shown them; they said that they had a great impact.

They brought home the truth to them, they said.

"We all had our own ideas about it, but we never realized how the baby was formed. But it's the thought of the people who do the abortions that's so terrible, not so much the abortion itself, or the baby itself."

"They showed the sucking out of the intestines of the child, we saw the little feet, the little hands, of some of the children."

"You couldn't mistake the little feet and seeing the instruments cutting … or the scientist cutting open the child's heart, to see how it works."

"And there was a photograph of a doctor with a baby in an incubator and he had little needles in his fingers for some experiment."

There is no doubt that Father Marx, unreeling his phenomenal statistics about America, can paint a truly horrifying picture of that country, where respect for human life seems always to have been less obvious where the subject was most vulnerable. And I suppose that it's no harm to remember that a Department of Health which wasn't much interested in the fate of Ireland's thalidomide victims won't be too worried about the rights of the foetus either.

The situation in England, too, is a frightening example of what can happen when liberal principles are too liberally applied, or when a humanistic argument is given legal status in an atmosphere of humanitarian hysteria. Nothing like this must be allowed to happen here, but it is to be hoped that the battle won't have to be fought with Catholic guns. The anti-abortion campaign, *any* anti-abortion campaign, should be well able to exist independently of the Catholic Church in Ireland.

Mercifully, Father Marx isn't typical, although his polarizing effect on the Irish must inevitably be damaging to the anti-abortion cause. In a tremor of embarrassment and horror, I sat through the film that he showed to the meeting of the Catholic Nurses Guild in Cork. None of this reaction was directed against the abortionist at work in the film; it was all against Father Marx, for being a priest with the licence to show such films. A lot of people at that meeting were not nurses or involved in medicine at all. I don't accept that the film should have been shown to anyone other than medical students. Medical material can easily take on the appearance of pornography outside the medical school.

The film was shot in an operating theatre where a woman was having a suction abortion. Her face was shown, plus her hand receiving the injection, her shrouded abdomen, her stirruped legs, and her shaven pubic area. All in full colour with a casual hand slapping on the green disinfectant. Then the instruments were shown being inserted, the spectrum into the vagina, the catheter into the urethra,

the cervix being grasped and pulled down, the suction hose being put in. Then came the blood and other fluid, the thick matter that was, presumably, the baby. All awful, the consciousness that this was a baby especially so. But operative procedures seen in cold blood by people who are not involved in medicine *are* quite horrible. They're horrible anyway but we prefer not to think about that.

Certainly neither this film, nor the bottled foetus or Father Marx himself with his mock-hip phrases and his insistence that abortion will inevitably follow contraception, seemed to bear much relation to our real moral dilemma. This centres, I am convinced, on our basic attitude to children, sex, and motherhood.

We are so easily moved to pity, but we have no commitment to love.

28 March 1973

Mary Maher

Surveying the Married Woman

Why do women with children want to work or not to work? Up until four years ago, before women were discovered in Ireland, a statistic on their habits or attitudes or characteristics was as difficult to come by as absolution for a reserved sin. Both problems, I believe, have eased dramatically. It is now possible to get almost any information you'd like about women, including such items as "Belief About Friends' Attitudes to Married Women Working Classified By Own Attitude" and "Non-Farm Women Not Working: Main Reason for Not Working Classified By Marital Status".

These particular mines of fascinating fact are only two of the seventy questions tabulated in the latest publication of the Economic and Social Research Institute, "Women and Employment in Ireland: Results of a National Survey". It is about whether and why married women work or don't work and I find it makes me uneasy.

I may be unfair. I am now so cross-eyed with reports that I flinch if I see a percentage sign and the enamel on my teeth will wear through if I ever again read anything like "macro-economic background", "female participation rite" or "the first indicator of excess labour supply provided by the survey data derives from the answers to the questions…"

But there are some other new and interesting facts. The percentage of married women working who have small children these days is 8.3 per cent of those with children under two years, and 10.3 percent of those with children between two

and four years. Of all non-farming married women who stopped and then resumed work, the largest proportion—30.6 per cent—returned to work before their children were five.

Add to this the fact that 29 per cent of all married working women work at home, and 42 percent of those employed with children under four years, and you have some idea of the number of women so in need of money or diversion that employers can hire them without social welfare insurance. Faced with the question of whether they thought young children should be left in day-care centres while their mothers worked, only 14.9 per cent of all the women queried approved, compared to 25.2 per cent who disapproved strongly

There's only one other little matter to clear up. Someone will have to come up with the jobs. The authors note, with some surprise, the number of women who cited "no jobs available/unemployed" as their main reason for not working. It ranked third at 8.3 per cent after "mother should not work if there are young children" and "no suitable facilities for children".

But since no one's mentioned full employment for years—ten, actually, since that state of happy surfeit was projected for 1980—I find myself growing more and more wary of every report that urges married women back into the job queue. Could it be that we'll all be expected to work for so much less than that dull, boring old thing, the married man, whom no one ever surveys?

22 January 1973

Christina Murphy

Bachelor Girl or Sour Spinster?

I remember clearly when a married couple I had not heard from for some time rang me up on a Friday afternoon and invited me to dinner on Saturday night. "Funny", I thought, "they left it this late to invite me!"

When I arrived, there were themselves and two men and me and I no longer thought it funny. I could just see them frantically searching their minds at Friday lunchtime.

"Who on earth should we ask? Joan?—No, she's engaged, and Margaret is going steady and she'd want to bring the boyfriend. Wait, I have it, Christina Murphy, she's not doing a line is she?"

Poor girl, they probably thought, she'll have nothing to do on Saturday night with no boyfriend.

That was the first time I realized I was being stereotyped and catalogued as a spinster, a nice spare partner for a dinner party. It's a syndrome which most single women over twenty-five are very familiar with. When I was fifteen, and at school, I reduced the religious knowledge class to hilarity by declaring that I wanted to marry at eighteen. I think it's what most of the rest of them wanted to do too, but they didn't like to say so.

By eighteen I had a great appreciation of what marriage in a small Irish town involved and I had pushed the age up to twenty-three. By the time I reached that magical age, I was abroad and having far too good a time to interrupt the

single trail. Twenty-seven would be a nice age to marry, I thought. Then I came back to university and thought thirty was a lovely mature age to marry. Nowadays I think thirty-five would be nice, don't you?

It's not that I haven't always wanted to marry. I have. But I have always felt there was so much else I wanted to do before I got married. First, it was travelling and living abroad. Then it was university, and after that came a career, and rightly or wrongly I have seen marriage as an obstacle to an interesting and demanding job. I get positively claustrophobic whenever the possibility of marriage presents itself.

But people do have these dreadful misconceptions. People solemnly take you aside and tell you you are being too "choosy" or too "bossy" or that "men don't like girls who are too independent or too talkative". You sometimes get the impression that you should tailor yourself to the exact model that men like, and then cruise around smiling prettily and waiting for Him to propose. I have been seriously taken aside by older unmarried women and told that they had been too choosy in their youth, and that one should trim one's sails and accept what was offered because spinsterhood was a very lonely life.

I'm sure it is; but so is being miserably tied to some creep you married just because he was an available male. I'm not saying that I didn't come dangerously close to getting married on a few occasions. I got cold feet at the last moment once or twice, and he chickened out once too, and left me biting my nails and ranting over the callousness of men.

I need hardly add that single men suffer none of the problems to which single women are subjected. People think that nobody ever *asked* an unmarried girl, yet they blandly assume that the unmarried man never found anybody good enough to ask. It never crosses their mind that perhaps he *did* ask—and was refused.

But possibly worst of all is the smugness of married friends. They settle into their own comfortable little suburban lives and regard you with a mixture of envy, suspicion and pity. Wives can tend to regard you as a dangerous *femme fatale* simply because you are single and available and their husbands knew you before they were married.

Husbands who used to be great butties at college become embarrassed about meeting you for a jar on their own in case the wives would be suspicious. Wives, up to their ears in mortgage repayments, regard you as immorally extravagant because you drive a car, spend money on clothes and eat out. They resent anybody their own age who is not hampered by the same commitments.

And they forget that you have it one way and they have it the other. They

have their house, their husband and children and all the comfort and security thereby entailed, while you have your independence and your extravagance.

So when the next married woman expresses surprise at your not being married, tell her there were not enough males in your age group, and that unfortunately you lost out—very unfair, but if she'd like to even things out she could let you have her husband for the next ten years.

23 May 1973

Christina Murphy

The Contraceptive Debate:
Ending or Beginning?

Next week in the Senate Mary Robinson seeks leave to introduce a family-planning bill as a private member's bill. This is the second time that Senator Robinson has attempted to introduce a bill on this matter.

One way or another it seems more than likely that some family-planning legislation will be introduced in 1973. The growing demand for contraceptives among Irish women is evidenced by the demands on the two Dublin clinics of the Family Planning Services Company, and there appears to be a more general acceptance of the need for such a service.

The last bill was defeated at the introduction stage, and was not printed or circulated to deputies, so never achieved a first reading. There is a strong possibility that leave will be granted to introduce the new bill but this does not, of course, mean that it will necessarily be passed. It would then have to be circulated to senators and deputies and the sponsors could hope for a first reading before Christmas.

Since the issue of contraception is regarded as an amoral one and thus as a matter of private conscience, government parties may decide on a free vote. Whether the bill would be passed under these circumstances is doubtful. The Labour Party has committed itself to changing the law on contraception and obviously there are people in the liberal wing of Fine Gael who would support it too. Fianna Fáil told us that they had been preparing legislation but were prevented from doing

anything about it by the High Court case which was then in progress, making the matter *sub judice*.

Viewed in the broad context of the political situation in Northern Ireland, it is doubtful that the government could afford to have the measure defeated if it were allowed to progress through the Oireachtas. It would certainly be an embarrassment and would not endear the Republic to Northern Protestants. With the prospect of a Council of Ireland looming on the horizon, the British government would obviously like to see the Irish government make some concession to the northern Unionists, however token. On a recent television programme shown both here and in the North, Dr Garret FitzGerald broadly hinted that some change in the contraceptive laws could be expected.

A contraception bill could assume many different forms, and the contents of Mary Robinson's will not be known until circulated to deputies and senators. It is interesting to note that it is addressed to the Minister for Health and not to the Minister for Justice, as was the case with the previous one. This would appear to envisage getting contraception out of the legal realm and into that of health, certainly a positive move.

Whatever form new legislation would take, two previous pieces of legislation would have to be amended. The Criminal Law Amendment Act of 1935 that prohibits the supply or sale of contraceptives would have to be amended to exempt those premises licensed by the Minister for Health—or Justice—to sell and supply contraceptives.

This would give the option of contraceptives being made available only through chemist shops or family-planning clinics, for example, and only on a doctor's prescription, although it is doubtful if doctors would want to be bothered by prescriptions for, say, the condom. While such legislation would be broadly acceptable and has the advantage of strict medical control of contraceptives, it does leave people dependant on their doctor's discretion. And judging by the debate at the recent Medical Union meeting in Sligo, many women would still find it difficult to get any.

There is also the problem that the people most in need of contraceptives are reluctant or embarrassed to talk to their doctor, whereas they might buy spermicidal jellies or condoms anonymously in a shop. Generally speaking the medical profession has been pretty conservative on the contraceptive question and reluctant to commit itself to support for a change in the law. The retaining of contraceptive control in the hands of the medical profession through the device of a mandatory

prescription might dispose them more favourably towards change. Another suggestion is that contraceptives be made legally available only to married couples. The availability of contraceptives on doctors' prescriptions could go halfway towards meeting the objections of those who would not want single people to avail of changes in the law.

The other pieces of legislation that require amendment are the Censorship of Publication Acts of 1929 and 1946 which prohibit publications that advocate the unnatural prevention of conception. There is a school of thought which would like to allow the Pill but not the intra-uterine device or "loop". And then there is the question of vasectomy and female sterilization. Vasectomy is performed in a few hospitals in Dublin, but there is a great reluctance to perform the less reversible tubal ligation or female sterilization, both of which are severely frowned upon by the Catholic Church. Incidentally, both of those operations are not illegal as they are not covered by the 1935 Act. An enabling legislation permitting the Minister to make regulations would remove the necessity for discussing all such details in the original bill.

There remains the question of the attitude of the Church to any proposed change. Many liberal Catholic priests are now condoning family planning. This does not necessarily mean that the Hierarchy would approve. However, at this stage it appears the Catholic Church is more liberal than the State on the issue! If introduced, Mary Robinson's bill would have a first and a second reading in the Senate. If it successfully passed these two stages, it would then be transferred to the Dáil as a bill from the Senate for the committee stage.

Then the real fun will begin. If the bill is successful it will represent a useful role for the Senate. Unlike the Dáil, the Seanad has a number of politically non-aligned members such as Mrs Robinson who are more likely to examine controversial legislation on its objective merits rather than from possible constituency backlash. The level of debate is less pedestrian and it gives a good opportunity for the discussion of the broad issues of principle on a more neutral basis before the nitty-gritty committee stage in the Dáil itself—not to mention its use as a sounding-board.

8 November 1973

Rosine Auberting & Christina Murphy

The Forty Foot Campaign: Two Views

In Sandycove, South Dublin, there are two bathing spots. One is the public beach and looks much the way you would expect a close-to-the-city beach to look—not very scenic, not very clean, with an unavoidable view of the car-park. On sunny days it is noisy and overcrowded and turns, when the tide is out, into a long pool of mud. When the tide is in, the beach measures six foot by six. This is where the women, children and dogs gather.

Just around the corner is the other place. Known as the Forty Foot, it is one of the most ideal bathing spots in greater Dublin. Never affected by the tide, equipped with a diving-board and toilet, sheltered from the wind and surrounded by a high wall, securing the bathers from inquisitive females eyes and other nuisances, it is where men gather.

At the top of the steps to the Forty Foot is a sign reading "Gentlemen Only" and on the strength of that sign, women have been refused the simple pleasure of a dip here for years. On Saturday, 20 July, the Women's Liberation Movement of Ireland invaded that bastion of male chauvinism to put an end to this ridiculous form of prejudice.

The invasion was repeated four weeks in a row. Every time, the newspapers read, "Dolly-Birds Invade Forty Foot" or "Led by shapely Mary, a teenager …" or "Twenty-two-year-old so-and-so from New York". We were called "chicken"

for not swimming in the nude as we were supposed to have said we would. We never said any such thing. What we did say, when asked what we would do if the men took off their trunks, was that we would simply take off our suits too.

Of course, what the Forty Foot male regulars were trying to achieve by threatening to expose their "heavy artillery" was to scare us off! We never claimed that the Forty Foot protest was the greatest achievement ever for the women's struggle in this country, but we believe in fighting discrimination wherever we find it.

Yet the press decided to turn it into a farce. Imagine black militants invading an all-white beach, a similar protest to ours. Would headlines next day read, "Handsome darkies invade an all-white beach" or "Led by sexy Leroy Brown from Harlem … one of the white bathers was heard to remark, 'I have nothing against niggers. I think everyone should own one.' " Remember this: we are not "ladies". We'll shout and we'll fight, but we'll be heard and we'll win. And the Forty Foot is a nice place to swim. We enjoyed ourselves!

Rosine Auberting was a French women's activist whose piece prompted a vigorous debate.

(✳✳✳)

Christina Murphy writes

Quite frankly I think the whole thing is an absolute waste of time and a red herring as far as the real issue of women's liberation is concerned. It has managed to confirm a lot of men in what they always thought about women's liberation (and which is not true): that those involved are irresponsible, publicity-seeking sensationalists. And I have an awful feeling that it is going to acquire the status of bra-burning in the folklore of the Irish women's movement.

Having said that, it seems to me the whole fiasco is more the fault of the media (and I suppose one cannot escape blame oneself) than the girls themselves. I arrived at the Forty Foot armed with rumours to the effect that boats of nude women were going to descend on the August bank holiday. I met television cameras, photographers, reporters and even the BBC, but no ladies, nude or otherwise.

"Sorry, Miss, this is a gentleman's only bathing place," said a very belligerent attendant at the entrance, an oldish man who seemed quite overwhelmed and appalled at the rumpus which had broken around his ears in the past few weeks. The fact that I was swathed from head to toe in a trouser suit didn't allay his

worst suspicions, but I managed to neutralize him by explaining that I was only there to report. He poured out his troubles: "Have they no decency or self-respect, walking in here with nude men all around?"

For the benefit of readers unfamiliar with the eccentricities of south Dublin, it should be pointed out that the Forty Foot is a bathing spot near the Joyce Tower in Sandycove which carries the sign "Gentlemen Only" and "Bathing togs should be worn after 9 a.m." The tradition was that men—sorry—gentlemen could swim nude before that hour; but it seems that they have been swimming and sunbathing nude at all times in recent years. It is a public spot, so legally they cannot exclude females.

Behind the concrete wall were several gentlemen sunbathing in their well-tanned birthday suits. They peered up, casually appraising the female invasion, and carefully raised newspapers—to cover their faces. The funny thing was nobody at all wondered what self-respecting man would swim in the nude. Several suggested that women should go off and swim in the nude somewhere else. But I honestly wonder what would be the reaction if twenty women were to lay claim to a corner of Killiney beach and label it "Women Only, Nude Swimming Here". I have an awful feeling that there would be a public outcry and charges of indecent exposure, permissive society, and whatnot. Yet the most respectable and impeccable of male citizens have been doing it in Sandycove for years. As one girl at the Forty Foot mentioned, "Young fellas are getting two months in jail for streaking yet these doddery old fools can do it here all the time."

I'm sorry for the poor confused men who have been bathing quietly for years with nothing further from their minds than equal pay, battered wives or mothers' rights and have suddenly bewilderingly been landed in the middle of the repercussions of all this—and a lot more.

7 August 1974

Mary Leland

In Defence of Eroticism

What is so terrible and calamitous about eroticism? If it is one of the dreaded consequences of a reform of our anti-contraception law, then surely we must have some understanding of just how dreadful it is. The word, whatever its ecclesiastical overtones, is not enough by itself. The bishops are as worried about eroticism now as the Catholic Church has been through the centuries. Their preoccupation with its evils indicates how strong the Church's aversion to sexuality really is and just why this basic human urge has had so relentlessly to be subjugated, and even submerged in marriage of a kind. Marriage, that is, which is better than burning.

But it is fairly obvious now that sexuality has a value of its own in the personal sense, separate from that of procreation and even as—the Church still has it somewhere—from "the relief of concupiscence". And while the Catholic Church did finally accept that men are quite likely to have sexual needs and desires, even up to recently it did not recognize any female need—or at least any female expression of such a need. The man, out of duty, asked. The woman, out of duty, gave: "Because of her innate modesty, requesting intercourse is gravely embarrassing to the woman."

So, on the assumption that eroticism is going to flourish once contraception is available, it is time to see what harm this is going to do to our way of life. "A very significant change in the quality of life," as Cardinal Conway put it, may

seem like a vague but appreciable threat. At least to those who have never heard of—never mind read—something like *Future Shock*, or the Prices Commission, or An Taisce. But it can hardly have escaped the Cardinal or any other members of the Irish Hierarchy that we are already in a time of very significant change in the quality of life.

The fact that changes are also taking place in our sexual awareness, the understanding of marriage, the questionable value of premarital virginity, all spurred on by the impetus of totally irreverent and commercial exploitation of sex (so accurately described by Dr Cathal Daly) should not surprise anyone. Some of our values are disappearing and in some cases it's good riddance. They are, hopefully, being replaced by better, more realistic or more charitable ideas that influence our words, thoughts and finally our deeds for the better. It is possible that the same thing is happening to sexual attitudes and I believe that this could even be "A Good Thing".

I do believe, for example, that some sexual experience before marriage can only help the relationship of a married couple. I could be all wrong—but looking at the evidence of marriages where both partners were sexually ignorant until their wedding night, I feel the possibility should at least be considered. In fact I have recently developed a comforting (to me) futuristic structure out of this possibility.

One of the areas of significant change which the Cardinal may have had in mind when he used the phrase recently is that in which girls and women have well-paid and interesting jobs ahead of them and their social need for marriage—economic security—is no longer pressing. Their personal needs, sexual excitement, approval, companionship, and satisfaction, can be met through thoroughly enjoyable relationships that, while more than casual, are not necessarily expected to end in marriage. Their whole attitude to men, marriage, sex and children is different even to what mine was, only six or seven years ago.

Girls like this are not likely to rush into marriage. They will probably be older when they marry, and probably wiser, and will have some basic understanding of their own sexual character as well as the deep personal nature of a sexual relationship and the need it seems to contain for the kind of permanence and commitment it can only find in marriage. I feel that marriage between people with that awareness can only succeed.

Eroticism, of course, is awareness. It is a conscious delight in sexuality, and without its common and unhappy abuses, should be a power for good. It should reveal our common physical structure and make it easier to express concern,

sympathy, pleasure, and the love that is called charity in simply physical ways. The prurient, like the poor, may be always with us. Just as poverty is often a stick with which to beat the occasional but real values of the affluent society, so prurience is the willful human failing that detracts from the positive values of sexual confidence.

Irish people, however, do not know either how to be sexually aware or happy. Prurience, as far as our education is concerned, is all we ever need to know. Irish law and Irish logic have no obvious relationship, so it is unfair to assume that out physical ignorance is a *deliberate* result of our censorship laws, but the fact remains that we can buy the Marquis de Sade's *Justine* in a bookshop, which is forbidden by law to stock *Boy's Questions Answered*. Their educators may consider it right to let Cork schoolgirls thrill to the sibilant horrors of Father Paul Marx and his little bottled corpse, although they may not read a guide to life and love by the gentle and protective Dr Benjamin Spock.

These and other excellent books are banned—or in the case of Dr Spock, not ordered by bookshops because they are expected to be banned—because somewhere they contain an explicit reference to birth control. But *Justine* and Genet and the American sex trips are there to titillate the thrill-seekers and confuse the anxious. The bookshops are loaded with paper-backed sexual violence and there is nothing about good clean and honest sex to balance the impression such books may leave. In such an atmosphere, where we are all aware of the very worst in ourselves, where masturbatory sex is the highest pleasure the single girl or boy may know and even at that is still high on the sin-list, where confession for a courting couple becomes a detailed and almost salacious ordeal, is it any wonder that Dr Daly's eroticism strikes with such a deep, dark and fearsome knell?

It certainly terrifies Dr Daly and I can quite see why. He and the bishops and even Cardinal Conway have declared with unshakeable conviction that this shameless flood of promiscuity and infidelity—not to mention VD, abortion, euthanasia, and all the terrible rest of it, strip joints and blue movies and porn on the high street—will follow from the legal tolerance of contraception. Their vehemence allows only one conclusion about their own role. They have failed, and they know they have failed, to promote an active morality in their Irish flock.

They have admitted it in their statement. Religious beliefs and rules are not enough, the Hierarchy is saying, to protect people from their old original urge to do wrong. They must be prevented from doing wrong by the law of the State. Without those laws, the bishops say, the Catholic Church and its people will

rush like lemmings towards a vast and tireless ocean of eroticism.

Of course the bishops may be right, but I don't think they are. I think they are just frightened. They cannot deal with the situation that has developed rapidly over the last ten years, when the gradual change in society was accelerated and left them—and most of us—without a philosophy. What it produced among other things was a new working woman, beginning to see her life more positively than ever before, beginning to realize her value to society, to the family, to the Church and State, beginning to make her own demands. Jansenism cannot survive where women are important economic units, and vocal as well.

19 December 1973

Elgy Gillespie

Will Unmarried Fathers Please Stand Up?

You're probably getting around to thinking that our single mothers ("Don't call us unmarried mothers—we're not unmarried, any more than you are!") are doing alright. Their allowance is going up to £9.15 next month, Senator Mary Robinson's Illegitimate Children Maintenance and Succession bill has been given a first reading in the Senate, and there's a climate of warming sympathy…

But members of Cherish are still far from thrilled with their lot. First of all, £9.15 (less if you earn over £5 per week) scarcely makes a realistic wage for mother and child, hardly enough to allow an unemployed mother a free choice between adoption and rearing her own baby. Secondly, they would like more time to make their choice. "Nobody who hasn't been through those nine terrible months could know what it's like: will I keep him, will I give him away, will I, won't I?"

Thirdly, and this is what Senator Robinson's bill is all about, they want a more effective way of getting financial help from the unmarried (or married to someone else) father. A very tricky task.

At present, she must find a solicitor and swear an affidavit as to the identity of the father. After that she must bring him to court and supply some kind of evidence (an eye-witness account of the couple in bed, a hotel register entry labelling them Mr and Mrs). Only then can she sue for maintenance, and all this must be done within six months of the baby's birth. It's all pretty ludicrous, as Maura O'Dea, the chairman, and other Cherish members point out. It takes a

lot of collaboration from the father for a start—and he may well have done a disappearing act.

As Maura says—and knows herself—the last thing a single mother feels like doing in the first six months of her baby's life is going into a tangle of strenuous litigation that she probably can't afford. Again, chasing the father into court may well mean the utter ruination of a relationship which even if not permanent or ideal is valuable to the mother, and at some future date to the child as well. This is why few single mothers have taken men to court so far.

"They don't want to. It never occurs to them. I mean, at that stage you feel you never want to set eyes on the guy again." Later on, though, the mothers can find themselves in severe difficulties. At present a lot of mothers wish they had sued for maintenance, but find it is too late by the time the child is two or three. Under the terms of Senator Robinson's bill, single mothers will be able to bring the fathers to court and for an indefinite time after the birth, and illegitimate children will also stand to inherit from their father's estate. This bit is going to cause sudden hysteria among some very respectable families out there, Cherish points out gleefully.

Cherish members I met were coping cheerily and smoothly with the double strain of being a single parent. All admitted that having a good job, financial independence and loving parents were what made keeping their babies possible. But when the Minister for Justice Paddy Cooney said at the recent Limerick adoption seminar that a child still stood a better chance of happiness if given away to adoptive parents, Cherish members said they felt as if they'd been given a slap in the face.

Mr Cooney praised the work of Cherish at the same time, but then said, "When people say a child needs a father as well as a mother we say: of course."

"But who's to say a child is less happy with a mother who has chosen the harder line, a vocational mother if you like, than in a family where the father may be alcoholic or violent or something," said a Cherish member. Nor are Cherish members happy about adoption assessment. They now have their own social worker—a major triumph—and find accommodation for mothers and babies whenever they can, and help mothers to train for careers through their rehabilitation board. This they regard as of paramount importance since it leads to financial independence. No Cherish member I met had any regrets about her choice, although making the decision was traumatic for one and all, and may have meant wearing two roll-ons, having pernicious anaemia, looking at every

last kip in the city, tramping the pavement for four months for accommodation, and more.

"People think you've got two heads and four legs or something when you tell them—they think you can't possibly get any joy out of your child," said a Cherish mother.

Adds another one: "And of course my mother says I've ruined my life. 'You'll never get married!' she says."

A third: "I was twenty-five, I had a good job, and I felt better off than a widow with three kids."

And more: "For me now, giving him away would be just like a mental abortion. At first, I thought of going to England, but then I thought, well, I was born and reared here and I've worked here all my life and paid my taxes—so now my country can do something for me."

"… It's the best thing that ever happened to me!"

8 June 1974

Mary Cummins

Suitable for Motherhood?

"Above all, pregnancy is a turning-point because it prompts so many questions about yourself and what you want out of life."
(from *The Single Woman's Guide to Pregnancy and Motherhood*)

Every unmarried mother searches her soul for the reasons she allowed herself to become pregnant. Every unmarried mother worries and panics about the future. Every unmarried mother spends hours, days, weeks, thinking about her child, whether that child will love her or blame her, whether that child will notice her inordinate exclusive pride in him or her, and conflictingly, her painful social embarrassment.

How many married mothers, I wonder, search their souls in the same way?

Many unmarried mothers will have to give their children away. For them the tragic episode that began with the discovery of the pregnancy through the months of confusion, the minutes of elation, the growing physical discomfort and mental distress, the lies and evasions, the desperate search for a solution, will never be over. The child will be given to two strangers whom society has said will be able to cope much better than she could ever hope to. She will be alone with herself. Many unmarried mothers will never fill that aching gap.

A lot of unmarried mothers will decide to keep their children. In Ireland the number is unknown, though we do know that the number of illegitimate births

almost doubled in the ten years between 1961 and 1971, when the annual figure rose to 1842.

And although about 70 per cent of illegitimate children are placed for adoption, it is a fairly probable assumption that more mothers are keeping their children and raising them on their own. In Britain there are at least 620,000 single-parent families and the majority are single mothers.

Britain provides more concise statistics in other areas, too. In 1972, 200,000 single women became pregnant. In the same year 54,172 single women had legal abortions, 69,172 children were born illegitimately, and 67,328 children were conceived before their parents married. And also in that year, almost a thousand women who gave Ireland as their permanent residence had legal abortions in England.

These figures are only useful because they show us that increasingly, even if gradually, changes are taking place in people's attitudes to old and cruel traditions in Ireland. But the slow change in this country is being wrought by the courageous few, who must submerge their sensitivities and sharpen their wits, so that they and their children can survive.

Because in the clear light of 1975, a year dedicated to women's rights, what is the position of the single mother?

A lot depends on her own attitude, her job, her friends, and her family; but in the majority of cases, her child will have to be hidden away to some extent. Her child may never know its grandparents, aunts, uncles or cousins. Her child may not know its father. Her child will be the cause of poverty, stress, and an isolation that she would never otherwise have experienced.

Her child will openly and legally be called a bastard. Her child will be the focus of much public debate and much private censure. Her child will be discussed at almighty length by politicians, the clergy, social workers, journalists. Her child will be discriminated against, legally, until some measure of civilization is forced on politicians to change the laws.

She will be viewed with a mixed reaction of false liberalism and downright insult. She will very likely lose her job and be forced to exist on the pittance that the State provides. She will then be a Social Problem, borne out by the stark words of the Department of Health and Social Welfare leaflet that accompanies her claim for the available allowance. The leaflet is headed "Warning" and lists nineteen instances which can affect the amount or stop the allowance. Aside from changes of address or the post office of payment, no fewer than eight of

the "warnings" include possibilities like the imprisonment of the mother, her detention in a mental hospital, the admission of the child to a reformatory school or institution, and the child being taken over by the local authority.

There are just too many of them not to suppose that whatever bright minds drew them up obviously see the single mother and her child as a source of public nuisance. And the last two items on the list are the possible employment of the mother or finally, her marriage. A single mother's best asset is a well-paid job.

21 May 1975

(*＊*)

Daisy Cummins was born on 3 March 1974, and she was fourteen months old when Mary Cummins wrote this plea for single mothers. Mary wrote another piece about the subject, a much more personal one, if no less impassioned, when Daisy turned twenty-one on 9 March 1995.

> So she is twenty-one and I have realized I cannot go on saying I am still thirty-nine. She is full of purpose. She will travel the world. She will conquer LA. She will discover lost tribes. What about me?
>
> I have run out of excuses for not doing all the things I swore I wanted to do. If I, who have always kept the day job going, feel as blank, empty and destitute as a new piece of blotting paper now that my child has flown, what do women feel who have dedicated their entire lives to them? Much the same, I imagine. It is only now that I sleep lightly until she is in at night that I realize why my own mother still worries when I am not home at a reasonable time. After all these years, she has not got used to the fact that I just forget the time. That the hours fly by.
>
> This story has two endings:
> 1. Oh Lord, thou art hard on mothers.
> 2. I love you, babe.

Christina Murphy

My So-Called "Condition"

"Pregnancy", said the books, "is not an illness. It is a normal state of affairs." Only a man could have written that, I thought indignantly. Only a man could have felt that walking around feeling half dead was normal.

If I hadn't known I was pregnant, I really would have thought I was dying—indeed at times I thought I was dying anyway. There was an ever-present, ever-gnawing feeling of strong nausea; there was the feeling of constant exhaustion and misery; some smells—cabbage was one—would precipitate a furious dash to the bathroom, and the sight of a person spitting in the street called for acts of almost heroic self-control. I developed a sort of nervous cough to try and camouflage the retching, and I'm convinced that on several occasions people on the last bus were convinced that I was paralytic as I struggled nobly to keep my two Britvic oranges down, at least until I reached Ranelagh.

To my amazement, women whom I thought sailed gaily through pregnancy suddenly started to admit to the awful first three months. "Labour was nothing by comparison," confessed one. "Nothing that could ever happen to me again could ever be as bad," said another, who had suffered fainting spells as well as sickness.

"But ..." I spluttered, "you never said anything at the time." "Well, I didn't want to make a fuss," came the reply. And that's the problem really; we don't want to make a fuss, we accept that it is our lot to suffer, and sure, won't it be over soon anyway? I did the same myself, of course. I got out of bed, staggered into work,

went home to bed, and did literally nothing else for twelve weeks. How on earth a woman with three small children at home copes is beyond me. I kept thinking of the single girl who is having the baby only to have it adopted at the end. Imagine going through all that agony for nothing! Imagine if you had been raped or didn't want to be pregnant at all!

It was bad enough with a supportive spouse around, but imagine it on your own. I worked myself into a fine rage every time I read one of those Cara ads about not having an abortion. They'd help you through the pregnancy. That's alright in the clinical surroundings of the Cara consulting room, but the day any priest or bishop has to leap off the number 11 bus in the pouring rain to avoid being sick all over the back seat, then let him come back and talk about pregnancy to us, I fumed.

Then miraculously, and almost exactly in the twelfth week, just like mist lifting slowly from the landscape, the horror retreated. Sitting on the bus one day going past St Stephen's Green, I suddenly realized that I was actually looking at the trees and noticing the people on the pavement. I was normal again. The relief was unimaginable, the misery of the past twelve weeks retreated almost into oblivion, and I suddenly felt so healthy, happy, and yes, sensual, it was almost a compensation for the previous misery.

22 July 1981

(***)

There's no doubt about it, but people have a fantastic attitude towards pregnancy. It's like going out for a walk with a big friendly dog; it breaks down all sorts of barriers. Total strangers have regularly come up to me at bus-stops and beamed, "How long have you to go now? You must be feeling pretty hot and sticky on a day like this!" The woman in the local hardware shop, who had never exchanged a word with me in five years, has suddenly developed a compulsive interest in my well-being and is counting the days more avidly than I am.

It's a great feeling, almost like being a celebrity or a star for a few months, and sometimes I think, my God, I don't want this ever to end. The high point was recently when a bus pulled up specially to let me off at the Shelbourne Hotel. I had ambled up to the driver to get off in Kildare Street, to find the bus no longer went down there due to road repairs. "No problem," said the driver, peering concernedly down at my bump, "I'll let you off at the Shelbourne." As

we approached the hotel, the bus was caught in the third lane of a barely moving traffic jam. "It'd be just as handy if I jumped out here and weaved across the traffic," I offered. "Certainly not," he said, sternly. "We can't have you weaving through traffic in your condition." And he proceeded to pull right over to the door of the Shelbourne to drop me specially.

The previous week, I'd scrambled on the Number 8 to go to a class in Holles Street when a conductor bellowing "All upstairs now, seats upstairs only!" suddenly spotted my "condition" and added, "Not you, over here!"—and smartly ejected a surly teenager from a downstairs seat to accommodate me.

On my way to Holles Street another day, a distinctly oldish-looking nun rose to offer her seat. I muttered: "Not at all, Sister, I'm all right, I'm only going as far as Holles Street," whereupon six people in surrounding seats, panic clearly showing in their faces, leaped up to offer their seats.

In the lingerie department of Clerys a few weeks ago a concerned assistant noted my jumble of Roches Stores and Arnotts bags and immediately rushed to get me a large carrier bag. "There, put them all in there now, that'll be easier for you to carry." And again, the smiling look of approval. I felt she would have patted me encouragingly on the head, given half a chance.

(✳✳✳)

At the theatre door the anaesthetist introduced himself and explained exactly what he was going to do. This was reassuring, as were the doctor's words: "Now, you mustn't feel guilty. There's absolutely nothing to feel guilty about. You've worked for over twelve hours in labour, that's as much as anyone can be expected to do. Don't feel guilty that you can't deliver."

Guilty? Me, guilty? All I felt was relief, and would they for God's sake get on with the job quickly! "Not to worry," said Dr Y, "I'll do you a lovely neat bikini slit and you'll hardly notice it." I didn't know what a bikini slit was, but if he had suggested opening me down the back of the head I'd have agreed cheerfully.

I thought I'd at least have the satisfaction of feeling the pain ease away; but no, I was gone like a flash. Later—an eternity later—I have a blurry recollection of someone holding up a baby wrapped in a blanket. I vaguely felt that some gesture was called for, and I think I kissed it on the nose. During a long, painful and half-remembered night, nurses came and went, checked my blood pressure and the drip in my arm, and gave me pethedine injections.

At 6 a.m. they brought me a cup of tea and it took two nurses to haul me up to a position from which I could drink it—every inch of the way an agonizing and painful mile. Had I seen my baby, someone asked? I wasn't sure. During that long and painful night, I thought someone had said I had a baby girl. Then they brought him in. "Ten pounds," they said, "a huge ten-pound baby boy!"

He looked sort of ordinary, like most babies. "He's a bit red in the face, isn't he?" I said. "All babies are red," said the nurse defensively, and I got the feeling she was a bit disappointed in me. Later in the morning the telegrams of congratulations and the flowers started to arrive. I felt incensed. Here was I, in agony and unable to speak, incapable of moving, and they were sending me telegrams of congratulations. "Mass cards would be more appropriate," I muttered.

(✷✷✷)

In that first awful week after the birth I cried far more than the baby did. The poor little mite—although I suppose you can hardly call a ten-pound baby a mite—slept away peacefully in his cot most of the time while his mother was the one who sat up in bed bawling her head off.

Bawling your head off is a regular occurrence in maternity wards and at times it seemed as if half the ward was at it. There was a public telephone outside the door of my room and a regular stream of red-eyed women at the phone. The nurses were great. "It's perfectly normal. It's far better to cry than to bottle it up," they'd say, putting an arm around my shoulders and patting me on the back.

Exhaustion is my main recollection of that week. It seemed as if I'd never get a night's sleep again. I'd lost the night I went into labour and the night of the operation, and for two further nights I failed to sleep more than an hour or two. Even the sleeping tablets failed to help. "A night's sleep, just one full night's sleep," I used to wail. "I'd give anything for a night's sleep." I honestly felt I would cheerfully have given away the baby if the devil had appeared and offered me sleep in exchange. Again, the nurses were great. They made me cups of tea at three in the morning, fetched more painkillers, and sought out even stronger sleeping tablets.

I think it was when he began to feed successfully that I really began to take to him. He'd lie there so peacefully, curling his toes like a cat in contentment, that you couldn't help feeling that you were doing something useful. About half the women in the ward were breast-feeding and my goodness, but some fierce battles were fought with howling infants before many of them got it organized.

There was every encouragement and the nurses invested endless hours helping out. But the proportion of breast-feeders varied enormously and one week later with a new batch of patients, only one woman out of fourteen was breast-feeding. She confided that she felt obliged to pull the curtains around her bed while feeding as she felt the other women thought it a "bit odd".

Gradually I got used to the little snuffling and whimpering bundle in the cot beside me, until finally in the second week as I took him down to the nursery for the night, to my horror I found myself overcome with guilt at abandoning him. I had visions of him bawling and lonely and, almost despite myself, I found I kept him with me the following night. The bonding was beginning to work.

Actually, I think his father took to him faster than I did; but Dermot had the advantage of seeing him within a few minutes of birth, whereas it was the next morning before I saw him. Giving birth by Caesarian is a funny sensation when I think about it. You have a baby but you haven't really given birth. Despite the worries and reassurances of both doctors, I haven't the slightest feeling of guilt— but I do feel a bit cheated. I mean, here I am, a mother, and I still don't know what childbirth is really like!

29-31 July 1981

Christina Murphy 1941-96

A decade after first being diagnosed with lymphoma, Christina Murphy wrote anonymously about her struggle with cancer; on quality-of-life issues and refusing chemotherapy with clear eyes. Anonymous or not, the piece was obviously hers and read in a way that came as a shock to her husband.

During the summer my doctor suggested a new course of chemotherapy and I demurred. When the time comes—as it inevitably will—that I have to make a decision on severe chemotherapy with side-effects, I hope I will have the courage to live out my last months in dignity, without palliative chemotherapy. Living with cancer is not a nightmare: I live a normal life, work hard and enjoy myself. The only reason I am not identifying myself here is because it would also identify other members of my family, which I feel would be unfair.

At the time of her death she was Duty Editor at the Irish Times *and Editor of the Education and Living supplement. Her widower Dermot Mullane adds: "Christina had full-blown lymphoma and survived for ten years from the time of the first diagnosis. That the illness was far more serious than she conceded reflected the strength of will which enabled her to work up to three days before her death on 15 September 1996."*

Profiles

Caroline Walsh

The Critics and Edna O'Brien:
Envy, Envy, Envy

Edna O'Brien's play *The Gathering*, staged at the Dublin Theatre Festival in 1974, was greeted with criticism that was predominantly hostile, even savage. It must have taken courage to come back with another play, *A Pagan Place*, which opens at the Abbey next week.

She herself admits now that during the barrage that followed *The Gathering*, her first impulse was never to come home again. "I was wounded and I was shocked, but in retrospect I was very furious, because I don't think that play deserved that treatment. I still think it's a play that could be well done one day."

Most of all she mistrusted the motives of the criticism, and felt it had more to do with her as a person than with her writing. "I have in a sense to fight that. When you are even remotely photogenic—God help us!—you get a lot of attention; but you pay in kind, because it's counteracted with envy, envy, envy."

Often she feels that when people are offended by a work of art, they don't explain why, but attack the writer instead; and here she offers some points about criticism in general. "I feel that in surgery, in bus driving, in food packaging, there are standards below which they cannot go, but in so-called criticism there aren't any standards. Anyone can say what they like." Something that particularly appalled her in 1974, she claims, was that one reviewer allegedly got his copy by walking through the audience and jotting down their reactions.

Now she has steeled herself against the critics. All writers, she says, go through periods of being courted and loved by journalists and then being rejected by them, so the writer has to be indifferent. He or she has to live with criticism, good or bad, and dismiss it when they sit down to write. Criticism, she adds, is like the waves of the sea: "You just have to ride them."

"Anyway—and I think it's my mother's blood in me—I'm blessed, blessed with determination. Nothing stops me and nothing will stop me. It's very nice to be praised and it's not nice to be kicked, but you yourself are the judge and guardian of your own talent and you yourself have to mind it."

Even more recently than *The Gathering* came the harsh criticism of her novel *Johnny I Hardly Knew You*. In England, where many of the reviewers were women, the notices were generally good; in Ireland almost all the reviewers were men. "I feel the book upset quite a lot of people, particularly men. I think they felt their sexuality and their dignity was in some way called into question."

It is not only criticism that she has to face over here. There has also been the banning of her books, and the occasion when some copies were bought out and burnt publicly by a priest in her native County Clare. Yet she keeps coming back. Though she doesn't want to sound too saintly, one of her reasons for returning is that she was reared a good Catholic convent girl who believes in turning the other cheek. Above all, she comes back because she loves Ireland—not so much Dublin, where she gets distracted, but the countryside around Galway and Clare, especially at dusk or evening time when she feels them to be both heart-wrenching and inspiring.

Now that her mother is dead, there will be no going home for Edna O'Brien; no going back to Drewsboro, the house outside Scariff, about which she has written such a great deal. "The wonderful thing about writing, however, is that what you lose in life, you regain in literature; and that house haunts me with its trees, its avenue, and its mounds of grass. It's in *Pagan Place*, and I love it so."

Has she ever stopped thinking of herself as Irish? "No, never. How could I? One's speech, one's fears, one's dreams—they are all absolutely Irish."

Returning home in the seventies she sees a changed Ireland, though the change is marginal. "That's what I like to see and want to be part of. I won't let literary thugs keep me out; it would be their win. No, I'm happy to be here, and I'm not afraid. I've been through too many bad trips to be afraid. All I want to do is go on writing, and a bad review never stops you doing that."

Were it not for financial considerations, she would love to have a house in

Ireland. She is sad that her friend Samuel Beckett has not seen this changed Ireland. Once she described him as the Holy Ghost in a Trinity that held Joyce as God the Father and Myles na gCopaleen as God the Son. Now she speaks of Beckett simply as The King. "What I love is his reserve, his austerity, and his humour. I love people to come slowly to one and not to jump in."

Today she lives in Chelsea, getting up between 8.30 and 9 a.m, reading the mail or not reading it, and having a cup of tea before going into her work-room. If she is not writing, she may read a bit of Chekhov, Proust, Beckett, some pages from *Ulysses* or the work of contemporary poets such as Ted Hughes, Seamus Heaney, or the late Robert Lowell.

One real dread is of being gregarious or frittering away the talent. "As a writer you have to be careful not to become too famous; not to become a person who spins her talent in a bar or in a series of bars, and at the same time not to become someone who just lives in an Ivory Tower."

She never, it seems, got over the time when, playing the Virgin Mary in *The Miracle of Fatima*, she tumbled down off the butter boxes. That was a long time ago when she was a girl at the convent in Loughrea, but the memory is with her still.

"I always say that what I need from the point of view of my work is a wife, a nice wife who'll look after me and protect me from the onslaughts. Instead, as a woman writer, you have to earn your living, rear your children, and get insulted. It's unfair and it's exhausting." Of her children, Carlo (twenty-three) and Sasha (twenty-one), she is very proud. They are, she says, so developed and supportive. "I love them to the ends of the earth." Though she would, if she could, delete a few episodes from her life, the one extra thing she would have liked was to have had more children.

While the critics frequently hark back to her early books, she sees the work as improving all the time. "What happens is that the books I write are attacked at the time, and later received, and I have to take it and I will take it. It's like Saint Sebastian with the arrows, only I'd prefer if the arrows were a bit softer."

2 **November 1977**

Christina Murphy

Here's To You! Senator Robinson

For all her bravery and outspokenness, Mary Robinson is a shy person—or so it seems to me. I wanted to find out about Mary Robinson the person, the wife and mother, the girl from Ballina, the side that we don't hear much about. She was much happier talking about politics and law and civil rights, she said, but nonetheless she did talk, if hesitantly, about herself.

She is shy and even nervous talking about her family, but when you move on to national issues, you see a change. You can almost see her intellect working as she rationally and intelligently analyses aspects of Irish society.

Though not the sort of person to insert deliberate jokes into her speeches, she can be very funny to talk to. *Hibernia* described her in a recent article as totally devoid of humour, a remark which she found hurtful and not one with which I could agree. We had a few giggles about absurd attitudes to women. And I loved the story about the time she was staring intently at the faces of the jurymen on the Western Circuit when the foreman of the jury suddenly winked broadly at her. Girls were not familiar on the circuit, and the young Mary Robinson blushed to the tips of her toes.

It seems almost incredible that she is still only thirty-three years of age, she has packed so much into her life. She was born Mary Bourke in Ballina, County Mayo. Both her parents were doctors, various uncles are lawyers and she is quite prepared to admit that she comes from a privileged professional family and had

a fairly privileged upbringing.

She attended a private local school with her brothers until the age of ten when she went to Mount Anville, a convent boarding-school in Dublin, and did a year at finishing-school in Paris. Then it was a scholarship to Trinity, a degree in law and post-graduate studies in Harvard, and back home to the Western Circuit before she left it for politics and teaching. She went to Trinity because two of her brothers were studying medicine there and it seemed best to have the family together. Her father went to the Archbishop of Dublin for permission for his daughter to attend the banned university.

She had no political background at all and her family had no involvement in party politics. As a student at Trinity, she got involved in many activities, but not politics! "I went to a few Maoist meetings, but gave up out of sheer boredom." She debated a lot and very successfully. She got elected to the students' union and was secretary of it for a year.

Her years in Harvard, she feels, influenced her most. She found it an exciting experience: the approach to law was much more open and questioning. "The young people I met there, from many countries, were much more prepared to accept responsibility, to see and to grant involvement." She came back home with a feeling of the need for change, the need for young people to become involved.

Her experience on the Western Circuit further influenced this. "I saw Ireland quite differently, how we needed change, law reform and that even our parliamentary structures needed opening up." She valued her period on the circuit enormously and feels it was more beneficial than starting in Dublin.

"In Dublin you tend to be in court only for your own cases but on the circuit there is nothing else to do but stay in court and you learn a lot more." But it was lonely, too, involving a lot of sitting around in hotels and pubs.

With this sense of the need for young people to become involved in public life, and to highlight the need for change, she decided to stand for the Trinity seat in the Senate when the next elections arrived. "I was not at all sure that I would do well. I had three disadvantages: I was young, I was a woman, and I was a Catholic."

She went and talked to Canon Luce in Mayo and "he was most enthusiastic and encouraged me. He thought it was a great idea to get young people in the Senate." This was the encouragement she needed, so she decided to stand.

"I still remember my father's face when I told him. He was out digging in the garden in Ballina, and he leaned his elbow on his spade and looked at me for a

long time without saying anything." They were a bit staggered in the beginning, but rallied around marvellously and helped her a lot in the campaign.

What happened after the campaign is history, but it is the history of the public figure and behind it all there is the private Mary Robinson. How on earth does she manage it, many envious mothers must wonder. Marriage, a family, two small children and a full-time career? She doesn't like talking about it much because basically she just goes ahead and does it all and is mildly surprised that people wonder. But pressed a little, she does talk. She has no live-in help but a daily girl comes in the morning and looks after the children during the day.

"I don't like the idea of having somebody living in with the family, and anyway we don't have the space." She cooks breakfast and has it with the children and then hands them over to the home help while she goes to work. Tessa is at school and William goes to nursery school. She comes home in the evening and cooks an evening meal for them and relies on her husband and relatives when she has to travel or be away in the evenings. They both try to be at home most weekends to cater for themselves and the children.

She loves being with the children at weekends and talks about them with great affection. Talking about William playing with Dinky toys she smiles, almost embarrassed, and has the look of a doting mother on her face. "The children are a great reserve of strength for me; when I'm feeling depressed they can lift me like nothing else." They give her a feeling of continuity too, a sense of the future. "I look at them and I think of what the world will be like in twenty years' time. I take their perspective."

(***)

She always wanted children and never considered putting it off until her career was more advanced. "I had a terribly happy childhood and I have always had this sense of a happy family and wanted children immediately." She didn't consider postponing marriage for her career either. "I very much wanted to marry Nick and I have found marriage has been extremely liberating in so many ways." It's given her a greater sense of confidence and stability and of belonging, and she finds that in many ways in politics and law there are many things that she can do more easily as a married woman. "I found my freedom in marriage."

Her husband, Nick Robinson, is a practising solicitor. "We have joint interests in the area of law but he has other areas of interest which I don't share and I

think that is good." He is involved in conservation, An Taisce, photographic archives and other areas. Mrs Robinson talks a lot about the partnership of marriage and the importance of tackling things together. "I'd love to be able to say that Nick was great at changing nappies and so on, but he's not. But then I started off as a novice too, and we just muddle along together."

She admits she must be a very difficult person to be married to and that she is extremely lucky to be married to somebody who is not at all put out by her numerous activities. Sometimes there are funny moments, as when they went to Japan together and everybody thought the tall bearded man was the senator, but it doesn't worry them.

She never ever considered being a full-time housewife. "I would simply go mad." She looks forward enormously to weekends at home with Nick and the children, but, "I am always happy to pick up my briefcase on Monday morning and go back to the office." She has an "enormous sympathy" for housewives who are housebound in suburbia. She would campaign to the last for the right of married women to work, but equally she feels that too much emphasis has been put on this and that women who do not are made to feel inferior. For this reason she was reluctant to become involved in the early Women's Liberation Movement.

She's not great at housework or over-enamoured of it. "Yet I can get great satisfaction from doing a big washing up. It's almost a mechanical satisfaction." She says she is totally devoid of any sense of the visual or of possessions. "I would safely say that there is not a single item of furniture or a picture in our house which has not been chosen by Nick." It's the same with clothes; she likes to be neatly dressed, but ideally would prefer someone else to buy her clothes and never remembers what anybody else was wearing. She hates shopping: "It's funny. My mother loved clothes and so does Tessa, but it seems to have jumped a generation with me." She doesn't mind Tessa being madly feminine at all. "It would be utterly wrong to condition a child in that way but when she starts saying that boys will be doctors and girls nurses, then put her on the right road."

The sense of family and the importance of family life comes out over and over again. Family life is and always has been of paramount importance to her. She adored her mother and was very affected by her death. "It's the sort of thing I still find hard to talk about. I keep getting the feeling that I'd love to have been able to show her my children." Her mother was a doctor who cheerfully gave up her career to raise a family, and sounds like she was a great woman.

She has, she says, "a deep sense of being a Mayo woman, over and above anything

else." At a meeting of women graduates in UCD last year she was amazed when the women came up and didn't say "So, you're Mary Robinson!" but, "So, you're Tess Bourke's daughter." To them she is Mary Bourke, local girl.

26 February 1977

Maeve Binchy
in London

Shy Miss Murdoch Faces the BallyHoo

When I met Iris Murdoch she was sitting in the Dickensian rooms of her publishers, Chatto and Windus, looking wistfully out of a window towards Trafalgar Square and wishing all these chats with press people were over.

"Do you hate it all?" I asked sympathetically, as if I weren't about to sit down and add to her troubles.

"I hate it," said Iris Murdoch sadly, "I really do, and actually I never do it. I really don't. I mean, if people think they are going to like the books, they will go out and buy them, and if they don't they won't be wooed by anything I say in an interview. But because of All This … you know … well, I have to talk to the press."

"All This" was the Booker Prize which Iris Murdoch won last week. It's the biggest honour that exists for a novelist, and it's also worth £10,000.

Was she surprised?

"Oh yes, very, and very, very pleased. Well, I mean, you hope, don't you, that people will like what you write but, in a way, it's like talking to people. When you are having a conversation with someone, you don't stop anxiously and peer into their face to know how they're enjoying it so far…"

Was it true that she never read her critics and didn't rush to see what kind of reviews she got?

"Yes, totally. It's not arrogant. It's nothing to do with being big-headed or anything. What do I do if they say they love it? I can't write the same book again; and if they hate it, I'm surely not expected to withdraw all the copies that have been published already…"

Was it true also that she is a maniacal worker? As soon as one book is finished they say, she pauses for half an hour and then begins the next?

"Yes, if you mean that thinking out a book is beginning it, I start that at once. I plan a lot in advance and by the time I start to write I know more or less exactly how it's going to look."

(∗∗∗)

She's shy, Iris Murdoch is, and she hates talking about herself. It's almost as if she can't think of one single thing about her own life that would interest anyone yet her fluent, constant writing would make you think that she had views on every subject and was anxious to share them.

"I suppose I am a bit different to a lot of writers in that I'm always longing to be writing," she said. "I look forward to the hours spent working on a book and there are hours, you know, hundreds of them.

"I always hear that other writers say they hate the sitting down to it and that they'll do anything rather than write the words 'Chapter One'. With me it's the reverse. I grudge any time away from it."

Iris Murdoch is Irish. She was born in number 59 Blessington Street, Dublin. Isn't it funny, I said, the way they always call you a British writer, nobody ever mentions that you're a Dubliner?

"Well, to be fair, I did leave Dublin when I was six weeks old," she said. "I spent every holiday there for years and years and I know a whole bit of the coastline better than you would. All that bit from Killiney right the way into Sandymount. In the school holidays years ago I explored every inch of it.

"Yes, of course I loved it. Imagine the whole adventure of getting on a train and a boat and then making that great long journey when other children never did anything like it. It was magic."

Is Ireland still magic to her or has that dimmed over the years?

"No, nothing has dimmed. I'm in Ireland a lot. I was in Dublin ten days ago when my husband was giving a lecture in Trinity. I often go to see Honor Tracy in the West. I think she's one of the most funny and right-minded people I

know. I get whole new insights into ways of looking at things after an hour talking to Honor."

Iris Murdoch lives in West London, not more than a mile away from me, it turns out. She loves walking around London in the autumn. She thinks it's one of the most restful cities in the world despite its size; those huge parks are well kept, the magnificent architecture, so well preserved. Sometimes she could cry when she sees what happens to beautiful things in Dublin and the way they are all being torn down.

Yes, she knows that there's more money and everything for preservation and conservation in England, but there are some really beautiful things in Dublin. She'd have thought that alone would stop people in their tracks.

She has more or less everything she wants in life. She'd love to be finished with all this Booker ballyhoo of talking about herself but she doesn't want people to think that she's ungrateful for the prize. However, it is very attractive, she says, to think of sitting down in peace at a typewriter. No, of course, she couldn't spend all day every day writing. She ran a house and a garden and didn't have anyone to help her and there were all those dreary things like washing, especially the sheets.

"Don't you use a launderette?" I asked, anxious as always to throw in some helpful advice to everyone, even if it happens to be one of the most famous novelists of our day.

"I don't use a launderette", said Iris Murdoch, "because, you know, I've got a washing machine. But it's still fairly tiring, you know, all that folding and everything and that kind of thing."

And we talked about that and her prizewinning book, *The Sea, The Sea*, and how much she liked Australia and wished it only took two hours to fly there because if it did she'd go there every month. And she said she didn't really know many writers in Dublin and didn't mix with a literary set there but she always felt a great surge of happiness when she walked around parts of Dublin and if it didn't sound a bit silly, she did think of it in a way as a home place, but then Dublin ... or what's left of it ... is so beautiful that anyone might like to feel at home there, even people like her—a resident until the ripe old age of six weeks.

30 November 1978

Chapter 5

The North Erupts

In 1971, the introduction of internment without trial by Northern Ireland Prime Minister Brian Faulkner resulted in a rapid escalation of violence, hostility and confrontation. Less than two years earlier British troops had been offered cups of tea in Northern Irish houses. Now there were no cups of tea for soldiers and a new ban on marching was having the opposite of its intended effect. Over 100 people were killed during the July marching season. Six months later, the thirteen deaths of Bloody Sunday in the city of Derry on 31 January 1972 launched a year of bloodshed that amounted to more than 2000 explosions, over 10,000 shootings, 500 dead, and 5000 injured.

When Conservative Party leader Edward Heath subsequently declared Direct Rule from Britain, Faulker and his Cabinet resigned. The findings of Lord Widgery's investigation into the Bloody Sunday killings were, and remain, controversial. So were the convictions ruled by the no-jury Diplock courts. Secret talks between the new Northern Secretary William Whitelaw and Provisional IRA chief Seán MacStiofáin broke down on "the declaration of intent" issue. The Sunningdale talks foundered over UDA and IRA demands. Loyalists eventually staged their own strike. The crackdown by British troops contributed to the quickening crisis. *The Irish Times* Northern office, staffed initially by Fergus Pyle, Henry Kelly and Renagh Holohan, and afterwards by Fionnuala O'Connor and Ed Moloney and others, became the busiest section of the newspaper.

Mary Cummins
in London

Bernadette Devlin Expecting Baby in Autumn

Miss Bernadette Devlin, MP for mid-Ulster, is expecting a baby in the autumn but she is determined to fight the next election. Last night she said: "I will stand at the next election. When I was first elected, I said I would try to achieve betterment for the people in a short time because I realized it was going to be a long haul... My position now is as it was then. My morals are a private matter. As a Member of Parliament I represent a political programme."

Mary Cummins: You are expecting a child?
Bernadette Devlin: Yes.

But you are unmarried. Won't this cause consternation in Ireland?
I don't know. I am not at all certain what the reaction will be. After all, the people of Ireland have many reasons for being concerned and truly desperate about the situation there. Whatever they think of my being pregnant, it ought not for a moment distract them from facing up to the real menaces of bad wages and exploitation, slum houses and oppressive landlordism, rural poverty and the splitting of families by emigration. My situation is of no great significance when compared against the problems we all face in Ireland.

But can I deal with personal aspects? You are a young woman; you are engaged in strenuous political activity. Are you really a fit person to rear a child?

I do not expect it to be easy. And when I say this, I am not talking about conflict of interests. The claims of my political activities are heavy but these are—or I hope they are—reconcileable with a home life.

How long have you know about this?

In February I visited a doctor, before I began my lecture tour of America. Then, it was difficult to say whether I was definitely pregnant. I went to him again when I came back and learned that I was going to have a child. I felt that until I decided on my course of action I would not tell anyone. I felt that I wanted to decide for myself.

Who is the father?

I am not saying.

Why are you not saying?

I am not prepared to answer that question either.

Did you think of having an abortion?

I personally did not consider it. My moral position on abortion is that I would not be able to justify it to myself. This is something that people have to decide for themselves. My decision was: No.

When you have a child and are looking after it, you will obviously not be able to maintain the same level of political activity. Have you thought at all about how you will reorganize things?

I have, but I don't know exactly how it will work out. Other MPs manage to combine a family life with their political activities.

Is that quite the same thing?

Perhaps not, but still I am quite confident that I will be able to do the ordinary day-to-day work of making representation on behalf of individual constituents and so on. I do a lot of this at home anyway—typing letters, making phone calls to government departments and local government offices, etc. That side of things should not present any great difficulty. What I will almost certainly have to curtail is addressing meetings around the country.

Is that an important part of your activity?
It has been in the past, but I don't think that curtailing it is going to make me ineffective. I shall just have to plan my activities more exactly.

What has been the pattern of your work until now? What, for example, have you been doing in the past week?
Well, let's see. I came over from Ireland last Wednesday where I had been speaking in Limerick and Galway. I spoke at meetings of trade unionists in Bristol and Southampton on Wednesday and Thursday and in Acton on Friday. I went to Belfast on Saturday for the conference of the Socialist Labour Alliance which lasted until Sunday evening when I came back to London. On Monday I was at the House of Commons. I put down some questions about the Keane case, Harland and Wolff, the use of CS gas and other things. And I attended the censure debate on prices and unemployment. On Tuesday I went back to mid-Ulster to talk to my political associates and my family and I came back here last night. I have a meeting in Ilford tomorrow night, an anti-Tory rally.

It's a heavy schedule. Is it a typical one?
Fairly typical. I also visited "Butch" Roche, the Commons CS bomber in Pentonville Jail last Friday. I know I am not going to be able to maintain that type of programme over the next few months. I am speaking in Trafalgar Square on 11 July and we have a series of meetings on unemployment planned for mid-July in the constituency. Apart from that there is a lot of organization work still to be done, especially in mid-Ulster itself. That will occupy a lot of time in the next couple of months.

Your 40,000 voters are mainly Catholics. And your family live in Cookstown in the heart of your constituency. Do your relatives know you are pregnant?
I have told my family.

How did they react?
Well, they took it in different ways. But most of them were good about it. I felt better for telling them.

And your constituents? Do you think they will vote for you?
I don't know. At the last election some people questioned whether I was morally fit to represent mid-Ulster. My position now is as it was then. My morals are a

private matter. As a Member of Parliament I represent a political programme. One thing no critic can say about me—they can't say I have neglected the constituency since the last election. And I see no reason why I won't be able to continue to work hard for my people, both in parliament and outside.

I have no doubt that some will be prepared to use my personal life for political ends. And there are some who will honestly, in conscience, not be able to support me or will not be able to do so without a great deal of conflict. Of course I understand this and I am certainly not saying I am owed support. I know that I am not. I believe politics and personal life should be separate but it often is difficult to disentangle the two and maybe this is more difficult in my case than it would be for many other people.

So do you expect to lose some support?
Yes. At the last election I didn't ask people to vote on a basis of personal support and I certainly did not solicit votes on sectarian lines. I hope that most people who voted for me did so because they supported my socialist programme, designed to bring equality and progress to mid-Ulster and to the rest of the country.

Would it not be fairer to have the child adopted?
I recognize the practical difficulties. My child is as yet unborn but in about five years time it will be able to read. Or the child will meet with others of its age who will not hesitate to tell it exactly what they have been told. In such circumstances it might be thought preferable for the child to be brought up in a family with a father and mother. I have made my decision. I feel that it is my right and duty, not somebody else's, to bring up my child.

Society is wrong in penalizing illegitimate children and that very term is a misnomer. There are no illegitimate children, only illegitimate parents, if the term is to be used at all.

The self-righteous argue that every child has a right to be born and therefore there is no right to abortion. Yet they call children illegitimate and imply that they have no right to exist, and give scandal by the very fact of living. My child has a right to live and I do not think that, in supporting this right, I give scandal or set an example that is likely to be followed.

You've said morality is a private matter not to be entangled with politics. Yet you have been prepared to talk about these matters for publication. Is that not a contradiction?

No. I have already said how it is difficult to separate these matters entirely. And in these circumstances some people might want to see me hide and skulk. Others might feel they were owed some explanation. I have spoken to you and I will not elaborate on this conversation in further newspaper interviews.

Are you sure you have made the right decision?
Yes.

2 July 1971

Elgy Gillespie

No Surrender: So Far, So Tribal

In Gormanston, the "primitive conditions" slur from the BBC camera crews visiting the Irish army's refugee camp rankled south of the border. There was a feeling that all the responsibility had been dumped on the poor and inadequately equipped army alone, who knew hardly any rest all week. Eight cooks had been working to serve 4000 refugees in the steam of kitchens meant to cater for 300-600.

Work began at 6.30 a.m. and ended far into the small hours, and always there were loose ends to be looked after, not just the food and the bedding, but the split families looking for lost children in other camps, or for news of home, for prams, for Paddipads, for tranquillizers, for EnteroVioform…

"Last weekend back in the Ardoyne we got no sleep at all, we got a cup of tea now and again if we were lucky," said one woman. "So we can hardly complain down here."

The work went on. The largest hangar was emptied of aircraft while sixteen lorries brought enough mattresses for another 1500 refugees. Meanwhile busloads of kids drove away to Dublin convents and schools. The last load waited to roll, singing, "No surrender is the war cry of the Belfast brigade!"

The other kids, the last few hundred, played with the soldiers, snatching their caps when they weren't looking. Unlike their southern contemporaries they know all the words and verses to "The Soldier's Song".

But their behaviour can be unpredictable. Walking into a hut, I was neatly and brilliantly tripped by a small boy who had been pretending to sweep the steps. Then photographer Pat Langan was lightly thumped by a young girl who giggled as she slapped him. But what had she worked out in her own mind about the muddle? How did she piece together what she saw on UTV and what she'd learned in the streets?

Two years ago in Jamaica Street and in Farringdon Gardens the Catholics were on good terms with the troops. The girl's mother said the neighbours had made pots of tea for the soldiers, said they were glad to give them tea, and her elder sister went to dances with them.

Back in those days the UVF was accusing the troops of being soft on Catholics. Now, the mother adds, the girl throws stones at soldiers with the other kids and sings new words to old songs like, "Where's your peelers gone?" And the soldiers swear foully back and sing their own versions: "Where's your Paddy gone?"

Mothers sat on the beds feeding the children, smoking and talking. They had left it until the last possible moment to move; they had spent the weekend on the floors of their houses under the crossfire. On the Sunday night—according to Patricia MacDunne of Jamaica Street—the Green Howards had wakened every house in the middle of the night, and had made the men march up and down the street in their underwear and pyjamas with elastoplast taped over their mouths so that they could not shout.

One man had been "a fifteen-year-old cripple" (*sic*.). One door had been on the latch, but they shut it again in order to break it down. They raided the Shamrock in Bruton Street and got stupid drunk and were shouting, 'You got one of our effing men shot and we're going to get the lot of you!' "

Then came the paratroopers. "On Monday they really went mad. We had a shrine in one of the gardens for Paddy MacAdorey the IRA leader in Oakfield Street. And they were spitting on it and putting their bayonets through the flowers and shouting, 'We got the bastard today and there's more to come!' "

It was, they said, only since the killing of the three Scottish soldiers in the spring that they had really lost their head. "And that was done by the lot in the Shankill and they know it, they're only pretending not to!" Mrs Annie Lagan of Farringdon Gardens spoke of being stoned out of her house by Protestant neighbours in the same street.

"They wouldn't let us take a stick of furniture. We left in what we were standing

up in and the Green Howards made a human barricade at the bottom of the road while the UVF set fire to the house. Why do they never search the Prods is what I want to know?"

19 August 1971

Anon.

Second Girl Engaged to Soldier Is Tarred in Bogside

Another girl was tarred and tied to a lamppost near the Bogside Inn in Lecky Road, Derry early this morning. A crowd of men and women stood and jeered at the girl for fifteen minutes until others came to her aid and released her.

A cardboard placard—"Soldier Doll"—was hung from her neck. A crowd of about two hundred watched as a woman cropped her dark hair with scissors and then poured red and black liquid of either paint or tar over her head.

She was reported to be engaged to a British soldier. One eyewitness said the girl, aged about eighteen or nineteen, was stopped in the street by at least seven women and brought back to the Bogside in a car. The girl, who lives in Westway, Creggan, was tied to the post by her chest and feet with wire, to the same lamppost as nineteen-year-old Miss Martha Doherty who was tarred there on Tuesday night. Miss Doherty's hair had also been cut with scissors and afterwards closer with a razor, then tar was poured over her head and she was tied to the lamppost while a crowd of about eighty looked on, many of them shouting, "Soldier lover."

Last night, Miss Doherty was jeered as she left her home to stay with friends. She wore a brown wig. Her fiancé, Private John Larter, aged eighteen, of the Royal Anglian Regiment, comes from Suffolk and was planning to become a Catholic before the marriage, which is due to take place in St Columb's Church, Waterside, with an army padre officiating.

Neighbours last night doubted if the wedding would take place as planned. The Army tried unsuccessfully to arrange a meeting between Miss Doherty and Private Larter through journalists yesterday afternoon. Reporters who approached her house in Drumcliffe Gardens were told to leave by her father.

An Army spokesman said: "We hope the wedding will take place on Friday, but we cannot know whether this will be so. If they were prepared to do this to the girl, just what are they prepared to do to her parents?"

Mr John Hume MP described the tarring as shameful. "I condemn it absolutely, but the incident was inevitable with anti-Army feeling running as high as I believe it is running in Derry." Earlier this year, three men in the Bogside shot Private Larter in the hand, as he left Miss Doherty's home after midnight.

Last weekend the women's section of the Official IRA issued a warning that girls fraternizing with soldiers would have action taken against them. In the Bogside, the slogan "Soldier Doll" has been seen daubed on at least one other house. The mother of the family in this house said she had got her daughter away before she could be taken out of the house, and the girl was now staying with friends in a secret hideout.

Earlier, a twenty-year-old factory machinist was taken from her home by six girls and questioned about whom she had gone out with; and she was also asked to name other girls who had gone out with soldiers. Her hands were tied behind her back and she was blindfolded and had her head shaved.

11 November 1971

Renagh Holohan believes she may have been the author; bylines were still rare in the news sections at this date.

Nell McCafferty

We're All Terrorists Now: "Jesus Christ Himself Couldn't Stick It"

"We're all terrorists now!" was a closing remark at an anti-internment meeting organized by the Socialist Resistance Group in Derry last August. Last week in Derry the middle classes entered the arena. At a public meeting of four hundred ratepayers in the city—comprising business and professional people, among them architects, lawyers, dentists, doctors and ex-public officials—a resolution deploring violence from whatever quarter was overwhelmingly defeated.

Nor was any regret expressed at the tarring and feathering of Martha Doherty two days earlier. Violence as a way of life is accepted by all. The eminently respectable committee which raises funds for the internees now sells framed rubber bullets as souvenirs.

On Friday the local Catholic paper, which has condemned violence in the past, along with the IRA, Communism and all things anti-establishment, carried not one single word of condemnation, from any source, of the punishment meted out to the girls who befriended soldiers. The front page carried the story and pictures, but discreetly left out the girls' names.

There were, however, statements from both wings of the IRA, denying responsibility for the incidents, but re-emphasizing warnings against fraternization. Regrets for the incidents are confined, by and large, to the method and not the principle of punishment. In a confused and confusing situation in this city,

where no one group has the erstwhile overall authority of former Civil Rights days, the judgment is that a freelance women's revenge group translated more sanctions against the girls into "excessive and unauthorized action".

But that action has been judged in the context of three years of horrific and continuing violence against a people who have suffered political, economic, police and military oppression, and to whom the tarring and feathering of two girls came a short time after the death of a mother of five children. The close time sequence of the events—the killing of a woman by soldiers, and the punishment by other women of girlfriends of soldiers—is seen as wiping out any more comparisons.

In Derry, they're saying that when Kathleen Thompson was shot, Army personnel said over the radio, "I hope she's dead." Later, they claim, the following Army message was broadcast: "The score is civilians three, military nil, we are now playing into injury time. The Army marksman will be awarded five hundred Embassy coupons."

People to whom I have talked about this were incensed. I have no reason to doubt the truth of their statements, or the accuracy of their hearing. I myself heard some other sentiments broadcast by the Army following the death of William McGreanery some weeks ago.

On the day after Kathleen Thompson's death, the IRA issued a final warning against fraternization. "The time has come for action," the warning said. Posters were put up in the Bogside condemning the soldiers as judge, jury and executioner of the people, and the people themselves then became judge, jury and executioner of girls who befriend such soldiers. And what Solomon will judge the moral, military and political morass into which Derry has subsequently plunged?

Derry has long been a garrison town. The American communications centre in the Waterside provides much-needed jobs and husbands in a city with 20 per cent male unemployment. When the British naval base where troops are now stationed was closed, there was an outcry led by the Nationalist Party at the loss of ancillary civilian jobs.

When troops came to replace the Navy, they were welcomed with smiles and cups of tea as defenders of the minority; and the Catholic Church gave them their first base in the Bogside—in school grounds. The children have since been subjected to CS gas, rubber bullets and, their parents say, vicious verbal abuse.

Martha Doherty met her fiancé in those happy, pre-riot days of 1969. No one objected then to his being a soldier. No one that I could find objected seriously when she was tarred and feathered last week. In the intervening days before the

second girl was punished, the IRA could have—yet didn't—take action against unauthorized groups.

But the IRA alone is not responsible for the area. The Bogside, Brandywell and Creggan are currently administered by three tenants' organizations, two women's action committees, five political groups, and autonomous street defence committees; they have no unified political or civilian voice, but they do have one clearly defined enemy, the Army without the Pale, and one clearly defined objective, survival.

"This is no time to talk of civil liberties," a man who had watched the tarring and feathering told me. "You get civil liberties in a political situation. This is no political situation. This is a war. If these girls who go out with soldiers never consciously give any information, every word they say is a piece in the military intelligence jigsaw.

"And even if they never said anything, they're giving comfort to an army which nightly comes into this area to fight with the people. Man, woman and child, no one is safe. People are dying, people are being interned; children who go to school learn that their classmate was killed the day before.

"We spent the last three years on the barricades night after night, protecting who against what? So these girls can sail safely through with soldier boyfriends? Have you any idea what we've gone through, you who make moral judgments from the comfort of Dublin and London?

"That firm who sent wigs to the girls who were shaved, what have they sent to the children of Kathleen Thompson? Sweet damn all. Nor do they give a God's curse about the soldier's doll. They're looking for publicity. The world outside asks for normal standards. What human beings could live through death, destruction, fire, day in and day out, and remain normal? Who's normal? The girls who comfort soldiers or the girls whose fathers and brothers have been taken away by soldiers?

"What does normal mean anyway? Jesus Christ Himself couldn't stick it. He asked for the bitter cup to be taken away, and He had only three days to suffer. We've gone through it now for three years. There's pressure weighing on us like the lid on a boiling pot.

"There are 35,000 people in this area, and not one of them feels safe. They could lift anybody. They could shoot anybody. And they have done so. And you want to worry about the judicial refinement regarding the trial of three girls who have been out having a good time!"

And what were those judicial refinements? Deirdre Duffy's mother wants to know "if any of their sons died for Ireland, those women who did this to my daughter?" Her son John died in the Bogside ten years ago at age sixteen, of self-inflicted accidental wounds while cleaning a revolver. His death is mourned by the Official IRA annually.

But last week her seventeen-year-old daughter was shaved, tarred, covered in red lead, and tied to a lamppost. Deirdre's maternal grandfather served in two World Wars as a British soldier. Her paternal grandfather was a much respected police sergeant who served in the Bogside as a member of the Royal Irish Constabulary. Her paternal grandmother, a Protestant, became a Catholic. Her brother, Hugh, was a civil-rights activist.

Deirdre's mother brought up five children on a widow's pension of £9.50 a week, eking out the allowance by working as a charwoman day and night. By Derry standards the family is a credit to her; both sons working in a trade, a daughter married and actually housed, and another daughter educated through technical school, working as a secretary.

And then Deirdre herself: the outgoing, friendliest member of the family, who liked to dance? The soldiers offer the only place in Derry to dance nowadays and her dancing went on. But Derry standards last week dictated that she danced with the wrong tribe. She should have gone across the Border four miles away to the dance hall there, she said.

She had been repeatedly warned. Factory girls with whom she had worked had punched and beaten her. One of them was present at her trial last week.

I know her well. I taught her at school. I watched her march for demands that she was told by public opinion were right. I watched her fight in 1969 when she was also told by public opinion that she was right. And I have seen her on the barricades defending the area against soldiers, told again that she was right.

But back in 1969, Deirdre and her friend were told it was right to befriend those same soldiers. To live in Derry now is to know only what is wrong—to know that street lights are out, that jobs are out, that amusement is out, that life itself can be wiped out if you are in the wrong place at the wrong time.

And in this tribal context, public opinion states that it is wrong to step outside and claim the right to enjoyment with those whom your tribe has said is the enemy.

Tribe is a primitive word, war is a primitive situation and the civilized judgments from outside have no meaning here. Derry is no mean city; its people are not mean; by what means, now, can Derry be judged? "You have to live here", said Mary Duffy, "to know."

And several Derry girls, after last week's incidents, have chosen to live here no longer. Some left with their families, some alone.

One girl's father, a railways worker, stopped the train as it left Derry and asked his daughter to come home. She refused. She was going away to England, she said, leaving this bitter place to marry her soldier. She was eighteen years of age. Some of the girls going with soldiers, though not many, have remained behind. I asked one, a nineteen-year-old, if she would continue to see her boyfriend. "Yes, I will," she said. "Even the IRA is saying now that they will not condemn girls who are in love with soldiers. I'm in love with mine.

"I met him in the beginning of 1970 when he was on foot patrol through the city. I brought him home and my parents liked him and the neighbours liked him and nobody then had a word to say against him.

"It wasn't the British Army started the trouble in Derry. It was the police and I hate the police. It was the Stormont Government and they brought the soldiers in to clear up the mess left by the police. My boyfriend doesn't agree with the situation here but he can't understand why the Bogsiders have turned against him now. He's only doing his job and I know he's a good boy.

"I think the Army have been wrong sometimes. But so were we. The soldiers are tortured all the time with people shouting at them, throwing stones at them, and shooting at them, knowing quite well that the Army's not allowed to fire back. Sure the Army has the odd bad soldier in it, but there's bad people in Derry too.

"My boy's parents think that Ireland should be free and wish that he wasn't over here to do the dirty work of the Unionists. I don't think anybody remembers any more what started this all off in Derry. I don't know, and I don't know any more what we're looking for. All I know is I love my fellow and he's kind to me and he loves me and he even wishes we could settle in Ireland, at the Ballykelly camp or somewhere.

"Look at all those Derry girls who married soldiers before this, and there's some of them now who've been living with their husbands in Derry for a long time. Nobody tells them they're wrong, because they met their boyfriends when Derry was peaceful. Well, I met my boyfriend when Derry was peaceful and I'm

not giving him up now. I didn't start this, neither did he. But we're left in the middle and hated by everybody because they don't know who else to hate."

Her mother said, "I'm all mixed up. I'm on the side of the Bogside against anybody that attacks us, but I know Tom is a good fellow, I can't tell my daughter how to rule her own heart. I can see a case being made against the informers, but sure my wee girl is no informer and well they must know it.

"But I'm in fear now that they'll come for her, for who would dare to take her side? Everybody knows there was wrong done last week. Didn't the IRA themselves say the revenge group shouldn't have done it and didn't they say wee girls have a right to love?"

The family, she said, would not remain in the Creggan estate. The Commission had offered them a house out of the area and they would move to the other side of the river. She was in tears. "I'll be leaving all my friends, but then who has friends at times like this? Everybody is afraid to speak up in case their turn comes next.

"They say you can't have friends in a war. It's me that knows it this good day."

15 November 1971

Nell McCafferty

Three Men Die on Barricade: Troops Conduct Described

Three men died on a barricade that I vacated below the high flats in Rossville Street, as four British Army tanks came rushing up the street.

I ran into Colmcille Court, a car-park behind the maisonettes, and burst into a woman's home. As I lay on the floor shots rang out and there was a simultaneous knocking on the door as men cried: "For Jesus' sake, missus, let us in, they're shooting."

The woman of the house let them in and I heard more shots ring out. I looked out the window where, beyond the picket fence of the back garden, a man lay on the ground.

Paratroopers had taken up position at the far end of the courtyard. They rushed forward and surrounded about thirty people whom I had left at the gable wall giving entrance to the courtyard. Among the thirty arrested was a woman whom I watched protesting to the soldiers. A paratrooper struck her across the face with the butt of his rifle, placed his boot against her stomach, pushed her back against the wall, and ordered her to follow the crowd of arrested men.

Later Father Bradley, curate of the Long Tower Church, told me that he had been among the crowd arrested. "I said to the soldiers", he told me, "that one of the men had been shot in the shoulder and pointed him out and said he could not raise his hand above his head like the rest of us. They beat the man then and

set upon me, punching, pulling and kicking me. And then for some reason they let me walk away."

About ten minutes later a group of Red Cross officials came into the courtyard. A young female wearing a white coat with Red Cross clearly marked ran into the middle of the courtyard, waving her arms at the soldiers. I watched her duck and run for cover as a soldier fired on her. Meanwhile the other Red Cross official dragged a body away.

Some time later the soldiers withdrew from the courtyard and I came outside. I joined the Red Cross officials who were administering what aid they could to a man on the ground. They told me that they could not remove him from the area, as the soldiers were shooting anything that moved.

I then went to Free Derry Corner, from which point I watched two women emerge from a house carrying blankets. They placed them over a fallen body and waved across the road at a doctor in shirtsleeves. He crossed the road in the company of more Red Cross officials, his hands raised high, and administered first aid. The body was carried away, and the entrails and clotted blood left behind were covered over by the banner of the Derry Civil Rights Association.

The mound of stone that made the barricades beneath the high flats was also covered in blood and guts. I then went home and listened to Army messages on the radio. "Messrs Hume, Cooper and Bernadette Devlin are over at Altnagelvin stirring it up," the Army messages said. Miss Devlin, who was in the house at the time, rang the Army and informed them that she was not at Altnagelvin Hospital.

Several hours earlier, when the crowd were leaving twelve o'clock Mass in the Iona Tower Church, a soldier who had been taking up a position in the yard of the junior boys' school had said to me and another reporter: "Good morning folks, it's a fine day for killing!"

31 January 1972

Nell McCafferty

Derry Numbed and Restless in Aftermath of Killings

How do you spend the day after thirteen people have been shot dead? For Free Derry it was numb exhaustion, an inability to sit down, a desire to keep constantly on the move, a grim seeking after detail about the events of what we now call "Bloody Sunday".

Nobody worked. No children went to school. Some families do not know as yet where their sons, husbands, fathers fell. Nor have they retrieved their dead. They lie in Altnagelvin Hospital still.

Mickey, aged twenty, died when a bullet pierced his cheek and went out the back of his head. Five times on Sunday night his family saw him singing and shouting on the television screen, but between newsreels his sister tried frantically to contact their scattered family in Wales, Rugby, Strabane and Buncrana, County Donegal, to tell them of his death.

Throughout the last thirty-six hours, the few phones in the Bogside have been inundated with calls from relatives in far-off places, asking to speak to their families up the street or round the corner. Neighbours congregate in each other's houses, often simply walking in with a pot of tea to help out in the crowd.

Rossville Street and the maze of courtyards off it where the boys were shot down was like Calvary and the Stations of the Cross combined, a man said. Here he fell, there he called for help, here he was kicked, there he died. And

there. And there. And there. The blood-stained Civil Rights flag remains on the ground below the high flats, pinned down with a Rosary of flowers. And placed on top of it, in an open matchbox, the ghastly remnants of an eyelid complete with eyelashes, the remains of the man who died there.

There is a merciful threshold of tolerance, beyond which limits the mind refuses to reach. Several times since 4.15 p.m. my mind has gone blank. Others confirm the experience. Did I really see a paratrooper shoot at a girl with a Red Cross uniform? Like everyone else I went back to look. On the wall of the court-yard where I sought shelter in a house there are two deep holes (reminders of the bullets that missed). Like doubting Thomas, I put my fingers into them and checked the diagonal line between the holes, the girl's position in the middle of the square and the paratrooper's position at the far corner.

And then there were the things one had not known about. Six bullet holes in a single window pane of a second-storey flat. Discarded shoes, coats, gloves. The abandoned houses on the perimeter where soldiers had taken up firing position. In retrospect you realize that you were not safe anywhere in that whole area.

We walked and talked in circles yesterday and smoked and went home for cups of tea and came out again. Sometimes it hits you, this awful sacrifice that was made, and then it goes away because there is no comparable experience to which you can relate it. It is almost comforting to hear strangers describe and make intelligible on radio, television and in newspapers the overall picture. It is awesome to hear, *in toto*, what we went through. But it's not enough, and we go back relentlessly to the minute details, the personal experience, and then we ask what could be done to bring it home to the outside world. There is talk of bringing one funeral to Dublin, to march from the Garden of Remembrance to the Dáil.

Beyond the Bogside, the town, it seems, has closed down. I watched six boys throw desultory stones at a foot patrol in Waterloo Square. Immediately a Saracen came out of the barracks, followed by six soldiers on foot. But the boys had run home. The soldiers took up positions anyway, aiming their rifles at a solitary granny who came walking down the street.

Yes, sir, that was telling us. As if we didn't already know. And these soldiers weren't even paratroopers.

1 February 1972

Mary Cummins

Visitor to Long Kesh

You see it, not suddenly. It grows on the pale, February landscape in poles and hangar roofs, an unexpected clutter in an empty space, pastel and grey like the afternoon.

You pass the entrance, and down the road about a quarter of a mile you turn into an open space that is the car-park. Through clouds of cold and winter mist the camp is more defined; you can see figures and corrugated roofs and spaces between the buildings.

Last week, day visits were resumed at Long Kesh after about three weeks off, because the internees were protesting against vigorous searches made before and after visits. Internees are allowed one half-hour visit a week. Three adults and two children can visit at that time.

In the car-park there's a caravan where if you have a pass, you check in and leave any parcels you have brought. That day, a man had to take away bales of wood; they said they could be used as batons. He had brought them for the internees to carve them into shapes; we saw them later, harps and crosses and wooden lockers with little mirrors on top, carried off by their families. Near the caravan were two wooden huts with yellow doors: toilets. The Ladies was locked, out of order. In the Gents were three lavatories in a row, grubby, no toilet paper. The wind seemed to whistle through. In the large wooden waiting-room—steps up to it and a door at either side facing each other—it was warmer. There was a

heater around which we grouped the chairs. In the corner, two Quaker ladies sold containers of tea or orange juice for a penny and little packets of biscuits.

That day, about thirty women and half a dozen children were there. Up to three weeks ago there was no hut for them to wait in. Through the winter months, they waited in all kinds of weather in the open car-park for their names to be called. Now they wait in relative comfort, with chairs to sit on and white painted timber walls crying out for a witty or aggrieved pen. Already some of the walls are well covered. "Up the boys", and "Up the Tyrone boys", among the graffiti as well as lines of songs and poems.

We sat around sipping our tea and wondering if we would be called. Because it was the first day visits were resumed after the internees' prolonged but successful protest, nobody was sure if it was all over. Somebody had rung Long Kesh in the morning and was told she would be allowed to visit; but they said the same thing had happened in the previous weeks—one had sat until 8 p.m. before being told that she could not see her husband. The army's explanation was that if the men would not accept their visits, it wasn't their fault.

We cracked jokes to cover my nervousness; they said I'd probably only get a year if I was caught. I turned my ring around to look like a marriage band; I was supposed to be the internee's sister-in-law, so I repeated my name and address over and over again to drum it into my head and blot the other one out. My accent? "Just keep your mouth shut, I'll do all the talking. Just answer any questions and don't raise your voice."

The woman who was taking me in had been coming since November. She knew the ropes. We waited on for about half an hour, her more patient than I. This is nothing, I was told. You could be here until five or six o'clock. One woman from Ballymurphy with seven young children at home, all under eleven, left at 11.45 a.m. to get to the Falls Road in time for the bus which runs to the camp for five shillings a head. It left there after two. It was now after three o'clock. Almost all the women were in the same boat, having to leave their children in the care of the oldest, usually aged between eleven and fourteen. They talked about the young boy who was electrocuted recently while his mother was away visiting his internee father. They worried about the children coming home from school; they might get shot; they might get run down; they could get hit by a rubber bullet or into a fight.

At last the warden came to the door and started calling names, one by one. We waited. We were almost last, and with another warning to stay behind her and

say nothing, the woman and I moved out of the other door, down the steps, and into a Sureline Coach. "At least we're this far." We sank back relieved. After about ten minutes the coach moved off, down the road. We sang "Dublin in the Green" and "The Men Behind the Wire", and gave the V sign to two passing Saracens.

A tiny, whippet-thin woman with a mass of black, wavy hair led the singing. She knew the ropes too. Her husband is in Long Kesh and her three brothers variously in Magilligan, the Maidstone and Crumlin Road. She makes about three or four visits a week, a half an hour at each one. Between her own and her husband's relatives, near and far, forty are interned. And her house has been raided thirty-one times since 9 August. She laughed, tossing her hair and sang louder as we approached the entrance. A bland, ironic sign, "No entry beyond this point without a pass."

We had to wait while an armoured car with soldiers, guns at the ready, pulled out slowly. They looked back unblinking at the tongues stuck out. At either side of the entrance, there's a post covered with green netting and topped with timber. You could just make out a figure in each, but anyone taking a pot-shot would have to be an acrobat.

The coach drove through slowly. Mud, yellow and slimy on the ground. Just inside the entrance are the Army huts—not Nissen like the internees' but spaced out. "Look at them," I was told. "Look at the difference between those and the ones inside." Soldiers walking around. Young; some of them looked about fifteen. "Watch that one," they said, "you should have heard the language of him to us last week. You wouldn't repeat it."

The coach stepped outside a wooden building. Wardens and soldiers outside. One soldier called the names one by one. Ours were called. We went in shaking and passed him while he looked us up and down, forty shades of green. Inside two soldiers sat at a desk checking the passes. They gave us a good look but didn't ask anything. We went into another room where there were two youngish girls in green uniforms. We passed them and sat inside. After about ten minutes they came in and went past us through another door. The women started moving in, one at a time. The searches had started. Panic. Once again I went through my bag. Everything identifiable gone except, Christ, a cheque with my name on it. "Stick it down your bra … no, in your boot … no, in your knickers."

Tried them all and none of them safe. Then my motherly friend said to give it to her, and hid it in her copious holdall.

Then it was my turn. "Remember your name and say nothing else." Inside,

they asked the name and wrote it on a large brown envelope. One took my bag, took out keys and matches, and put them in the envelope. The other one said "Open your coat."

Then she started at my head, felt my hair, down to my shoulders, breasts … she'd have found the cheque in my bra … waist, examined my belt, pulled up my jumper, felt the waistband of my skirt, down to crotch, thighs … she'd have found the cheque in my knickers. Asked me if I had anything in my boots, then opened them, felt the toes and tapped the heels. Asked if I had anything in my pockets, then put her hand in. Turned me around, frisked me down the back. And finally—this took about three minutes—let me go.

Inside another room at the far side of the search room, the women were sweating. They thought they'd got one. After about another ten minutes, a warden came to the locked door and started calling names, one by one. They went out. He locked the door again. Opened it again to let other visitors back in. They came carrying harps and plaques and handkerchiefs painted with heads, internee names, and drawings of the wire.

Then it was our turn again, almost last. It was five to four. We went down the steps onto the muddy path. A high wire fence on both sides and a high gate ahead with Long Kesh Internment Centre, white on blue. And barbed wire all around each fence. The compound ahead stretched out of the slush. Guard dogs howled and barked inside somewhere. Lots of soldiers. Trees, muddy green and bare and patches of grass outside the fences.

It was desolate and grim, bitterly cold, and no description except concentration camp seemed proper. Clichés came to mind and fitted … cages, pigs, brutality, injustice, victims.

The warden led us down into another wooden hut with a long, narrow corridor. Wardens outside every door; small numbered cubicles. The woman gave her name, a warden told us the number. We went in.

The internee was sitting at a table, four chairs. She whispered who I was in his ear while kissing him, and we smiled without fuss. Outside the warden looked in. There was a whitened out window and it was warm enough. "But don't let this fool you," he said.

"It's as cold in the cages as it is outside." Flagged floors, he said, and a space under the door to let in the wind and rain. They all had to get warm underclothes and layers of jumpers after being put there.

He's a mild-looking, middle-aged man with a lined, worried face and fingers

stained dark brown with nicotine. He lit cigarettes, topped them halfway through, and seconds later lit them again.

They hadn't seen each other for three weeks and in hurried fits and starts of conversation they told each other the news. Their fifteen-year-old wanted to leave school, so-and-so was lifted, the housed was raided. When he heard that, he jumped up and shook a clenched fist at the door. "I'll get the bastards, why don't they leave you alone?" She said, "Pigs!" and then he told her about a fellow they both knew who was put in recently. He was a young fellow with no cigarettes and a blackened ear and a closed eye. He was doing his best for him.

His voice came in short, hurried sentences, as if now that we'd got here he didn't know what to say, then remembered something, then rushed on to another topic. "Don't keep telling me things I can read in the paper," he rasped at his wife. "Tell me things I don't know." Afterwards she said his nerves were bad since he was put in. In a wondering voice she said: "He never used to be like that. Never raised his voice to me."

They are wakened, he said, at 7.30 a.m. Breakfast of an egg, tea and bread and butter at 8.30. Then they do the chores they are allotted, cleaning and such. Each cage has an OC and each compound a Quartermaster and an Adjutant. Lunch of meat, potatoes and another vegetable is at 12.30 p.m. Then they have tea at 4.30—an egg and tea, bread and butter like breakfast, maybe one sausage. The food, by common admission of the wives I spoke to and the internees, is bad. Tea is the last meal of the day. Usually, at ten o'clock they are locked into the huts and lights out, but this is left at the discretion of each hut. In a grumbling voice he said, "Some of them are so carried away with the woodwork it's all hours sometimes."

In this hut they have a kettle and can do a limited amount of heating up of food but he told his wife that the packets of soup she sent were no good. She would have to cook it. She couldn't put it in a flask as flasks aren't allowed. Neither are tins. He asked vaguely what the layout was like on the side we came in. But he didn't look the type who'd get away. He remembered some bars of chocolate in his pocket and gave them to his wife for the children. He showed us a letter she sent him with colourful descriptions of the paratroopers, most of it blackened out, leaving desolately, "I love you too," at the bottom of the page.

The worst side of it? His face contorted: worry about the family, the food, being shut up, and fellows getting on your nerves. The endless talk about the 1940s and '50s. He stopped. It seemed too painful. He asked his wife to send

more handkerchiefs. "And write," he said. "It's great to get a letter." At three minutes to half-past four the warden knocked at the door. The woman said, "Take your time, it's not up yet!" and we stood up. They hung on to each other, and the warden told us to move on. Then he was gone, saying, "Don't forget to write!" with the warden looking backwards down the corridor.

The other cubicles were empty. We went outside again, the gate was opened. We looked for him on his way back to the compound, but he must have been round the other side. No sign of him. And we were the last out. Into the wooden huts again, claimed our matches and keys and other stuff. Into the bus, the women and children more silent now. Back to the car-park. Into the waiting room for the bus again. It was getting dark. The road quiet. The field with thirty caravans beside the camp for the English wardens was silent.

The woman from Ballymurphy who had left home at 11.45 a.m. got home at 7 p.m.

24 February 1972

Renagh Holohan

Explosion Wrecks Belfast Station: Night of the Big Bangs

Seventy people were treated for shock and there was extensive damage when a huge bomb exploded in a car-park at Glengall Street in the city centre yesterday afternoon. Estimated to have contained between 100 and 150 pounds of gelignite, the bomb was one of the biggest the city has experienced.

The bomb, left in a parked van behind the multi-storey Europa Hotel beside Great Victoria Street Railway Station, exploded at about 3 p.m. Six telephone calls warning about bombs, but all giving different locations in the same area, were received by police and there was considerable confusion before the blast. One of the calls said that there was a bomb in the railway car-park but was no more specific.

According to one report, a youth had driven the co-op van, which had been hijacked earlier, into the car-park and before running away yelled, "You have thirty minutes to get out!"

The bomb went off about fifteen minutes later before the area had been completely cleared. There were no serious injuries.

The explosion caused extensive damage, rocked the whole area and was heard over most of the city. The roof of the railway station collapsed and two trains were damaged. Train services from the station were delayed and only two platforms are now in use.

Every window at the back of the Europa Hotel was shattered and many at

the Glengall Street side were also blown out. All the buildings in Glengall Street received structural damage and nearly seventy cars were affected. Six were burned out.

I had just left the Europa Hotel and had turned into Glengall Street where my car was parked when the bomb went off. It's difficult to describe what happened. There was a huge bang, which seemed to shake the ground and buildings for some time.

I was knocked off my feet and fell into Great Victoria Street. Showers of glass and debris rained down and, looking up, I saw whole panes of glass fall from the Europa Hotel into Glengall Street. I got up, pulled my scarf down over my face and staggered across Great Victoria Street.

People were running in all directions, some of them crying, but the glass and debris that hit us was in small fragments and no one seemed to be hurt. There was no screaming or hysteria, just people running about crying.

By now, a few seconds after the blast, the atmosphere was black with smoke, dust and debris. Apart from the dust in one's eyes, it was impossible to see more than a few yards. No one knew where to go or what to do. Flames coming from the back of the Europa could be seen shooting into the air.

There was utter confusion. I felt fear more than hysteria. I thought I had seen the huge hotel shake and I now thought it might collapse. I didn't know where to go as I didn't want to leave my car.

Traffic came to a standstill in Great Victoria Street and people sought refuge from dust and debris in shops.

I had eventually sheltered in a dry-cleaners across the road from the Europa, but now attempted to make my way down Glengall Street to rescue my car, which so far was undamaged. As I walked down, odd bits of glass fell on top of me and I had to pick my way over pieces of wood and windows.

British Army vehicles screeched into Glengall Street from both directions. The area was cordoned off for fear of a second bomb and I, shaking all over but otherwise unhurt, was sent back to Great Victoria Street by a soldier who told me my legs were more valuable than my car.

Ambulances and fire brigades then arrived. The fire was dealt with and the injured, suffering from shock and minor cuts, were taken to hospital. A policeman rescued my car and I was taken off by the army who insisted I was in no state to drive and I was given tranquillizers by a military doctor at a nearby barracks. I was then deposited at my office by armoured car.

Inside the Europa Hotel, a target for bombers on several previous occasions, some of the emergency exits were blocked and guests on the top floors were trapped for a number of minutes. Some of the badly shocked included the kitchen staff who were changing shift at the time and some old-age pensioners in a nearby home.

The Unionist headquarters in Glengall Street was damaged and all buildings in a 250-yard radius were affected.

The bomb blew a six-foot by three-foot hole in the car-park. Afterwards, the whole area was full of charred wood from the station roof and water used to extinguish the fire. Two trains lay crippled in the station.

(∗∗∗)

Mr Donal O'Higgins, UPI manager for Ireland, was inside the Europa Hotel when the bomb exploded. He escaped serious injury. He said, "I drove up to the Europa Hotel car-park at about 2.45 p.m. and there was sixty-year-old Thomas King, the attendant, greeting me with a smile.

" 'I've saved your special space for you, Mr O'Higgins,' he said, waving me to a corner near the Great Victoria Railway Station.

"A few minutes later, sitting on the bed in my room, I reached for the telephone and called the London office to check in.

"It's a pretty quiet day," I told them and said I would make a few checks, put the phone down and stretched. There was a tremendous roar… Then the six-by-six-foot window of my room shattered before my eyes and wood and debris spewed across the room.

"Something … maybe it was part of the ceiling or the window frame … struck me violently on the head. I lost consciousness and slumped to the floor.

"I came to, lying in a bed of glass with the sound of someone screaming and banging on a door ringing in my ears.

"I rushed to the door, threw it open, and yellow smoke billowed into the room. An elderly chambermaid was standing on the threshold crying. I took her by the hand and rushed towards the fire escape.

"On the way we encountered three young girls with blood streaming down their faces. The five of us made our way down the fire escape to the ground, nine floors below. An ambulance took them to a hospital and I went to look around the building.

"In the parking lot firemen were spraying a hose on the remains of a car parked only five yards from where the bomb exploded. It was my car, in my special parking place."

23 March 1972

Mary Holland

Aces that Whitelaw Can Play in Direct Rule

There are no fresh starts in Irish history. If there is one thing that Mr Whitelaw should note from immediate reactions here to direct rule, it is how both sides have responded instinctively, out of their past experience, along traditional and apparently irreconcilable lines.

It is perhaps not quite clear in England how the news is seen here. For all the talk of proroguing parliament for a year, the Heath 'package' is understood quite clearly to mean the end of Stormont, of fifty years of Unionist government, of Protestant supremacy in Northern Ireland.

Catholics claim it as a victory. Protestants lament a crushing defeat. Both see it as a step on the road to a united Ireland, which the Catholics passionately desire and to which Protestants are implacably opposed. Talk of a "fresh start" implies a family quarrel that can be solved because both sides start equal and want to make things work. The Ulster problem is rarely amenable to such cosy domestic interpretations.

What direct rule does give is a breathing space to a people appalled by their own capacity for violence. How long or how short a breathing space will depend on Mr Whitelaw's skill in dealing with the immediate reaction to direct rule—reassuring the Protestants that their fears about a united Ireland are groundless, making the best use of Catholic euphoria.

If he is lucky and the Protestant masses fail to react in the way that Mr

William Craig and others of their leaders have threatened, he will avoid the need to deal harshly with them and provoke the kind of hostility between the Protestants and the British army that has hitherto marked the troops' relations with the Catholics. If he is twice blessed, all factions within the IRA will accede to demands for a truce if only because they must realize that the mood in the Catholic area is one of happy victory, and that to renew a campaign of violence at this stage—bringing in its wake the dawn searches, the CS gas, and the rubber bullets in the cramped streets—would be to go against the wishes of their own supporters.

But even if he draws the two aces from the pack, Mr Whitelaw will still have to face the issues that have brought down three prime ministers of Northern Ireland in as many years—violence in the streets, the need for dismantling and then rebuilding a whole machinery of government right down to local level in order to ensure an effective end to discrimination, and the intractable problems of deprivation and unemployment.

Going for him, Mr Whitelaw has the fact that most people in the province are heartsick and weary of death and maiming, violence and repression. If he can demonstrate convincingly that political and social advance can be made without these things, then it is just possible that the people as a whole will push the politicians into making the new order work.

If the army can be seen to be part of such initiatives, if it can hold off its violence, that will help. It may be that the army won't get that opportunity and, at all events, it probably can't hold off for very long. Sooner or later the guns in civilian hands must be collected and inevitably that will mean searches and accusations of brutality. But if Mr Whitelaw can be seen, immediately, as the bringer of peace and quiet nights that will be a big mark in his favour.

These are tenuous lifelines. Against them one must range the reactions, as so far expressed, of many politicians. First, because they are the most vocal at the moment, the Protestants. The Parliamentary Unionist Party has already made it clear that it does not intend to cooperate with Mr Whitelaw, nor to serve on his Advisory Commission. Instead the members will meet every week at Stormont to consider the government of the people they represent and will hold regular "Cabinet" meetings.

It was Unionist Chief Whip Captain John Brooke who spoke most intemperately of Mr Heath's meeting last week with Mr Faulkner, comparing it with Hitler's meeting with the Austrian Chancellor Dr Schuschnigg prior to the fall

of Austria in 1937. All the signs are that the Unionist Party will now move openly into what many people here suspect has been its posture all along—close cooperation with Mr Craig and his Ulster Vanguard.

At the monster Vanguard rally last Saturday, there were delegates from more than twenty local Unionist parties. At his press conference yesterday, Mr Craig said he was confident that Vanguard and the Unionist Party would move much closer together and added that, if Mr Faulkner was prepared to lead his people in resisting the Westminster Package, they would be happy to welcome him.

It is clear that Mr Faulkner has written his way into Protestant history with his resignation. His popularity is at an all-time high. An editorial in the *Belfast Newsletter* consciously echoes the mood of 1912: "Today we may be lonely but we are not alone. We have a leader. And we have a people more resolute than at any point in the history of our State."

Carson's mantle, it suggests, is there for the taking. Whether Mr Faulkner is the man to wear it is another question. He is not by temperament likely to be sympathetic to the suggestions made by Mr Craig: the arming of Protestant vigilantes, compiling dossiers on known members of the IRA, making plans for the setting up of a Provisional Government. This is largely sabre-rattling. What everyone is waiting to see, including Mr Faulkner, is what response Mr Craig gets to his call for a two-day strike starting on Monday.

If Vanguard can bring the province to a standstill, if in particular there is a real response from the police and public service officials, they will probably be encouraged to mount a widespread campaign of industrial stoppages and civil disobedience with the aim of "bringing Heath to negotiate with the majority".

Where this leaves the Reverend Ian Paisley is the question looming over Protestant Ulster. He has been effectively excluded from the alliance which includes Vanguard, the Unionist Party, the Loyalist Association of Workers and the Orange Order. Many of his supporters have been confused by his moderate stand lately and by his call for more complete integration of Northern Ireland within the United Kingdom. But if the Protestant masses turn away from Mr Craig, fearing the Vanguard campaign can only lead to more violence and some kind of Protestant UDI, Mr Paisley would then be in a very strong position. He will be seen as a leader who has been moderate in times of stress and whose only demand to Westminster has been for complete reassurance on the links with Britain.

Among some people, there is a real fear that Protestant frustration may be vented in attacks on Catholics living in isolated areas. If this should happen, it

would immediately bring the IRA back into play. While internment lasts, the big banned marches will continue to demand the release of all prisoners. If the army stops the Easter commemorations, and violence follows, this could be enough for the IRA to convince many Catholics that nothing, after all, has changed, except that now they have an Englishman—and more suspect yet, a Scot—in control.

This brings us back full circle to the beginning, to the problem of a United Ireland and the conflicting desires of Protestants and Catholics over the future. It is this nettle that Mr Whitelaw will have to grasp if he aspires to be remembered as the man who brought lasting peace to Ulster.

26 March 1972, The Observer

Mary Holland

Second Thoughts on Sunningdale

After fifty-five hours of talks at Sunningdale, just enough agreement was reached on the new Council of Ireland to save Northern Ireland's seventeen-day-old power-sharing executive from collapse, Mr Whitelaw from losing his reputation as peacemaker *extraordinaire*, and Mr Heath from the nightmare of having to add new failure in Ireland to his multitudinous other problems.

From the beginning the Social Democratic and Labour Party had made it clear that, unless a Council of Ireland with tangible executive powers was set up, it could not take its places on the executive. Mr Faulkner had retreated somewhat from his original position that the council could only be advisory, but was still adamant that the Southern Irish government must give formal recognition to Northern Ireland's constitutional place within the United Kingdom. In the end the main contending parties, aided by the respective sovereign governments, yielded just enough. Mr Faulkner accepted the Council of Ireland and in return the SDLP endorsed Mr Liam Cosgrave's formula for the southern government's recognition that there could be no change in the state of Northern Ireland without the consent of the Protestant majority, a formal reiteration of official southern policy since the crisis began.

Whether this concession will be enough to save Mr Faulkner remains to be seen. His acceptance of the new council has already been described by a Belfast university professor as "the most shocking betrayal since the Nazi massacre of the Jews in Warsaw".

Mr Heath appreciates that Mr Cosgrave is anxious to cooperate on the question of sending IRA men to the North to face trial but that it is proving notably difficult to get the extradition orders enforced by courts in the South.

The question of the police and of the status of the Royal Ulster Constabulary was the most vexing issue discussed. I have already explained in these pages that the RUC is a force of particular potent significance to both communities in Northern Ireland. To Protestants it represents their protection against Republican lawless, to Catholics it seems the strong arm of the Protestant state. It is a very long time, indeed, since any policeman in Northern Ireland attempted to arrest a drunk in one of the exclusively Catholic areas of Belfast, for the good reason that if he tried it would provoke a political riot. To try to gain acceptability for the police force, the SDLP has demanded a new police authority be set up under the Council of Ireland, which could control forces on both sides of the Border.

Here, the Unionists baulked at meetings with Southern policemen. Consultation with the Council, yes; but the RUC unchanged and unrestructured must remain. In the end the issue was put to one side, in the pious hope that as things get better in Northern Ireland and a general lawlessness fades from the civil scene, the whole problem will become less acute and fade away.

That is what, to plagiarize Conor Cruise O'Brien, might be dubbed the benign scenario for the Council of Ireland's future. The general hope to emerge from Sunningdale is that if enough people can be persuaded that the new institutions—the executive, the Council of Ireland—can work, then they will work.

It is understandable that Mr Heath should want to get Ireland out of the way before gloom descends to envelop a fuel-less nation. It is hopeful that everyone involved in the Sunningdale talks has sufficient incentive to reach agreement, to ensure that the frail vessel of power-sharing is not grounded before it ever reaches the open sea. But to assume that this is the last of the Irish problem may be premature. Lord O'Neill, formerly Captain Terence, produced a cautious turn of phrase on the BBC the day after Sunningdale: "Extremists have tended to be successful often in Irish politics."

14 December 1973, New Statesman

Elgy Gillespie

Gospel of Two Union Jacks on High

Six to seven years old, the Martyrs Memorial Hall seats 3000 within yellow brick with dangling white lights and "We preach Christ crucified" in bronze on the back wall as its only ornamentation. It would make some poor homeless symphony orchestra a wonderful home; Belfast's Whitla Hall looks like a labour exchange beside it.

It has no altar; just a pulpit bang in the middle with stairs, up which the Reverend Ian Paisley strides in order to announce Hymn 34: "I'm not ashamed to own my Lord!"

We all get to our feet and start belting it out, every member of the packed congregation singing lustily, as never happens in any other kind of church. Every female in the building is wearing a large hat, except for me. Young girls seem to fancy floppy-brimmed straw in white or black, matrons favour the stiffer brimmed boats and neat navy and white, while the glamorous grannies go for the petalled pillbox effect.

As well as being the only one not wearing a hat, I'm the only one not carrying a Bible. But I get many welcoming smiles, and the old man next to me offers me a share of his.

Meanwhile we were still belting, "I'm not ashamed to own my Lord!", interrupted every now and again by the Reverend Ian, urging us to "Raise a shout they'll hear way over in Mountpottinger Unitarian Church!" Afterwards they explained to me that the Unitarians were enemies of the True Church, because they believe

Jesus was just a Good Man and don't believe in His Blood Shed for Us.

"Louder!" he cried again. "And the burden of my heart roll away," we roared back, the lady behind me adding, "Oh, happy d-a-a-a-y!" by way of a spontaneous solo. Then we sang something about, "Firm as a rock His promise stands", and the Reverend yelled, "You couldn't say that about the Vatican, could you?" and started the balcony singing against the ground-floor pews, in a competition to see who could sing the loudest. We won.

Then the Reverend Ian called us to prayer. Young Kyle Paisley in the front row, restive and bored, put down the crayonning book his mother Mrs Eileen Paisley had handed him and suddenly flopped over to touch his toes. Meanwhile, the Reverend thanked God we still had our old-time religion; the Reverend prayed that the hard times would ease—there were still bombings, there was still terror (gusty sighs from the back of the hall), but we knew Christ, we could be born again! Cries of "Hallelujah" and "Amen" from around me.

The gentleman to my left and I each held half a Bible together in the Authorised Version while we read Matthew 16. The Reverend Ian trumpets, "And we preach no modern-day perversion!" He warns us of the danger of quoting the Scriptures out of context, and—in case you are interested in theology—added that the reason the Romish Church was not the true one was because it was built by Peter, whereas we could all see that Jesus had said to Peter, "Get thee behind me, Satan!" He added that the passage was all about self-denial, "but there wasn't much self-denying where the Pope was concerned, was there?" Loud laughter. "Do you know how many bedrooms the Pope has in his palace? 340, and what he does in all of them I wouldn't like to say. I'll leave it to your imagination." Louder laughter.

By this time we were all in a jolly, singalong mood. Notices followed: thirty-nine members of the church had gone down to Dublin to distribute pamphlets and literature. We all wondered and wanted to ask how they had done, but he didn't say. "The sower soweth his seed…!" he boomed, and so we all guessed that the seed had fallen by the wayside, upon stony ground and amongst thistles.

But now we came to the really interesting stuff, the question of the First Assembly. "Some of you might have wondered how there were two Union Jacks flying from the roof while we held our Assembly. Whitelaw didn't want them two Union Jacks to fly. But I had a wise word in the ear of a workman…" (appreciative laughs, since Paisley's staunchest followers are workmen, while Whitelaw's are not). "… And he gathered around with the other workmen and when Whitelaw said to them, 'Furl them flags!' those flags were not furled. I

heard afterwards that every man in the building refused to furl them. Them flags flew, and Mr Gerry Fitt and Mr John Hume didn't like it.

"In case you think we did it because we weren't getting anything out of the Assembly, let me tell you that Mr Craig and I were asked about it by the National Executive, but that wasn't why we did it. Mr Mitford didn't like it because I knew more about parliamentary procedure than he did. You can only be called upon a point of order if you leave your chair, I wasn't asked to take my chair. They didn't mention the time Miss Bernadette Devlin crossed the floor of the House of Commons and tore Mr [Reggie] Maudling's hair out."

The unrepenting Reverend Doctor strode on to tackle ecumenism: "I went to see Archbishop Simms. 'Oh,' says he, 'don't you know the Catholic Church has changed?'" He imitates Simms' hands deferentially clasped in prayer. "But I get three Catholic papers a week, and in the *Catholic Herald* I showed him this." He brandishes a photo of the Pope with the headline, "Reaffirms Authority".

He chilled us with some graphic and blood-curdling stories of what they did to heretics in the Inquisition, pouring oil on their heads until their skin cracked. "Do you know the Papists don't think their Pope John has saved his soul, for they're still saying Masses for it." He told us the one about the Belfast man preaching at Hyde Park Corner. A drunken Irishman comes up and cries "What about the shamrock?" The preacher replies, "The only rock I'll stand on is the Rock of Christ. All other rocks are *sham*-rocks!" The congregation had heard that one before; there were groans.

"We don't think anyone is infallible. The only infallible thing we know is the Word," the Reverend Gentleman concluded, triumphantly brandishing his Authorised Version above his head. He announced the collection hymn next—no plastic buckets, this time, but pound notes featured prominently in the bowls. Last week, they told me, the collection had been very nearly £350.

When we filed out, my Bible-sharing gentlemanly neighbour asked me if I had enjoyed the service. A matron asked me if I was over visiting and where from. Dublin, I said. They smiled kindly, not knowing what to say next. And then the good members of the congregation passed along loaned copies of the *Protestant Telegraph* (you're not allowed to buy things on the Sabbath) and went home to their God-fearing suppers.

4 June 1974

Profiles

Rose Doyle
talked to Gerald Davis

Gerry "Bloomsday" Davis: "I'll Show Them!"

Gerald Davis has spent the first forty years of his life in Dublin. Since he has no desire to spend the next forty anywhere else, he'll probably spend them here too. He loves the city, and the feeling seems to be mutual. He says he likes to think of himself as a businessman who is an observer and patron of the arts. Most people who know him think of him primarily in the second role as well as being an active and fine painter in his own right. His business acumen is probably what keeps him on top—in a position to observe, to help and to stay involved. What he says of himself is that basically his profession is that of "a businessman who happens to be very interested in the arts … and I happen to paint as well."

That he's only a second-generation Dubliner comes as a surprise, since he appears so much an indigenous part of the city. But then, there aren't too many second-generation Dubliners around these days anyway. His grandfather's generation of Jewish people came to Ireland from Lithuania around the turn of the century. They were mostly Tallymen who went around the country buying and selling.

"A lot of them used to buy feathers. I'm not sure what my grandfather did—but he wasn't very successful anyway because my father shouldered the responsibility for the family from when he was about fifteen. We're only blow-ins, like Mr Cosgrave said…" His father moved from van to shop and he remembers him

selling hobnails, shellac, and razor blades during the war years—rare and much-desired commodities. Gerry was younger than seven then, but it's all there in the scattered childhood memories.

By the time he was sixteen his father had established Davis Stationery of Capel Street, and he became part of the firm in the tradition that learns from the bottom up "the importance of working". Leaving school so early he felt that he "was losing out by not going to college, as all my contemporaries were doing". At school he'd been encouraged to paint by a very special teacher called Christopher Ryan, now head of art at St Patrick's College, Drumcondra. "A remarkable man, and to my mind one of the real teachers, in that he educated people, brought out from them what was in them. Painting was the one thing I really liked." Rather than do nothing when he has finished work for the day, he decided to go to the College of Art in the evening.

"At one stage I used to leave work, go straight to the college from seven to nine o'clock, and then to the Pike Theatre where I was acting." His time in the theatre wasn't without its moments—he appeared in the premiere of *The Big House* by Brendan Behan "… and I was in the Gate Theatre in a play; I had two lines, one of which I forgot".

(✳✳✳)

He painted all the while, and in 1962 he had his first exhibition in Dublin Maccabi, the Jewish sports club. "I shared with Maurice Friedberg, who was a big influence on me." There followed showings at the Molesworth and Brown Thomas galleries, and one in Trinity. He was part of a group exhibition in New York and had a small one-man show and a London show in 1977. Joyce and Beckett have been major influences on the way he sees things. His last show of importance at the Barrenhill was something of a performance as well. He'd started reading *Ulysses* again that year—"In my thirty-eighth year I realized that I was the same age as Bloom. So I thought to myself that I should do something about this."

The Bloomsday pictures were the result. It was in for a penny, in for a pound; he had a Bloom suit made in the manner of 1904, had photos of himself taken in Joycean situations, then painted them. The whole thing had a mischievous aspect which he enjoyed. He was still painting all the time.

In 1970 he opened his own gallery, not expecting to make money out of it. "I just happened to have a space in my premises that lent itself. There were very

few openings for young artists to show in Dublin at the time." This was before the big boom in galleries. Cearbhaill Ó Dálaigh, Chief Justice at the time, opened the gallery. Gerry thinks he was an extraordinarily fine man—"He used to look in and took a continuing interest." He also bought some of Gerry's work.

A number of artists were initiated at the gallery where he's also had the "pleasure and privilege of showing some of the big artists like Eddie Delaney, Charlie Brady, Charlie Harper—and giving people a start who'd never been shown before like Donal O'Sullivan, Pat Connor, Martin Gale, Johnny Devlin. I've had great fun. My policy is to show people who like to show with me, and whose work I like to show, and if anything crops up that I'm really excited about I'll show them. I keep the options wide open all the time for the gallery." He feels that in addition to whatever he has as a painter, "the one talent I seem to have is on the entrepreneurial front. I'm better at managing other people's talent than managing my own because that's another day's work."

He feels his background—the constraints of being in business since he was sixteen—has forced him to be a pragmatic person, and that he's now putting it to the use that pleases him most, working with creative bodies in the jazz and painting worlds. "There's nothing clever about it—you'd want to be deaf and dumb not to realize how good Louis Stewart is." In other words, he was just the midwife and thought it all finished there. But now actor Niall Toibin is also on his Livia label, owned and run and sometimes recorded and designed by Gerry, while his wife Joan has been developing a creative modern dance class.

The blame for the country's lacklustre arts scene he rests squarely with the last Arts Council. "It was very tightly controlled by a very small tight clique. The tragedy was that they destroyed a number of potential artists. That's why the arts have been so poverty-stricken. But in spite of it all, it seems to have risen like a phoenix. There's a lot of talent around, not *great* talent. But good and lively stuff is happening, as lively here as anywhere else. I think America has become jaded— they've tried everything, and Europe has tried everything, and I think England is demoralized—this is the mouldy reactionary coming out!" He's gratified by what the new Arts Council is doing under Colm Ó Bríain: "They've opened things up!"

The businessman in him sees wisdom in giving money to small manageable industries. "This country has been paternalistic for too long. The most exciting thing I see happening is that people are beginning to cop on that we're not idiots, that we can do things for ourselves. All you need is the few bob and the initiative to do it."

The main need is to nourish our own entrepreneurs. "It's great to see somebody like Noel Pearson opening a show on Broadway, and in B.P Fallon there's one of our own lads managing more of our own lads, the Boomtown Rats. We've complained about exploitation for the past few hundred years but now we have the talent ourselves, so let's let do it to ourselves, let's exploit our own selves…

"But then plough it back in. What we have to exploit is the fact we've intellectually colonized the western world. We have Swift, Beckett, Wilde, Behan, Joyce, and that's the type of colonization nobody resents because it all becomes a part of them. We haven't cashed in on that at all. That's the part of ourselves we should be selling, exploiting, instead of trying to sell second- or third-hand country and western rubbish to America, we should be developing what we have indigenously here. The big market is out there. Australia, America, Germany want it all like mad. They want genuine Irish stuff."

16 February 1979

Renagh Holohan

The Toughest Not Only Survive but Win

Renagh Holohan was London Editor of the Irish Times *when Margaret Thatcher was elected Tory leader.*

Mrs Thatcher got where she is not because she is a woman, but because she is a good politician. She is clever and efficient. After winning a scholarship to Oxford she worked as a research chemist and then changed stream completely to study law. She was called to the Bar shortly after her children were born in 1953.

She is criticized for being cold and unemotional, but all politicians are; they wouldn't be where they are if they weren't. Politics is a tough game and players who show their feelings have remarkably short runs. Remember Ed Muskie?

Most men in big business are cold and unemotional, too. But no one attacks them for it because it's acceptable in males; the toughest not only survive but also win. Mrs Thatcher's saving grace is that she looks very feminine. I've met her several times and can vouch for her typically English peaches-and-cream complexion. She is a good-looking, well-dressed, smart, middle-aged, middle-class, typically British woman, and streets ahead of Queen Elizabeth in style and looks.

Of course, a political leader's looks and appearance should not matter, but so many refer to Mrs Thatcher's looks in uncomplimentary terms that they must be mentioned. Was Golda Meir less of a success for not being a beauty? Will Jane Byrne of Chicago be a better or worse mayor for being attractive? Of course not.

Mrs Thatcher is condemned in this country for caring not a whit for Ireland. True; she doesn't. Heath cared a lot and made far more effort—witness the dissolution of Stormont and the Sunningdale Convention—than any Labour Prime Minister ever did, and it didn't do him any good at all. Heath recognized Britain's responsibilities to Ireland. Callaghan didn't even pretend.

Mrs Thatcher is not interested in the North. There are no English votes in it and the British public simply doesn't want to know. If she thinks about it at all, she probably holds the old imperialist, Unionist, Tory view. Her anti-devolution stance hinged greatly on the undesirability of further breaking up the Empire. But Willie Whitelaw is a close confidante and his humane view of the North may control the right-wing element.

I've met Mrs Thatcher and I like her. She is a bit stiff and formal and schoolmarmish, but so what? Should she win, and I hope sincerely that she does, she will have opened up the highest office in the land for women. She forced the allmale clubs of Mayfair to admit women because she was a person who could not be refused. She worked her way up from the bottom, meeting the men on their own grounds, without wailing about inequality and discrimination. She succeeded in doing her job so well that her 280 Conservative colleagues selected her to lead them into a vital election.

If she is a bit unforthcoming on specific policies and refuses to debate with Mr Callaghan on television it is because her advisers know she is ahead and are terrified that some gaffe will wipe out her lead. She is surrounded by advisers— Whitelaw, Keith Joseph and until his murder, Airey Neave—and, as a man from Tory Central Office told me, they are terrified that she will make an irreparable mistake. A woman is such an unknown quantity that her every move is closely watched. She is a risk; she knows it and they know it.

She does, he said, sometimes get a little carried away in debates and argument, so they have to watch her; but her brain and her ability to grasp issues and get to the kernel of a problem are faultless. At the time of writing Mrs Thatcher seems set to win the election. Labour has had an appalling winter and if the Conservatives lose, unfortunately it will be because they were led by a woman and because the electorate weren't yet ready. But I'm confident she will win.

28 April 1979

Maeve Binchy

Beckett Finally Gets Down to Work as the Actors Take a Break

Samuel Beckett has consistently refused to give interviews. Maeve Binchy got permission to watch him directing a rehearsal of Endgame *on the understanding that she would sit there silently. But Beckett came over to talk to her.*

Beckett looks fifty-four, not seventy-four; he looks like a Frenchman, not an Irishman, and he certainly looks more like a man about to go off and do a hard day's manual work than a man directing one of his own plays for a cast which looks on him as a messiah come to rehearsal.

He has spiked hair which looks as if he had just washed it, or had made an unsuccessful attempt to do a Brylcreem job on it and given up halfway through. He has long narrow fingers and the lines around his eyes go out in a fan, from years of smiling rather than years of intense brooding.

He is in London to direct the San Quentin Workshop production of *Endgame* and *Krapp's Last Tape* for Dublin's Peacock Theatre. It will open in Dublin on 26 May. Beckett has been very involved in the San Quentin group since the early 1960s, when he heard what was happening in the big American jail.

One of the prisoners was Rick Cluchey, who was serving what might have been a life sentence for kidnap and robbery but turned out to be only eleven years, and he persuaded the authorities to let the prisoners do Beckett plays. They performed

them in a studio theatre in what used to be the prison's gallows room.

The plays made such an impact on the prisoners, who immediately saw similarities between the imprisonment felt by Beckett's characters and what they themselves felt, that they performed them over and over. The word got out, and it got as far as Beckett in Europe.

Nowadays Cluchey and Beckett are friends, something the prisoners in San Quentin would have thought impossible. Cluchey and his wife Teresita Garcia Suro have called their two young children after Beckett and his wife Suzanne.

Rick Cluchey knows nearly every word that Beckett has written but, when he is in the position of actor with Beckett as director, he says he tries to forget everything he ever thought himself, to strip his mind and memory of actors' tricks and his own interpretations, and just wait like a blank sheet of paper for Beckett to tell him what to do.

This is what was happening down at the Riverside Studios in London where they were getting the rather minimalist set ready for a rehearsal of *Endgame*. They need a chair for Hamm to sit in, a ladder for Clov to run up and down, and a dustbin for Nagg. Nell, the other dustbin inhabitant, hadn't arrived yet (she is Teresita and was coming over from America the next day), so this day Beckett played Nell.

He was endlessly finicky and pernickety about the height and shape of the props. He ran up and down Clov's ladder a dozen times to see was it the right kind of ladder, and whether it gave Clov space to turn around and deliver his lines.

He sat in Hamm's chair another dozen times, raising it and lowering it so that it would be at the right angle when Clov came over to whisper in his ear. I thought I was going to die with irritation and impatience, but the American actors, Bud Thorpe, Alan Mandell and Rick, hung onto every instruction and rushed to carry it out.

Doug Kennedy from the Peacock Theatre in Dublin sat with his notebook, taking heed of all the requirements that would be needed in Dublin. Finally, Beckett got down to words.

The main thing you'd notice is that he thinks the play is a song or a long rhythmic poem. He can hear the rhythm, he can hear it quite clearly in his head, and his work as a director is to get the actors to hear it too. That's why he goes over and over each line, saying it not all that much differently from the actor (in fact you'd have to strain to hear the difference). But it has a beat the way he says it, and once that beat is caught by the actors, it sounds quite different.

He stands there in front of them, mouthing the lines of his own play, word-perfect to the pauses and the half pauses, quite confident that this conversation between wretched imprisoned people is almost the obvious definition of the human condition. He doesn't ever apologize for his own work, excuse it or say, "What I'm trying to say here is this…"

In fact, it seems to stand there beside him, this play, as if it was an important statement, and he is just helping the actors to unveil it.

Beckett is courteous, he never raises his voice. "Bud, may I suggest something here?" he says to young American actor Bud Thorpe, who thinks that, when he has grandchildren, they'll never believe this, not in a million years.

"Alan, Alan, take the rhythm. You have to knock on the bin, the rhythm comes in the knocks, it sets the speed for the conversation. Come, now, I'll get into my bin…"

And Beckett sits down beside Alan Mandell to play the loving scene between the two dustbin-imprisoned folk who can only remember, wish, and regret. Alan Mandell says he'll never forget it to his dying day.

He has ludicrous energy, Beckett. When the actors, all decades younger than him, were tiring, needing a break, a coffee, he was still as fresh as when he started, the tones, the rhythms were running through him; his spare body in its almost traditional uniform of two thin polo-necked sweaters moved from side to side of the stage, bending, crouching, stretching. Even I, sitting silently on my chair, began to feel weary and wished he'd stop for a few minutes.

He did. He lit another of the small cheroots he smoked and came over to me. I looked behind me nervously, assuming he was going to talk to someone else. It had been a very firm arrangement. I could watch but not talk. Write but not interview. I assumed he was going to ask me to leave.

He introduced himself to me, as formally as if I might have had no idea who he was and assumed he was someone who came in off the street to direct the play. He asked how the *Irish Times* was getting on and I gave him the usual loyal craven tale about it being the best newspaper in the world. He only saw it from time to time, he said, but he seemed to go along with my opinion of its excellence.

"I remember it more in the days of Bertie Smyllie," he said. "Did you know him?"

"No, but I believe he was a bit of a personality," I said helpfully, wishing that when Beckett had decided to talk to me I could find something entertaining to say to him.

"My memory of him was that he ran his newspaper from the pubs and that there were circles around him, listening to what he wanted done and running away to do it. He used to drink in the Palace. Is the Pearl still there?"

"No, it's been bought by the bank," I said.

"The bank," said Beckett thoughtfully. "The bank. How extraordinary."

It seemed to upset him deeply. I wondered should I tell him about all the alternative drinking places we had found, but I'd decided that he was more brought down by the notion of the bank owning the Pearl than the actual deprivation of the drink in it.

"And I believe the Ballast Office clock has gone," he said gloomily. I agreed, and hoped he might hit on something that was still in Dublin.

"How do people know what time it is?" he asked.

"I think they sort of strain and look down the river at the Custom House," I said.

"It's the wrong angle," he said.

He was silent then and I wondered was he really concerned about the people not knowing what time it was, or had he gone off on a different train of thought?

"Will you come to Dublin yourself to see this?" I asked.

"Not this time, no, I shan't be coming this time," he said.

His accent is sibilant French with a lot of Dublin in it. Not as lispy as Sean MacBride but not unlike it, either. I was afraid I had given him a bum steer by letting him dwell on the Ballast Office and the Pearl.

"There's a lot of it left, you know," I said.

He smiled. "I'm sure there is, but I must get back to France and Germany ... that's where my work is..."

"What are you working on next?" I asked him.

"A television play, it will be done for German television in Stuttgart. I like Stuttgart, not the town itself, it's down in a hole, a deep hole. But I like when you go up on the hills outside Stuttgart. And I like the people that I work with there. I am looking forward to it."

"Does it have a name?"

"No name, and no dialogue, no words."

"That's a pity," I said. After a morning of listening to his words I could have done with more. Anyway, I'm rigid enough to think that a play should have words, for God's sake.

He saw this on my face, and he smiled a bit. "It will be very satisfactory," he

assured me. "It's all movement, activity, percussion, cohesion…"

"Why do you like working with the people in Germany on this sort of thing?" I asked, the tinge of jealousy evident in my tone.

"Oh, they understand, we understand the rhythm of it…" he said. He picked up the issue of the *Irish Times* that was on my lap and looked at it for a while, not really reading, just remembering.

He had liked Alec Newman, he said, a very gentle man. He had admired Myles na gCopaleen and laughed so much at everything he had written, but had been a bit disappointed when he met him because he had expected too much. There were a lot of things about Dublin that he thought of from time to time. Niall Montgomery. Had I known him? He was a good man.

He decided those actors had had enough rest. He went back to them.

They took up at a part of the play where Hamm has to say, "This is not much fun." Rick Cluchey, as Hamm, said his line, giving it all the weight it deserved.

"I think," said Beckett, "I think that it would be dangerous to have any pause at all after that line. We don't want to give people time to agree with you. You must move and reply to him before the audience starts to agree with him." And Beckett laughed and lit another cheroot and settled in for hours of more work.

14 May 1980

Biographies

Maeve Binchy

Maeve Binchy spent her early years as a teacher, contributing freelance travel pieces to the Irish newspapers in her spare time. "I used to get the occasional article published in the *Irish Times* about my travels abroad and my foolhardy attempts to try and take the pupils on school outings. The paper paid three guineas, but back then that was three pounds and three shillings, a big sum if you thought about it, one fifth of your weekly salary as a schoolteacher.

"I used to pay a typing agency to type my offerings, and everyone naturally assumed that I could type neatly and accurately, as all women do in a newspaper. So when they offered me the job of Women's Editor in 1968 it didn't occur to anyone to ask could I type. I answered the question, anyway, at four o'clock on the first day, when I went around politely wondering who typed what I had hand-written. Very kindly, my colleagues typed up a page in order to save my job and they told me I would have to learn to type that night. Which I did. Two fingers on the left and two fingers on the right, and thumb for the space bar. It's neither accurate nor fast. But it got me through thirty years of journalism and fifteen books, so I can never thank them enough for throwing me in the deep end."

Binchy took the Women First page over from Mary Maher at a time when social issues and political change pieces increasingly jostled men's fashions and Paris couture and cookery columns. At the same time, she was tourism correspondent and Tourism Editor, and probably the most-travelled woman in Ireland. Five years after she joined the newspaper she was living in West London and working in the London office, and Christina Murphy took over as Women's Editor. A year later the Women First page was retired for good, and Maeve wrote: "I don't think there is a special place for women any more in a newspaper. It's like saying, 'We will have a section for redheads or people with long narrow feet…' Women read and write for the whole paper. They don't have to be tidied away into a little corner."

She remained as a columnist at the *Irish Times* until she retired at the age of sixty. She lives in Dublin with her husband, the writer Gordon Snell. Of her fourteen best-selling novels, plays and short story collections, the most recent is *Quentins*; and her work has been adapted for stage and screen, most notably *Circle of Friends* (1989), directed by Pat O'Connor and starring Minnie Driver, Chris O'Donnell and Alan Cumming. Her own account of her early days will appear soon under the title *Anecdotage*.

Mary Cummins 1944-99

Mary Cummins was a National Health-trained nurse from Ballybunion, County Kerry when she became one of Donal Foley's self-termed "babes" in 1969. She left in the mid-seventies and came back again in the eighties, working there until her death just shy of the millennium.

In the nineties Cummins contributed as the regular columnist of About Women, writing on everything powerfully and angrily, from the North to nursing. She was a true *bon viveur*, yet wrote about religion—on Lough Derg, Croagh Patrick, Good Friday—with all the passion of the spoiled nun. On Ash Wednesday she was always the only babe to show a mark on her forehead, and usually the sole employee. It never surprised us, nor did many of the other things she did.

Mary died of lung cancer in 1999. Her daughter Daisy, now an assistant director freelancing in the film industry, recalls Mary's version of how she was hired.

"The story that Mum always liked to tell about joining the paper, to me anyway, was this. Apparently it was in the days when you could just walk in off the street and sell yourself in a very informal manner. She met Donal Foley and told him in no uncertain terms that she was exactly what he was looking for and needed.

"I think he took a little persuading. However, she wore him down through sheer determination, and in the end he had nothing to lose by asking her to prove herself. He may have even got to see the back of her. It was the right approach—and she was taken on as one of 'Foley's babes'. She used this term with such pride, though it would appear to fly in the face of her strong feminist morals.

"Unfortunately that kind of enterprise doesn't really exist anymore, but I find it inspiring in that it could encourage anyone with the brass balls to just march in there and ask for a chance, despite a lack of qualification. What's the worst that could happen? They could get called a babe..."

Rose Doyle

"It was around 1970 and I was working in Personnel. The Arts Department needed a secretary, a source of trauma to all concerned since they didn't like change and the incumbent, Aideen Dempsey, was much loved. Over a couple of days I trotted the applicants in to meet Terence de Vere White, Brian Fallon, Fergus Linehan and Michael Viney for interview. The four were relentlessly

pleasant and polite, and absolutely confused by choice and the need to make a decision. As the last applicant left I told them I'd applied myself. By then they'd become used to me. I was familiar. They gave me the job and that was that, for nine years. Good years they were too, in the tiny Arts Office off the newsroom."

Later, Rose Doyle moved to Brussels and began life as a freelancer, returning to Dublin with her sons and contributing regularly to the Property pages and the Education and Living supplement of the *Irish Times*. She began writing longer stories while in the still-lamented *Irish Press*, where she was finally given a chance to blossom. Like her successor as Arts page secretary, Kathy Sheridan, she had been stuck with children's book reviews and leftover bits and bobs while still in D'Olier Street, one of the ways in which the old order hadn't changed. Now, however, Doyle contributes to its feature pages and makes her living as a teacher of writing and as an author of a dozen novels, the latest being *Gambling With Darkness*, a crime story set in Ireland during the Second World War.

Mary Holland

Irish Times columnist and political reporter Mary Holland wrote for *The Observer* and worked on ITV's *Weekend World* in the seventies, and was by far the most prominent and respected reporter in the North, winning a number of awards including Reporter of the Year. In the late seventies she moved to Dublin and contributed to the *Sunday Tribune* as a political columnist under the editorship of Conor Brady. Later, he moved back to the *Irish Times* and took Holland across the road to Fleet Street, where her columns on the scandals and the growing acrimony of the referenda-ridden eighties became required reading, on a range of issues, including the Ballinspittle Moving Statues, the tragedies of Granard's treatment of a teen who died in childbirth, the story of the 'missing' Kerry babies and the New-Ross teacher's dismissal. Her columns in the paper have remained a prominent forum.

Renagh Holohan

"I had worked on the UCD college newspaper and when I applied for a job as

a journalist—advertised in the paper, but not saying it was the *Irish Times*, I was interviewed by Donal Foley and Mary Maher. The job was as assistant to the Women's Editor. I got it, and went to London as assistant to the London Editor a year later, in 1970.

"The position was vacant and I expressed an interest. It was a wonderful experience; I was very young and I had a great time. I stayed a year before going as assistant to the Northern Editor in 1971. When Henry Kelly left Belfast in 1973 I was appointed Northern Editor and then appointed London Editor in 1974. The Editor or news editor made all the decisions in those days—no interviews or anything at that time."

She came back to Dublin at the end of 1976 and went on to the news desk, writing stories as well. From 1992 to 2002 she wrote the weekly current affairs column Quidnunc and is now an assistant news editor working full time on the desk.

Geraldine Kennedy

"I was the last of Donal's babes, joining the paper in February 1973." Coming from a farming community in County Tipperary, Geraldine brought an understanding of rural affairs and local politics to the paper. Her appointment by news editor Donal Foley coincided with the election of the Liam Cosgrave/Brendan Corish Coaliton government at the end of sixteen years of Fianna Fáil rule, shifts that she was well placed to observe and understand. Her first experience of foreign reporting was in East Africa, resulting in the series from which her piece is taken. Covering politics and feature issues like water rights or youth employment as well, she stayed in the newsroom until October 1980.

"After that, I was offered the job of political correspondent in the first *Sunday Tribune*, whereas I was fourth or fifth in line for a political reporting job in the *Irish Times*, so I left. From 1980 to 1982 I was political correspondent at the *Tribune*, then I moved to the *Sunday Press* and worked as Burgh Quay's first political correspondent for the following five years."

She then ran successfully for election as a People's Democracy TD, becoming their spokesman on Foreign Affairs and Northern Ireland, and Chief Whip from 1987-9. She took over the Saturday Column of the *Irish Times* in 1990, moving to public affairs correspondent in 1991-3, finally rising to the role of political correspondent 1993-9 and political editor 1999-2002.

In late 2002, after a period of downsizing, she became editor. She is not the first woman editor in Ireland (Anne Harris of the *Sunday Independent* holds that distinction) but she is the first woman editor of the *Irish Times*, and her promotion to the top post at a time of low morale was universally welcomed.

Maev Kennedy

"Yes, I was Donal's babe! And proud of it. When the *Irish Times* published my first article I was very pleased, if less surprised than I am now—but mortified that they had added aged fourteen to the byline. I had imagined the reader would be struck by its undeniably youthful, yet urbane tone. Hey ho.

"My father, my goad and an exquisite writer, got more disorganized as depression gradually swallowed him up like an anaconda tackling a calf. When he died ten years ago, not one word remained in print to show his grandchildren that he had ever been more than an unhappy civil servant who pottered about with old cars. There's a moral there somewhere. The *Irish Times* paid a stunning £5 for my piece, which in real terms is probably considerably more than I earn now. After deep consideration I invested it on a pair of brown flares, a long beige skinny-rib jumper, and a hipster belt, all from Penneys.

"In 1975 the *Irish Times* hired me in classic Donal Foley fashion. I went to see Donal straight out of college and pleaded for a job. He told me to go and learn shorthand and typing, which I did. Months later my mother, Val Mulkerns, met him at a party and he said he was sorry to hear the *Independent* had got me. 'But they didn't!' she said in horror. 'Oh,' he said vaguely, 'I heard she'd gone there—tell her to come and see me again!' He and Fergus Pyle interviewed me for the Belfast office. Somebody else left a message that I should start on Monday. I screwed up my courage to ask whether that meant Dublin or Belfast.

"It was Dublin; so on Monday I turned up, having bought a wire-bound notebook and steamed off the cover that said Reporter's Notebook, which I thought humiliatingly gauche. On the terrifying first day I was taken on the ritual visit to the stationery cupboard where I found a pile of identical notebooks, and got this warning from Donal: 'It's not the men you want to watch out for here, it's the women.' I was officially on three-months probation, and at the end was convinced I would be fired, and wondered if, like being hired; you just had to guess. Dick Grogan told me that nobody had been fired in living memory.

"People kept telling me how young I was, which made me anxious, feeling they couldn't have known that I was actually twenty-one. What people most often called me was 'an *Irish Times* woman', with an audible lift of the eyebrow. At a party I once asked a drunk Fine Gael vet what he meant by 'an *Irish Times* woman'; he eventually conceded he meant 'on the Pill and screws like a rabbit'."

Kennedy left in 1986 because there could be "no more blissful job" than Dáil sketch-writer, and moved to London. In 1987 she became a *Guardian* staffer, writing the *Guardian* Diary before becoming Arts and Heritage correspondent. She has started a dozen books and finished one, the *Hamlyn History of Archaeology*, but managed to produce a son, Samuel, bang on deadline in 1994.

Mary Leland

"Cobh and the *Lusitania* memorial. As the car shudders in the unrelenting traffic, a memory stirs—was this the first story I wrote for Donal Foley, the completion by Seamus Murphy of the work begun by Jerome Connor, the casting in bronze of the surmounting angel?

"The story won't come to me now—like all journalists I forget the details as soon as they have been published. But I remember another place, Aghiohill near Clonakilty, and a commemoration service led by Jack Lynch in a cemetery where we all trampled over innocent graves so that one grave might be distinguished.

"This was what we gratefully called 'a colour piece'. News markings under Donal's editorship became opportunities for reflection and observation, for not so much what was happening in real time but what events might signify. We could describe in a way not often allowed in a news story. And how I described!

"Seizing that opportunity relieved the passion for words, for atmosphere. We could afford the sideways look or excavation of emotional territory, or hint of the ironic or satirical. Did this approach add anything to the record of the event? I prefer to think it did. Certainly the muttered approval of Donal Foley released a willingness to try to look deeper or farther than might otherwise be warranted. For me it also promoted a confidence in phrasing and a caution in quotation. In these days when news broadcasters and younger journalists have never been required to know the difference between the use of 'may' or 'might' or between 'reticent' and 'reluctant', I remember the insistence on good grammar and exact punctuation (the latter, I admit, a rule I flex too freely).

"I remember Donal Foley, but not where we met or how or when. It must have been when I was on the staff of the Dublin office of what was then the *Cork Examiner*. I remember meeting Mary Maher, a conjunction I still recall with geographical precision and always gratefully, and after that Maeve and Elgy and the lamented Christina: all original, all brave, all creatively empowered by Donal Foley, who had many other things and people to think about. I did not remain grateful to him—perhaps we would all have developed as we did without his encouragement—but I have been loyal, at least."

Mary Leland was born in Cork and trained as a journalist with the *Cork Examiner*. After a couple of years in Dublin working for them and also RTÉ, she returned to Cork in 1966 and freelanced for the *Irish Times*. In 1981 she won the Listowel Writers Week short story award, and in 1985 her first novel *The Killeen* was published. She is the author of several other works of fiction and non-fiction. Her stories are read on BBC Radio 3 and 4, and she continues to freelance for the *Irish Examiner*, *Irish Times* and *Sunday Independent*.

Mary Maher

"In April 1965 I sidled into the *Irish Times* newsroom clutching a sample of cuttings from my three years' service on the women's pages of the *Chicago Tribune*. I was hoping for a job that would reap interesting foreign experience to catapult me to less boring work when I swanned back to Chicago. Not that I really thought of Ireland as foreign—like most Irish-Americans, I foolishly assumed I had a birthright to my place on the island, which had the added advantage of approval from my parents, who foolishly assumed I would meet no wicked men.

"Donal Foley looked at me glumly and asked my opinion of John F. Kennedy. With all the pompous assurance of youth, I replied that despite his good points Kennedy had failed to initiate the social change urgently needed in the USA. Had I been less gauche I would have waffled nicely on that one, because the assassinated president was still greatly mourned in Ireland.

"But since Donal Foley held much the same view, I was rapidly vaulted to the second stage of the interview. He explained vaguely that there was a sort of agricultural fair on that week called the Spring Show, and directed me to bring back an 800-word colour piece by 5 p.m. I obliged, marvelling at my first encounter with real pigs; Chicago's stockyards were not on the women's desk beat.

"They used the piece the next day and hired me on probation for three months at £15 a week. No one ever paid me for the colour piece and no one ever told me whether I passed probation. But I would have to say over the following thirty-seven years I cannot recall ever being bored."

Nell McCafferty

"While I was working as the unemployed and unpaid secretary of the Derry Labour party from 1968-70, so many journalists came to me for information about the civil-rights movement that Mary Holland of *The Observer* eventually suggested the *Irish Times* employ me directly. I wrote a trial piece on the Reverend Paisley explaining why Mr Paisley was beloved of anti-civil rights Protestants: he was a terrific campaigner. Donal Foley interviewed me. Our three-minute chat in the tiny radio cubicle consisted mostly of Donal's musings on how we Irish were attracted to the upper-class English. He cited several meetings with one Lady Docker, who had a yacht, later saying he gave me the job as I'd asked him if he and Lady Docker had had an affair. He also said he'd trouble understanding my accent, but I'm sure I did ask him. Human life fascinates me.

"I joined the *Irish Times* on Tuesday 19 May 1970, arriving a day late because Bernadette Devlin and I had both been convicted of and fined for a civil-rights offence in Northern Ireland. Donal wrote an editorial in which he made the proud boast that the hitherto pro-establishment Anglo-Irish Protestant *Irish Times* staff were now drawn from all walks of life and all parts of the island, from his own Gaelic-speaking native place in Ring, County Waterford, to my own anti-British battling Bogside north of the border.

"I was a bit lost in the strange Irish Republic. Donal typically arranged that his wife Pat cook us Sunday lunch; equally typically, he brought me to a pub first for a few drinks so we were horribly late. Pat was English-born. I was charmed by her and by their collection of paintings. I had eight great years with the *Irish Times*, writing as their pet anti-establishment Bogside mascot for Women First, then as columnist of 'In the Eyes of the Law' and 'In the Eyes of the Church'.

"The paper had boasted in a 1970 editorial that it possessed a Bogside journalist, my good self. Donal Foley had suggested that my civil crimes might now cease. I resigned in 1978 and went off to write the great novel—lousy, unpublishable novel—and after that I sometimes wrote shite for garage 'zines to survive.

"I wasn't anti-British. I was anti-British Army and anti-Unionist. At the end of the seventies, the Pope's visit put the fear of God in the Irish establishment with his attacks on feminism and (less effectively) on the Provisional IRA, with which by then anyone from the Bogside was considered a sympathizer. Certainly I never considered my neighbours' children in the Bogside to be criminals. The Pope and the *Irish Times* were not far wrong in this perception of feminism and northern nationalism as forces of change in Ireland.

"It suited the *Irish Times* that I fought for civil rights in the early seventies, but it's my belief that when I focused specifically, at the end of that feminist decade, on the wrongs done by men from both North and South to women, the *Irish Times* sat resolutely on the fence. Grand so, goodbye."

Christina Murphy 1941-96

After working in Germany and then coming home to edit the Institute of Public Administration's civics publication for schoolchildren *Young Citizen*, Christina Murphy was head-hunted for the post of Women First editor by Donal Foley in 1972 while Maeve Binchy was moving to London. By October 1974, when Women First ceased and "women's news" graduated to the main news pages, she had moved to education correspondent. In a piece called "Pastures New", Murphy wrote: "Women's pressure groups and lobbies have made women's affairs such a focus of public and political attention that it has become legitimate news in its own right. When I joined Women First, the AIM (Association of Irish Mothers) group was a fledgling; Adapt, Cherish, Irishwoman's Aid and the Women's Political Association had followed hard on its heels, highlighting other aspects of women's problems and rights... One begins to feel that the Minister for Labour can hardly make a speech without referring to the disgraceful discrimination against women."

Murphy also agreed with her predecessors Mary Maher and Maeve Binchy that running Women First was a thankless task, carrying the burden of irritating calls and queries about eyeshadow, not to mention remarks from men who pretended not to read the page, yet it proved to be compulsory, even revolutionary reading, for men and women alike.

"Women's liberation has grown from a frowned-upon, suspect fringe into an important, multi-pronged lobby, and in the process has pushed women's affairs

out of the cosy confines of the woman's page, and onto the front pages of the newspapers where it belongs."

Christina continued to write about women's issues as well as education, and ran a long diary about pregnancy (see pages 166-70) when she and her husband, RTÉ reporter Dermot Mullane, became the parents of Eric.

Eileen O'Brien 1925-86

It sounds insulting to describe Eileen O'Brien as Donal's babe, but she was truly one of his most personal finds. A respected senior reporter in the *Irish Times* newsroom with an immense track record as a Dáil and Seanad reporter, she had beautiful Galway Irish, an innocent sense of humour, and a deep love of the Black Protestant North. Before joining the newsroom as Dáil reporter, Eileen had been working in Gael Linn for Donal O Morain and before that on the *Yorkshire Post* and *Connaught Tribune*. But in the sixties she ended up in St Loman's undergoing treatment for alcoholism. Dr Ivor Browne treated her by playing his *feadóg stáin* to her and it did the trick. Before she left the hospital, she asked her best friend Patsy Sheridan to phone Donal Foley about a job. Eileen even asked Patsy to emphasize the fact that she was alcoholic so that Donal would be aware. Donal was delighted and welcomed her to join "all the rest of us alcoholics".

Though Eileen no longer drank, she permitted herself Patsy's whiskey-doused Christmas pudding at her Christmas dinner, after which her sense of humour became even sunnier. She was a deeply charitable woman, something known to us all—and guffawed loudly in Irish when Donal gave her "Man Bites Dog" to read at deadline while the rest of us frantic hacks groaned and ducked under the desk.

She had lived with her beloved father Professor Liam O Briain and after his death bought, with trepidation, a small house off Pigeonhouse Road. It was her last adventure before being taken to Baggot Street Hospital with lung cancer in 1985. We all went to say goodbye, hoping for her sake the end would be gentle and swift. I'd been commissioned by Eugene McEldowney to find her Gaeltacht-made biscuits. With my reporter's nose, I tracked down honey wafers made by the musical O Riadas of West Cork. They were delectable, but bore an unfortunate resemblance to Last Rites communion wafers.

Eileen's misery in the public ward was compounded by not being able to fix her hair, normally worn in a halo-like bun contrived with a zillion pins. She

looked at the communion wafers and turned green. "They're from the Cork Gaeltacht!" I explained rapidly, but she murmured, "I wonder … so sorry … could you excuse me?" A nurse pulled the curtains.

Maev Kennedy visited her weeks later at Christmas time and found her distressed by the idea of going to a hospice. She managed to stay and died there on New Year's Day in 1986. We will not see her like again.

Caroline Walsh

"Donal Foley brought me into the *Irish Times* in 1975. Having taken the well-worn path to London on leaving UCD in the early seventies and having worked for a year as secretary to the diplomatic and obituary staff at the *Daily Telegraph* on Fleet Street, then in its heyday, nothing would do me but to become a journalist myself. So I came home and fired out CVs and letters to every provincial paper in Ireland, begging for interviews.

"It was Nuala O'Faolain—a family friend—who said what I really needed was to meet Foley; and brought me along one evening to Sinotts on South King Street for an audience at which he had only one, fairly basic question: 'Have you written anything?'—to which the shame-faced answer was a pathetic 'No.' Fired by his injunction to get out there and write a piece on something I knew about, I ran home to Lad Lane and banged out an impassioned protest piece on my new Olivetti about the destruction of Georgian Dublin, then tumbling all round us. It appeared in the *Irish Times* more or less the day after I dropped it into Fleet Street. A few freelance pieces later, a reporter's job came up. I applied and got it. I was twenty-two. I have since been a reporter, feature writer, regional news editor, features editor and, for the last four years, literary editor.

"*The Irish Times* has been a staff in my life, guiding me through its many vicissitudes. Somehow, somewhere along the line, I hope I have given it something in return."

For details of the lives of Theodora FitzGibbon and Gabrielle Williams, see pages 48-9 and 59-63.